ASYLUM SPEAKERS

For my four foster brothers, for the larger refugee community and for everyone who has ever felt unwelcome anywhere, this book is for you.

For Nahom. For Jennifer Woodhouse. For Sarah Burkeman. For Yara's father Mohammed, Farida's father and brother, Shikhali's father, Noor's father and all the others who went before us in the fight for what is right.

COLLATED BY
JAZ O'HARA

ASYLUM SPEAKERS

CONTENTS

A NOTE FROM THE AUTHOR

There are no fictional characters in this book. Each story you read is that of a real person, whose words have been transcribed from interviews as accurately as possible. Most of these interviews were originally recorded for our podcast, *Asylum Speakers.* Any editing has been done for purposes of clarity only, while always maintaining the original sentiment. The brilliance in these pages belongs to the people featured within them.

You will hear not only from those with lived experience of displacement, but also a few others impacted by migration, such as volunteers and those working on the front line. Although their stories will never compare to the gravity of those searching for safety, they are included in these pages as people who have inspired me in their own way, in the hope they will too for you.

I look forward to the day when all the people in this book can share their own stories in a world where they are celebrated and heard. For now, I see myself only as the vessel with the book deal, here to help that day come sooner.

A GENTLE CONTENT WARNING

Some of the stories in this book may be triggering to some readers. We have done our best to highlight potentially triggering topics throughout, but please take care when reading and do not hesitate to take a break or seek support if you need to.

A WORD ON SEMANTICS

In our mainstream media, the terms 'refugee', 'asylum seeker' and 'economic migrant' are often dangerously conflated. I want to take a minute to clarify the differences between them. An 'immigrant', 'economic migrant' – or simply 'migrant' – is anyone who moves from one country to another out of choice. This is often for job opportunities or perhaps, as in my mum's case, for love – she moved from Amsterdam to England when she met my dad. Our current society typically celebrates this kind of movement when it comes to Westerners moving abroad to work or retire and often reframes them as 'expats'.

Most of the stories in this book, however, are of people who have left their countries because they *had* to. Once you are forced from your country as a result of a threat to your safety, you become an 'asylum seeker'. These words literally mean 'someone seeking safety' but this core meaning is often lost.

Once you arrive in a host country where you are able to 'seek asylum', you go through a rigorous interview process to prove that staying in your home country was a risk to your life. This process can take years, during which time you are not allowed to work. If you are denied, you face deportation. If you are accepted, you officially become a 'refugee' – a status that comes with certain rights in that new country, including the right to live and work legally. But this status doesn't last forever. In most countries, refugee status will expire after a certain number of years, at which point you must begin the long process of applying for citizenship. Citizenship is aspirational for many refugees as it brings with it additional rights, such as the right to travel to your home country,

which is restricted under refugee status. Gaining citizenship is a long and difficult path which most people in this book are still navigating, including my four foster brothers who have lived with my family for many years.

In this book you might find I use the terms 'asylum seeker' and 'refugee' interchangeably, although I prefer to stick to 'person' to avoid labels which only perpetuate an 'us' and 'them' narrative. You won't see me use the term 'migrant', as although there is nothing inherently negative about the word, it has been weaponized by mainstream media and used to alienate vulnerable people, often prefaced with the word 'illegal'.

There is nothing illegal about seeking asylum. As you will see as you read the stories in these pages, many people are forced into taking life-threatening risks and dangerous decisions, but this is because there is *no legal option*. If there was, believe me, people would choose it.

Underneath the terms 'refugee' or 'asylum seeker' are people who have experienced something outside of their control. And though bad things may happen to us, they do not define us. Instead of focusing on 'refugees', 'asylum seekers' or 'migrants', or any other terms that might label or divide us, let's remember that we're talking about 'people'. Everyone in this book is someone's child; many are parents or siblings. We are all human, and regardless of race, nationality, religion or language, we are always able to find common ground should we want to.

TAKING UP SPACE

I've had many a crisis of confidence while writing this book. Who am I to tell these stories? Am I taking up valuable space?

I don't have lived experience of forced migration. I definitely don't pretend to. I recognise I will likely never be unwillingly displaced from my country, leaving behind everything I have ever known. I cannot begin to understand what that would feel like. But I can commit to doing everything I can to stand in solidarity with those that do. I can continue to dedicate my life to advocate for the rights of refugees and asylum seekers, and be the best ally that I know how. So what does that look like?

Well, I know I have some serious privilege, and I've made a promise to myself to strive never to underestimate that or take it for granted. As one of my favourite writers, Glennon Doyle, says, "The worst thing we can do is privately hide within our privilege, revelling in it and staying safe, liked and comfortable while others suffer and die. There are worse things than being criticised... like being a coward."

I recognise my responsibility to use the privilege that has been afforded to me through the happy accident of my place of birth to work towards the change that I believe in. Of course I'm scared of getting it wrong, of being called out or criticised – but I'm more scared of the alternative. I will keep showing up and getting it wrong because I know in doing so, I will continue to get closer to getting it right.

This book is about using our incredible and unique ability as human beings to step into somebody else's shoes and look at life through another lens. The thing is, no matter how empathetic you are, you can never get away from your own window into this world. Although this book is about a cause and a vision for the future much bigger than me, it is written through my lens. All I can do with this book is invite you to come and take a look through my window, and share some of the interactions I have had the true honour and pleasure of experiencing.

Many of these stories begin or end with my own learnings. This is not a way to centre my experience, but because it's the only experience I have. The aim of this book is to amplify the important voices of the people within its pages and highlight where you can hear from them further, and how much we have to gain from doing so.

I will be honest when I say that I have received more than I could ever give through meeting the people in this book. That's what's had me pondering long and hard about why I'm writing it. Am I doing this for me? Yes, in part I am, because we all have so much to gain from migration and from each other. I grow and expand through connection, conversation and inspiration every single day, but I've come to understand that multiple things can exist all at once. I can give myself fully to this cause, while also appreciating the growth in my own heart and life as a result. In fact, it makes it even more clear that this is the only way. This is the future.

There have always been asylum seekers. Throughout human history, people have sought to escape danger and persecution by abandoning their homes and fleeing their homelands. Over millennia, millions have sailed across oceans, trekked over mountains, traversed deserts and crossed borders in search of refuge. While today, in the 21st century, there is much debate and controversy about asylum seekers and the international asylum laws, the phenomenon itself is ancient. Indeed, the concept of seeking asylum from persecution in a new homeland is deeply entwined within the oldest traditions of the major world religions. Stories of migration, the search for a new home and the of the exodus of oppressed people exists within Jewish, Christian and Islamic religious texts.

In the last century, the two World Wars sparked mass movements of people. Particularly during World War II, unprecedented numbers of civilians sought to escape invading armies or flee from persecution by totalitarian regimes, who targeted them because of their religious faith, race or political beliefs. Those who were unable to make their escape and died at the hands of those brutal regimes are rightly remembered as innocent victims. What we sometimes forget is that those who did escape appeared at border crossings or arrived packed onto ships in the ports and harbours of receiving nations. Like many of the people in this book, they were not always treated well or welcomed. Just like the human drive to seek asylum, suspicion of and hostility towards asylum seekers has a long history.

During World War II, more than 70 million people were killed, but another 65 million were forced to flee their homes. Millions were housed in special camps. When the war ended in 1945, international agencies made arrangements to repatriate those whose home nations were now safe, and to find new states for those unable to return home. This process took years, and eventually responsibility for refugees was taken over by the United Nations.

In 1951, while still processing the refugees and displaced people of World War II, the United Nations Refugee Convention established the legal definition of asylum that we still use today. Those international laws and protocols are one of the great humanitarian achievements of the 20th century.

Like many of those displaced during World War II, many of the people in this book never imagined that they might lose their homes or be targeted by oppressive regimes that took over their nations. Asylum seekers forsake their homes and family, embark upon perilous journeys to nations about which they often know little, because they have no choice. Because to remain in their home nations would place then in even greater danger. Some do not actively make the choice to seek asylum as they are too young to do so. Thousands of asylum seekers are children, and some of their stories are represented here.

They have always been asylum seekers and, because there will also always be war and persecution, there always will be. There will always be the need for compassion and empathy towards them.

David Olusoga

To truly understand the experiences and struggles of refugees, we have to read their stories. For us to be able to humanise, sympathise and show solidarity with asylum seekers, people fleeing for their lives, people on the move, we need to see them as individuals. Too often, we are painted with the same brush, viewed collectively although we make up a diverse group with different experiences.

There are over 100 million displaced people across the world (of which about 70 million are internally displaced). Most come from Afghanistan, Syria, Venezuela , South Sudan, and now Ukraine. Thirty million of these displaced people are considered "refugees", and the majority are hosted by neighbouring countries – Turkey, Jordan, Lebanon, Pakistan, Iran, Colombia, Poland. Only a small number of these people decide to make the long journey further into Europe or the USA, and the situation they find there is troubling.

Politicians and the media, especially the right-wing media, have created a culture of hate and hostility. It is easy to blame someone else for your struggles, and too often the blame for society's problems falls on the shoulders of refugees. This is not just wrong, but dangerous. The recent riots outside a hotel housing asylum seekers in Liverpool, in the north of England, are the result of a radicalised population and a growing anti-refugee sentiment.

I have been giving talks to raise awareness of refugee experiences since the publication of my memoir, *The Lightless Sky*, in 2015. In my years of activism and humanitarian work, I have never seen it this bad. Refugees and asylum seekers are routinely dehumanised and criminalised, left in limbo for years waiting for the results of an asylum application, subject to a culture of disbelief and threatened with deportation to any country who will have them.

But it doesn't have to be this way. I recently visited Poland and Moldova and saw Ukrainian families on flights destined for the UK. The outpouring of support for Ukrainian refugees has been incredibly touching, and a sign that safe, legal routes for everyone fleeing persecution are possible. We just need the political will.

My goal as an author and activist is not just to provoke sympathy and solidarity, but to inspire action. Befriend refugees. Mentor them, help them learn English, support them with integration. Campaign on their behalf. I've learnt, through years of working in this space, that most people have very little understanding of what it means to be a refugee, of why people leave their homes and what happens on their journeys.

People don't flee their homes for no reason. I was forced to leave Afghanistan as a child. I was thirteen years old and I crossed half the world by myself. I didn't see my mother for sixteen years. You can read more of my story on page 70. Believe me when I say that fleeing for your life is the last thing that anyone wants to do.

This is not just a refugee rights issue; it's a human rights issue. When we welcome asylum seekers in society, we are welcoming our future neighbours, our doctors, teachers, artists, scientists, engineers, journalists, politicians. "Refugee" is just a legal term; there is more to us. We are mothers, fathers, siblings, partners, human beings. And our stories, the stories you are about to read, are the stories of our time. Nothing is more important than this.

Gulwali Passarlay

INTRODUCTION

AUGUST 2015: THE PHONE CALL

I remember the phone call. It was a Sunday morning in the summer of 2015 and I was having breakfast at my parent's house in Kent. My mum was half-heartedly flicking through the Sunday magazine that came with the paper, chatting to me about my week. When the home phone rang, it was my dad who ran to answer it, standing in front of the window in the dining room. He was backlit, but I could see the silhouette of him holding the phone between his ear and his shoulder, leaning across the dining room table to grab a notepad and a pen.

"MESERET," he repeated slowly and carefully, writing the letters down onto the pad. "M, E, S, E, R, E, T." Mum cast the magazine aside. Both of us sat up straighter, listening carefully.

"He's 12 years old," my dad repeated, nodding. "From Eritrea and speaks no English."

My mum and I exchanged an excited look. A mixture of "Shit... is this really happening?" and "YES, it's finally happening." It felt like ages before my dad put the phone down.

> **"THAT WAS KENT SOCIAL SERVICES," DAD SAID. "THEY'VE FOUND A BOY AT THE FOLKESTONE EUROTUNNEL TERMINAL. HE HAD BEEN HIDING UNDERNEATH THE TRAIN."**

"That was Kent Social Services," he said, confirming what we already knew. "They've found a boy at the Folkestone Eurotunnel terminal. He had been hiding underneath the train. He's from Eritrea, seems healthy apart from a knee injury, and he's probably very hungry and tired. What do you guys think?" he said, looking at my mum.

"That's him," she replied. "That's him."

JANUARY 2015

Rewind eight months or so and my mum was experiencing something I imagine to be common as your kids leave home: empty nest syndrome. My youngest brother Fin was turning 18 and making plans to move out. The last of four kids (me being the first), our house had always been alive with friends and family. The door was always open, physically and metaphorically, welcoming a continuous stream of people around the long dining room table for dinner, providing the space to understand and be understood, to develop and challenge opinions, to change our minds, and to slowly form the humbling realisation of ourselves as a tiny part of the world around us.

My mum had put her everything into being a parent She wrote supportive notes in Dutch in my lunch box ("*Ik hou van jou!*" or "I love you!") when I was struggling to fit in at my new primary school in the village after moving back from Australia with a thick Aussie accent aged seven. She was always a

The Calais Jungle, 2015.

great listener, never shying away from difficult or embarrassing subjects such as sex and drugs when we were teenagers. I used the fact that she was from The Netherlands as an excuse for her often cringe-worthy directness, but as I grew older it was a trait I learnt to love and appreciate. With the last of us about to leave, my mum had to reimagine her future without the day-to-day commitment of motherhood that had shaped her life for the last 20-something years.

"I loved being a mum more than I could have ever imaginec," she told me. "Then all of a sudden I wasn't necessary anymore. I felt redundant."

She had come to the realisation that being a mother was at the core of her existence and purpose and what she did best, so she began looking into options for fostering or adoption. My dad took a little more convincing, unsure as to whether he could extend the love he felt for his own four kids to other

people, but it didn't take long for him to meet my mum where she was at. Together they embarked on the journey of becoming foster parents through our local council. It was a long, rigorous and invasive process, with home inspections, training and eventually a panel with a judge. But my parents persevered.

As they did, they learnt about something that was happening right on their doorstep. They learned that there were unaccompanied children arriving to the shores of Kent, the county in which they lived in the south-east of England, having crossed land and sea in an attempt to find safety. Refugee kids, arriving alone, and needing a family.

These kids were often teenage boys who spoke little to no English – an intimidating prospect for many other potential foster parents. Most were hesitant to take on older children, particularly those who didn't speak English or might be suffering from trauma. My mum and dad felt differently. They

thought this could work for them: their own kids were older, so they had lots of experience with teenagers, and mum, being Dutch, knew what it was like to learn English as a young adult.

"OK," they thought. "Let's do that. We'll let social services know we are happy to welcome an asylum seeker into our family."

The process of becoming foster parents took my parents around nine months. "The same as a pregnancy," my mum often said. And just like during a pregnancy, she took her time preparing a room for the new child. She painted it and laid new socks, pyjamas and a toothbrush on the bed, although she had no idea what size or gender our new sibling would be.

Towards the end of that nine months, my mum had a dream in which she saw the face of a boy. She described him having "a beautiful smile with very straight white teeth", and he was on his way to us. But mum woke up from that dream in a panic, and shook my dad awake next to her.

"He's young!" she said, "Younger than 16. We need to tell social services, he's not 16+, we need to change our form."

So that morning she called her social worker and told her about the dream. Probably thinking she was slightly ridiculous, but honouring her anyway, the social worker changed the requirements on the form to state that my parents were open to taking on a younger child.

A few weeks later, on a Friday, they went to the panel and were officially approved as foster parents. It was that Sunday morning, two days later, that we got the call.

MESERET

About 50 miles away, Meseret sat in a windowless room in a Kent police station. It was a Sunday morning and there were no social workers on duty, so it was two police officers who swapped his dirty, wet clothes for dry ones, gave him some food and took a mugshot. Using a translator, they asked him, "Do you want to go to a family?"

Little did we know that while my parents were going through this nine month journey, a young boy from Eritrea called Meseret was on a nine month journey of his own. We'll get into the details of his journey later, but for now let's go back to the moment where he sat in that lifeless room in a police station in Kent, exhausted and confused, but knowing one thing.

Yes, he wanted a family. Desperately. It was nine months since he had seen his mother in Eritrea. Nine months since he had left behind everything he knew: the unconditional love of his parents and younger siblings, the village he'd lived his whole life in, the friends he'd grown up with. So much had happened

Jaz sorting donations to take to Calais.

since. So many unbearable, unthinkable experiences beyond what he could ever have imagined the day he left.

"Yes," he nodded, "a family."

So Kent social services called Meseret a taxi, put him in it, alone, and sent him on his way to our home.

In the meantime, shit had gotten crazy at my parent's house. My dad frantically googled recipes for Eritrean food and headed to the supermarket with my sister. He held up random fruits in a panic, asking, "Does this look like the kind of melon you'd get in Eritrea?" My mum was also preparing for his arrival, hanging clothes she had bought him in the wardrobe and mentally composing herself for what was about to unfold.

I was less composed. Honestly, I'd never felt excitement like it. I was bounding around the house, not knowing what to do with myself, when the doorbell rang. "Calm. Down," mum told me. "Don't overwhelm him."

It is a cruel comparison that what we felt in preparation for Mez's arrival was excitement – the beginning of a new chapter of our lives – and yet for Meseret that taxi ride was yet another example of being thrust into the unknown, in a perpetual state of fight or flight. Mum opened the door and there he was, holding his bin bag of clothes in one hand and a couple of bits of paper in the other. He looked so young. "Come in," mum hugged him and led him into the living room. "Sit down. You're safe now."

Meseret spoke no English and even Google Translate didn't know his language of Tigrinya, so we made do with hand gestures and drawings. Somehow we communicated just fine. My dad prepared an Eritrean chicken dish called tsebhi derho, which turned out to be Meseret's favourite, and we got to know a little bit more about each other.

I drew pictures of our family, and taught Meseret their names; he drew me pictures of trucks in the desert, boats and tents. I started to get more of a feel for his journey. Something else had happened to me in the weeks leading up to this moment that stood me in a little better stead to understand the extent of what he had been through.

CALAIS

A fortnight before Meseret arrived on our doorstep, I was at home visiting my parents. I'd often come on Sundays as their house in the countryside was only an hour's journey from the busy London road where I lived and made for a welcome reprieve. We were sitting in the garden this time, and the Sunday newspaper was spread out across the table.

I remember the headlines well. On every page there were pictures of people in small boats, in camps, walking across Europe with their lives in their rucksacks and their children in their arms. The words used to describe them were dehumanising. 'Swarms of migrants' read one headline; 'marauding migrants' read another. The papers were full of the situation in Calais, in northern France just across the water from Kent, where there was an informal settlement of people forming. They were attempting to cross the Channel between France and the UK.

"Maybe that's where our future foster child is," mum wondered, looking at the photos of tents in the mud.

We chatted about how the news wasn't answering the questions we had about the camp and the people that were living there. Where were they from? Why were they leaving? What had their journeys been like and what was life like in the camp? We were keen to understand, but all we could find in our search for information were sensationalist images of hooded men trying to jump onto lorries. It didn't feel like it gave the full picture.

"Maybe you should go there, Jaz. Try and find out."

Those words planted a seed that grew instantly into an overpowering curiosity that I couldn't ignore. That afternoon I called my boss to ask if I could have a day off work that week. I worked in fashion at the

time but had always had an interest in human rights. After studying design at university, I found my dream job with an ethical underwear brand that produced fairtrade, organic cotton in India, and I split my time between the cotton villages of rural Odisha, the factory in Hyderabad and the office in Shoreditch, east London.

Next I called a friend who ran a restaurant and I used his wholesale account to get some boxes of things I thought that people in the camp might appreciate, naively filling the boot of my car with cereal bars and packets of nuts. Looking back, I had no idea. No idea what I was doing or how much my life was about to change.

To get to Calais didn't take long: an hour to Folkestone from my parent's house and you drive straight onto the Eurotunnel train. Forty minutes later you're in France. I flashed my passport at either end but didn't even need to get out of my car.

I saw the tents as soon as I exited the train onto the main road. As the colourful clusters of tarpaulin grew more compact, I pulled off the motorway towards them, parking at the base of a grassy bank. When I opened the car door I was greeted by a smiling man who introduced himself as Osman from Afghanistan.

"You don't look like you've been here before?" He seemed genuinely interested.

Osman offered to show me around. I followed him closely as we made our way through the precarious landscape of guide ropes and washing lines, the remains of open fires, and shopping trolleys filled with people's belongings between the densely packed tarpaulin structures. We approached a blue, two-man tent and Osman welcomed me into his home with the hospitality I have now come to recognise as typical of Afghan culture. It was too

small for us both to get inside, so he lifted the flap for me to see. The tent was as neatly organised as your life's possessions could be inside a two-metre-square space. There was a stack of warm clothes in the corner, a portable phone charger next to his folded blanket, a couple of plastic plates, a tiny glass and a saucepan which he picked up and filled with water from a battered transparent plastic jerry can. He balanced the saucepan on a jagged stone and began to build a fire from the pile of twigs, branches and bits of palette wood stacked beside his tent.

> ## THE TENT WAS AS NEATLY ORGANISED AS YOUR LIFE'S POSSESSIONS COULD BE INSIDE A TWO-METRE-SQUARE SPACE

I sat down cross-legged on a piece of cardboard but Osman asked his neighbour for a plastic stool, insisting I sit on this instead. Once the water boiled, Osman poured my tea into the singular glass, topping it with some condensed milk from a tin, forming a sweet, congealed skin around the rim.

As we sat there together Osman told me his story. He had left Afghanistan with about 100 others after the Taliban had taken over their village, aiming to walk the 3,500 miles to England. He told me that many of them, mainly the women and children "hadn't made it". He explained that at times they were so hungry that they ate grass, and one night, as they walked through Bulgarian woodland in the dark, he had tripped and a stick had pierced him through his eye. He spent two weeks in hospital in Bulgaria and the others left him behind. Osman carried on alone and eventually made it to Calais where he was reunited with what remained of his group.

So here he was. Sleeping in this tent in the mud, alongside around 2,000 others for whom this patch of asbestos-filled wasteland in northern France had become a temporary home.

Dinner at Osman's restaurant in the Calais Jungle.

"We're trying to get to England," he explained, "but it's very difficult." He went on to describe their late night attempts to climb the fences between the camp and the Eurotunnel terminal without getting spotted. When they were caught, they were routinely driven miles away by the French police, and often their shoes were taken away or their phones purposefully smashed before being told to walk back to the camp, barefoot and dejected. Osman, though, was still full of youthful optimism about his future in England and how bright it would be. He described a place where no one had any problems. I didn't have the heart to share that his perception of the UK was not quite aligned with the UK I knew.

After our tea we walked through the camp, which Osman explained was loosely organised by nationality. Closest to where I had entered were the Eritreans and Ethiopians who lived around a makeshift church built from wood and tarpaulin, two pieces of wood forming a proud cross on the top. As we walked deeper, we found ourselves in the Sudanese area, where tents were positioned in circular groups. I noticed some had doormats outside the front, and one tent had the bottom half of a plastic bottle on either side of the entrance, filled with a little water and a hand-picked arrangement of wild flowers.

Finally, we ended up back in the Afghan area, on what Osman called the camp's "high street". He told me he had the idea of building a restaurant here, somewhere to serve food during the day and sleep at night. His family had owned a restaurant in Afghanistan and he was keen to use his days for something productive. I asked him what kind of food he would cook.

"Afghan chicken," he replied. "Beans, spinach. I can make bread too if I have an oven."

Little did I know, as I stood there with Osman, imagining his vision, that I would go on to visit him regularly over the next few months, and that I would witness not only his business grow and flourish but also the entrepreneurial activities of many others in the camp. Osman's restaurant went on to become our hangout of choice. His food was delicious and his business mind was overridden by his generous spirit when he tried his hardest to refuse our payment. Every. Single. Time.

Never would I have foreseen that there would eventually be many restaurants throughout the camp, several mosques, a couple of schools, a hammam and even the clay oven that had seemed so abstract that day we first met.

Before I left the camp that first time, I had a few special interactions that left a profound impact on

me. A 23-year-old man from Darfur in Sudan, who remains a close friend to this day, told me the story of how the Janjaweed had come to his village on horseback when he was 18, burnt it to the ground and brutally shot many people, including his father. He showed me the bullet wounds on his lower legs. I felt his pain each time he spoke the word "family". He told me that every time he closed his eyes, he saw his mother telling him that he was doing the right thing. "Why, then, am I living like an animal?" he asked me.

I met many people who told me they had been doctors, engineers, lawyers and had other skilled professions in their home countries. They showed me pictures of the nice cars and beautiful homes of their past. The idea that they were coming to the UK for economic reasons was laughable. The whole thing seemed such a devastating waste of potential. I couldn't help but think that if anybody 'deserved' or had 'earned' the right to live in the UK, it was the residents of this camp.

Language was never a barrier. Those early interactions made me realise that so little of our communication comes down to words; that connection comes when two people want to listen and be heard. Never had I experienced someone

The Calais Jungle, 2015.

telling me such stories first-hand. I was unprepared and naive to the resonance they would leave. Sitting together with people as they shared their lived experience, – directly from their world to mine – it felt like they were handing me one of the few remaining treasures they held in their possession. Their story.

THE FACEBOOK POST

Newly entrusted with these precious gifts, I knew I had to do something important with them. With the luxury to think about something other than my own survival, I realised I had the space, time, energy and obligation to support those who didn't.

On the Eurotunnel train home I did what I knew how to do. I wrote. I wrote for myself, because I didn't want to forget, but also in honour of the stories with which I had been entrusted. I wrote with the view of amplifying these stories and unpicking some of the misconceptions that existed about the camp and the people who lived there. I wrote that I would be going back to the camp in an attempt to meet some of the basic needs for warm clothing, tents and sleeping bags. I set up a crowdfunding page with a small goal of covering costs of future trips, and I highlighted the need not just for financial but also physical donations. I posted my words on Facebook, intending to share them with my friends and family.

I fell into bed, ready for an early start manning our stall at a trade fair for work the next day. When my alarm went off the next morning, I reached for my phone and was met with a shock. The post had been shared hundreds of times overnight. My Facebook inbox was already too full for people to continue to message me directly and thousands of people had interacted with the post. I was totally overwhelmed.

That day things spiralled. I had to keep my phone on charge under the stall as the notifications came in thick and fast, draining my battery. I snuck

moments away to take phone calls from *The Daily Mail* and *The Telegraph* in the toilet cubicles of the Birmingham exhibition centre where the fair was. I had no idea how they got my number. I watched the crowdfunder soar, becoming the biggest crowdfunding campaign that the platform JustGiving had seen to that date. Something I'd written had struck a chord.

"You've never got more than like ten likes on a Facebook post," joked my brother Nils when I called him in a panic. But he straight away pitched in and offered up his home in South East London as a donation drop off point. Totally unprepared for what was to come, I shared his address, and my mum and dad's too, as places to bring donations. Little did we know that Nils's housemate would have to temporarily move out to accommodate the packages, boxes and bags of people's support in physical form.

We received countless Amazon deliveries of tents and sleeping bags. Hand-knitted jumpers with hand-written notes of support pinned to them. Care packages and shoeboxes of hygiene products.

THE WORLDWIDE TRIBE

For the next few months I was operating in a haze of minimal sleep and adrenaline. My friends and family (including Meseret, who had arrived amid this chaos) rolled up their sleeves and got involved in donation drop days, drives to Calais and distributions. It was a huge logistical operation, way beyond my capability or experience, especially when it came to organising an effective distribution among the camp's growing population.

At the same time, I was navigating the media attention. I'd set up a Facebook page called 'The Worldwide Tribe' which we used as a place to coordinate donations and share information. The online community grew rapidly and I recognised that many people had the same questions that I had before first going to the camp.

I did my best to answer these questions, offering a personal perspective to the rhetoric of the mainstream media. I made regular trips to the camp and enlisted the help of friends I made there to share their own story. We distributed not just clothing, but disposable cameras so that residents could share their perspective in a way that felt authentic and true to them. The Facebook page became a bridge between the people living in the camp and those in the UK keen to understand and welcome them. When we needed something in the camp we put it to our community in the UK and without fail someone knew someone who knew someone who could make it happen.

As time went on, the camp grew into the most incredibly diverse, totally unique town-of-sorts. Nils would get his haircut at the barbers there. We would eat spicy eggs and freshly baked flatbreads in Osman's restaurant for breakfast and meet friends in Kabul Cafe for Afghan chicken, creamy spinach and steaming chai for lunch. For dinner, we would join our Sudanese friends to experience some new and innovative culinary delights such as peanut butter on lettuce (delicious) and a sweet spaghetti dish they made with condensed milk – which Nils called spaghetti pudding – washed down with an interesting mix of yogurt and Sprite (together). We always felt looked after, not the other way around. (It is worth clarifying that the establishment of businesses like these were a survival mechanism, a way of making life in a perpetual state of limbo slightly more bearable. No matter how resilient and resourceful the camp residents were in finding dignity and creativity wherever they could, camp life was never desirable.)

When I was back in the UK, my heart was in Calais. I couldn't focus on my job, and in the end I left it behind. Nils joined me soon after. For over a year we lived, breathed and thought of nothing else but Calais and our friends there.

The Calais Jungle was demolished by the French authorities in October 2016, though many people stayed living in the area (and still do). We continued to support them as best as we could. By this time, our work had spread to Greece and Turkey, supporting people as they first arrived on Europe's shores. Over time it became clear to me that no matter how many tents and sleeping bags we distributed – no matter what we did to try and make the conditions in camps as livable as possible – no one should be forced to live like this in the first place. In the words of Desmond Tutu, "There comes a point where we need to stop pulling people out of the river. We need to go upstream and find out why they're falling in." So how could we get to the root of the problem?

During the early days of doing this work, I remember overhearing a conversation between two women while standing in line in the bank in my home town in Kent. They were talking about Calais and the people living there trying to cross to the UK.

"Oh it's awful," one of them said. "They're all running around with knives. It's so dangerous!"

I thought of my little brother Meseret. I thought of my friends in the camp. The tone this lady used to describe the people I now knew well didn't represent them and their stories at all. There was nothing scary about Meseret. He was a kid. A survivor. A hero.

I left the bank that day without saying anything to these women, but they had sparked a fire within me to tell the real story. The lack of education and the fear-based narrative fed to us by our governments and media was the reason why refugees and asylum seekers were not being welcomed with the open arms they deserved.

I knew instinctively that this was not how things were meant to be. That there was a truer, more just way. A more beautiful reality. One where people didn't have to make life-threatening decisions to find safety, only to be met with hostility and fear. It was this hope swelling and bubbling up inside me that motivated me to make this vision visible to others around me. It was this feeling that guided every story we shared on social media, every film we went on to make, every talk I went on to give, and behind the podcast I now host to amplify the voices of those impacted by migration. This feeling is the reason why this book exists.

Since that first trip to Calais I have gone on to work in refugee camps across Europe and the Middle East, and as far afield as Bangladesh. I am now the proud big sister of four foster brothers from Eritrea, Sudan, Afghanistan and Libya. It is around our family dinner table that I have learned how we can hold our differing beliefs, upbringings, religions and cultures close, while maintaining the utmost respect and love for one another.

Through my brothers becoming my family, I have learned that no one is born more worthy of freedom or opportunity than another. To dishonour another's humanity is to override your own. The story that some of us are worth less than others is just a story, designed to divide us and keep us fearful. Embracing diversity does not mean giving up how you feel or the unique way you do things; you can simply add to the abundant tapestry of your life. Take a minute to imagine what our communities would be musically, gastronomically, culturally, without the waves of immigration that have brought with them so much richness. True integration is all of us understanding how much we have to gain from one another – we can celebrate our surface-level differences while understanding that beneath this we are all connected. We are all human.

Man is an enemy for anything he does not know
الإنسان عدو ما يجهل

Imam Ali Bin Abi Taleb

HOME

MESERET

"I'd never heard the word 'refugee'. I definitely never thought I'd be one."

Meseret. The person who changed everything. My inspiration. My reason why.

He introduced himself as 'Messi' at first – the nickname used by his friends and family back home – until he learned the expectation this might place on his football capabilities, and decided, before starting school here in the UK, that he would go by the name of 'Mez'.

Mez is from Eritrea, a country that I'd never even heard of for the majority of my life. Eritrea gained its independence from Ethiopia in 1993 and has been under the dictatorship of Isaias Afwerki ever since. I remember walking past a protest in Trafalgar Square on my way to work many years ago, attempting to decipher the meaning behind the 'Free Eritrea' placards the small group were brandishing. I'd googled Eritrea and what I read had shocked and

horrified me, but by the time I reached the office I was back in my London bubble and I'd forgotten all about it.

Mez grew up in a village in the countryside of Eritrea with a loving family. It was the kind of village where everyone knew everyone. If Mez was naughty, any one of the village mums would give him a cheeky clip around the ear, but if Mez fell over, any one of the village mums would also be there to pick him up, dust off his knees and give him a comforting cuddle.

Despite his childhood innocence, Mez grew up with a looming sense of dread for what was ahead of him. He had seen his dad forced into life-long military service, compulsory in Eritrea, and Mez's older brother had also been taken away against his will to join the army when he hit his teenage years. The army in Eritrea is not the army as we know it. Days

spent carrying out back-breaking construction work and nights spent sleeping underground in what are essentially prisons, it is modern day slavery. "You get paid the equivalent of £10 or £20 per month," Mez once told me. "Not even enough to buy a packet of cigarettes, let alone support yourself or your family.

"I had to hide from the soldiers every day, they would come every single night. You have to watch yourself 24/7. It was very scary. If they found me, they would take me to the army. If they knew I was hiding, they would put me in prison."

Mez had never planned to leave his country, but one day in 2014, not long before his 14th birthday, the moment came that would change the course of his life forever.

"I was chilling with my two best friends Nahom and Johannes after school in the place where we always hang out," he told me, "when suddenly we heard people shouting and screaming and everyone was running. Gunshots were being fired up into the air and I just knew. I'd been having nightmares about that moment for my whole life."

"WE DIDN'T HAVE PHONES OR MAPS OR ANYTHING, SO WE JUST RAN IN A DIRECTION THAT FELT RIGHT. WE KNEW IT WAS TOO DANGEROUS TO GO BACK."

The three boys decided in that split second to run, knowing that if they didn't act fast, the army would have taken them then and there, without warning. Wearing only flip flops and the clothes on their backs, they headed in the direction of the next village. Having expected that evening to be like any other, ending with some food and their beds, they were unprepared for the fact that they would never see their families again.

"We didn't have phones or maps or anything," Mez told me, "so we just ran in a direction that felt right. We knew it was too dangerous to go back."

That first night, the three boys attempted to sleep under the trees of the Eritrean countryside. Scared of hyenas, they took it in turns to stay awake and keep watch, but Mez explained this plan didn't work so well. "I trusted those two with my life, but I didn't trust them with that," he laughed, "and none of us slept at all that night."

One year later, after Mez had arrived in the UK, we went for a family walk through the orchards around our village in Kent. "Are there hyenas here?" I remember him asking, making us all laugh.

ETHIOPIA
After a couple of days, the boys found themselves crossing the border with Ethiopia.

"It was just a fence," Mez explained, "we hardly realised we were leaving our country." But that underwhelming fence marked a profound moment.

Once they crossed it, the boys became 'refugees', and joined the hundreds of thousands of Eritreans that had been forced to leave before them and now lived in a refugee camp on the border. Bordering both Eritrea and Sudan, Ethiopia hosts one of the largest refugee populations in Africa, many of whom live in camps relying on international aid. In recent years, Ethiopia has become an increasingly unsafe destination, with the Eritrean army destroying refugee camps near the border and kidnapping or killing their inhabitants.

"I'd never heard the word 'refugee'," said Mez. "I definitely never thought I'd be one. I was so shocked to see people from my village in that camp. People I hadn't seen for years. I had no idea this is where everyone was going, what everyone was doing. Everyone was leaving. It was only at that point that I began to understand how bad things were in our country. We have no freedom of speech. No one can say anything against the government without fear of being arrested and imprisoned. For the first time, in that camp, we could speak openly about the fact we had no human rights."

Although Mez, Nahom and Johannes had arrived at the camp with nothing, they were welcomed by the community, who shared the little they had with the boys.

"I didn't know these people but I felt like I did," explained Mez. "They gave us rice, oil, bread and a blanket each."

The main thing on Mez's mind during his time in that camp was his mum. Decades on from the official end of the war in 2000, Eritrea and Ethiopia were still locked in a border conflict that severed phone connection between the two countries. Mez wasn't able to call his mum and let her know that he was OK, that he was alive.

"I dreamed about her every night," he told me. "I just wanted to hear her voice."

SUDAN

This desire spurred Mez and Nahom onwards to the neighbouring country of Sudan (Johannes made the decision to stay as close to Eritrea as possible in Ethiopia). The two boys travelled together on foot until they found themselves in a Sudanese refugee

Page 24: The photo Kent authorities took of Mez when he arrived in the UK;
Left: Mez with Bego shooting a film about their experience of life in Kent, UK.

camp, from which they could make the phone call they had been longing for.

"Mum. It's me," Mez said when she picked up.

After six weeks of not knowing whether her son was dead or alive, having disappeared one day and never come home, Mez's mum collapsed in shock, and Mez had to speak to the neighbour while she got a hold on her emotions. Although she understood Mez's reasons for leaving, it was hard to think rationally. She was a mother letting go of her beloved son into the dark pit of the unknown.

Mez and Nahom spent eight months in Sudan, working odd jobs where they could and doing the best to make ends meet. Mez dreamed of continuing his education and of days being filled with more than merely surviving. "I wanted to hold a pen and not a gun," he often says when we now give talks in schools about why he left Eritrea and the journey he was forced to make. It was clear that there was no life for him in Sudan, a country struggling with its own political instability, government corruption, violence and displacement, so Mez made the decision to continue to the next country.

LIBYA

Little did Mez know that the journey to Libya meant crossing the Sahara desert – one of the most dangerous crossings in the world, with over 2,000 deaths and a further 30,000 missing people recorded since 2014. He paid smugglers for the privilege of being squeezed into the back of a pickup truck alongside 100 other people in 50 degree celsius heat. Everyone wore scarves over their heads to stop their skin from blistering in the sun, and put the women and children in the middle to stop them from falling out as they hurtled across the sand dunes. This was a very real fear; if you were to fall out, the smugglers made it clear they would not stop for you.

"I didn't feel the hunger," said Mez when he told me that they were not given food during the 15 days

it took them to make this crossing. "It was the thirst. The most insane thirst. We were given one small bottle of water per day between two of us, and the smugglers put petrol in the water to stop us from downing it. It burned our throats and we could only sip it, which made it last the whole day.

"THE SMUGGLERS PUT PETROL IN THE WATER TO STOP US FROM DOWNING IT. IT BURNED OUR THROATS."

"We passed the skeletons of people that had attempted the crossing before us," Mez told me. "I couldn't help but wonder if that would be me next."

Libya has been described to me by many asylum seekers as hell on earth. Marred by political unrest and civil war since the deposed leader Muammar Gaddafi's death in 2011, Libya was locked in its own humanitarian crisis. As an East African visitor to the lawless country you are vulnerable to extortion and exploitation. Stories of slave markets, organ trafficking and torture are not uncommon.

On arrival, Mez and Nahom were thrown into a dark room with between 300 and 400 others. There was no room to sleep lying down, so they took it in turns, or slept standing up.

"I spent one month there," said Mez. "The worst month of my life. I wanted to die. We had one meal per day – plain spaghetti cooked in boiling water and salt. Eight of us shared one dish. It was given to us straight from the pan and we burnt our fingers and mouths trying to eat it as quickly as possibly. I would get one bite, go in for a second and it was all gone." Mez has never really liked spaghetti since.

Mez was to stay in smuggler prison until he was able to pay for his journey across the Sahara. As he

had no money, the smugglers, praying on his vulnerability and lack of options, watched over him as he called his parents.

"Dad, I need $3,000."

"But Mez, we can never pay that," his dad replied from his army bunk. At this point the smuggler grabbed the phone and told Mez's dad exactly what he would do to his son if he didn't pay.

"OK, OK," his dad cried, "I'll pay."

Mez's dad asked everyone he knew. He went to every neighbour and begged in the street to gather the money to free Mez from the hell in which he was living. During this time, Mez's health began to deteriorate.

Mez at home in the UK.

"I got very sick," he told me. "I was coughing up blood. There was no hospital. Lots of us were ill. If anyone complained, they hit us with sticks. They hit one man so hard in the face, we thought his eyes had burst. Eventually my dad arranged to send the money and I was freed. My parents connected me to a friend of a friend living in Libya who nursed me back to health. He gave me warm tea, he bathed me and he even bought me new trainers."

"You still have those trainers, right Mez?"

"Yes... they're my lucky shoes."

Mez knew he couldn't stay in Libya, but he also couldn't go back across the Sahara. There was only one choice left for him – to continue his journey across the Mediterranean Sea. This too would cost money, but by a stroke of luck another of his mum's relatives in South Africa had been able to send him over $4,000 to pay for the dangerous sea crossing. This was another heartbreaking moment for Mez, as Nahom had not been able to gather the money together, and was still in smuggler prison. About one year later, once in the UK, Mez sent his best friend the money to release from the hands of the smugglers, but he fears it was too late. No one has heard from young Nahom since 2016.

THE MEDITERRANEAN SEA

One dark night in the summer of 2015, 800 people were rounded up by Libyan smugglers and packed into a number of trucks.

"It was so tight we couldn't breathe. Many people fainted on that journey. I thought I was going to die before we even made it to the sea," said Mez. "I was shocked when I saw the boat. A big, old wooden thing that didn't look safe at all. They put 400 of us in the top, and 400 in the bottom. It was so dark, and I had never seen the sea before."

Mez couldn't swim, but he knew there was no other way than to take this enormous risk. The smuggler drove the boat into the open sea for about an hour, then selected one of the passengers at random to drive the boat, pointed him in the direction of Italy, and took a speedboat back to the Libyan shore, leaving 800 people to fend for themselves out at sea.

"I could smell the stomach acid as people vomited around me," said Mez. "It was too dark to see anything but I could feel my skin burning from the mixture of sea water and petrol on the tiny bit of wood on which I was sitting."

After three days at sea, surviving on only a day's worth of water, the passengers on the boat saw what they had been waiting for: a ship with an Italian flag. Excited, they began to jump and wave. The boat creaked under the pressure. As the rescue boat drew closer, the passengers began to shout for help.

The boat strained under its overweight cargo, and suddenly... CRACK. The boat broke in two, throwing all 800 passengers into the freezing water.

> **"I REMEMBER LOOKING UP INTO THE DARK SKY THINKING... THIS IS IT. I'M GOING TO DIE, HERE IN THE MEDITERRANEAN SEA, AGED 13. AT LEAST I TRIED, I THOUGHT TO MYSELF. AT LEAST I TRIED EVERYTHING I POSSIBLY COULD."**

"I remember looking up into the dark sky thinking... this is it. I'm going to die here, in the Mediterranean Sea, aged 13," said Mez. "At least I tried, I thought to myself. At least I tried everything I possibly could."

But Mez's fate that day was not to join the hundreds of bodies that rest at the bottom of the Mediterranean Sea (more than 17,000 since 2014). He was lucky enough to be scooped from the water by the fast approaching Italian coastguard. Safely on board the Italian ship, Mez was wrapped in an emergency blanket, given a greasy nutrition bar, and taken to Italy.

EUROPE

"Europe. Finally, somewhere I can be safe," thought Mez at the time. "I didn't know anything about Europe apart from what I'd heard others saying along the journey. I'd actually never see a white person apart from in the movies. But my understanding was that this was a place where there might be somewhere for me to live. Somewhere that I could go to school and maybe even find a family. Somewhere where I could be in peace."

Unfortunately Mez was wrong. He soon met other Eritreans who encouraged him not to stay in Italy, warning him that there was a high chance of being deported back to Eritrea if he were to try and claim asylum.

So Mez followed those who had gone before him, and continued his journey towards France. With no money, he hid in the toilets of trains and walked for days on end. One time, when caught by a ticket man with no ticket, a jolly German lady put her arm around Mez and told the ticket man, "He's with me," paying for his fare.

After about three weeks of dodging hostile authorities and sleeping outside, Mez found himself in northern France, where he was met with a sight that became iconic in the European refugee response. The Calais Jungle, where thousands of people were sleeping in tents in the mud.

"I'd never seen anything like it before," said Mez, "not even in Sudan. It was disgusting. Worse than the

Mez celebrating his first birthday in the UK.

refugee camps in which I'd lived in Africa. I didn't even want to put my foot into it."

Hearing Mez say these words does not surprise me. Not many people in their right mind would want to spend the night in the Calais Jungle.

Mez spent his first night in the camp with some Ethiopians. Though friendly and welcoming, when he woke up the next morning he found they had robbed him of the remaining cash he had been given by his family friend. Mez was confused and disappointed that they hadn't just asked him for help. "If someone was desperate for it and they had asked me, I would have given it to them," he told me.

The next night Mez followed the others from the camp who were making the dangerous attempt to cross to the UK. "I didn't know that I wanted to go to England, but I knew I couldn't stay there," explained Mez.

This treacherous endeavor involved scaling 20-foot razor wire fences, crawling through ditches, and running alongside busy motorways. "I took the laces out of my lucky shoes to use them like a ladder to get up the fence," Mez said. "Then I had to jump in some water to hide from the police. I was holding on to a tree for about 10 minutes, freezing cold."

Eventually the Eurotunnel train was in sight, and Mez managed to squeeze his slight body underneath it. Once he heard the engine fire up, he jumped inside the train. The speed at which it travels makes so much noise that many burst their eardrums during this attempt, and Mez covered his ears with his hands in pain.

Forty minutes later, the train slowed, approaching the Kent coast. Mez clambered on top of a lorry, ready for it to disembark the train. As the lorry rolled slowly down the ramp and onto British soil, Mez was spotted by British police, who signaled for the driver to stop and shouted for him to come down.

"I was so scared that they were going to arrest me and send me back to France. They were being

nice and went to get me a ladder, but I jumped and hurt my knee. They took me inside a warm building and gave me some hot porridge. I didn't know what it was but I ate it and wanted more. They gave me a very nice blue jumper and some very big flip flops because my clothes and shoes were wet."

It still makes me cry to think of Mez's first moments in the UK and the important decision he made that day that went on to shape our future.

"They were asking me lots of questions but I didn't speak any English. They found me a translator who explained to me that I had the choice of going to supported accommodation with other boys my age, or to a family."

Mez had no idea about the protocols and procedures for unaccompanied minors in the UK, but he knew one thing for sure. What he longed for more than anything was the unconditional warmth and love of his family.

"A family," he told social services, before falling asleep on a bench.

> **WHAT MEZ LONGED FOR MORE THAN ANYTHING WAS THE UNCONDITIONAL WARMTH AND LOVE OF HIS FAMILY.**

You guys know what happened next. A member of Kent social services found our file and called our house, and, once they'd got an enthusiastic yes from us, Mez was shaken awake and put in a taxi. The rest, as they say, is history.

THE UK

The desire to parent, nurture, protect and love Mez felt like it came from deep within. My feelings towards him very much resembled the fierce loyalty I felt towards my biological siblings.

For Mez, the transition was more complex. He wore the pyjamas my mum had laid out on his new bed over the top of his clothes. He hadn't slept in a bed for many months, and had never slept in one alone, always sharing with his siblings or with the hundreds of others he'd encountered along his journey. When my mum gently knocked on his door in the morning he jumped out of bed with a start, ready to run from the police, from the border patrol, from the smugglers. A warm bed did not erase what he had been through and it took some time before his mind and body could ease out of a perpetual feeling of imminent danger and into the newfound calm of family life.

"I couldn't believe I had my own room," said Mez when, years later, we sat down to record an episode of our podcast reflecting on those early days, "My own bed and my own wardrobe with my own clothes hanging in it."

Mez learned fast. "I'd never used a toothbrush so I just copied Fin [my brother] one night and thought, OK this must be how you do it." (NB: Mez has got the straightest, most perfect, white, healthy set of teeth you have ever seen.)

"There was so much to learn. Everything was new. I couldn't wait to go to school and keep learning."

SCHOOL

It took Mez about six weeks before he could join our local, comprehensive school. I was worried about him on his first day, wearing his brand new uniform of a white shirt, tie and pale blue jumper, obligatory new school shoes and too-big backpack. His English was still very minimal and whichever way we looked at it, he was going to stand out.

"It's OK Jaz," mum reassured me as we watched him from the window, sitting on the wall by the bus stop and waiting for the school bus to arrive. "If he can make it from Eritrea to the UK on his own, this is nothing for him."

But that first day he came home dejected. I have a clear picture in my mind of him sitting on the sofa,

head down, between my mum and dad who both had an arm around him. He explained how school in Eritrea was a privilege, and young people took it very seriously. The teachers were strict and their huge classes of students hung off their every word.

Mez ready for his school prom.

"But here, one boy had his feet on the desk, and a girl was putting makeup on in the class!" Mez told us in shock. Things soon got easier.

"Football and music were my calming things," he told me. "I would listen to my Eritrean songs in my headphones at break time, and go straight to the astroturf to play football at lunch time. In Eritrea it was me, Nahom and Johannes choosing teams. Here I got chosen last. No one passed to me but I didn't care, I just ran for the ball and got it myself. Mum told me that it took her a year before she felt like she had

friends when she moved from The Netherlands to England. I kept that in my head and it kept me going during those early days, to know it was just taking time and that was normal here."

In recent years Mez and I have gone back to this school to give assemblies in the hope of making this integration process easier for any future asylum-seeking kids who might join the school. This was something Mez always wanted. "The kids at school thought I was on holiday at first! They had no idea."

Now the whole school knows where Eritrea is. Seeing how students respond to Mez telling his story, how much they relate to him, see themselves in him, and how powerfully this challenges their stereotypes around the word 'refugee' has led to our mission for every student in the UK to have met a 'refugee' first hand. Mez and I want every student to see a face when they read the words 'asylum seeker' or 'migrant' in the headlines, and for every student to be able to put themselves into the shoes of another and ask, "What would I do?"

UK THE NETHERLANDS

OEDA

"I'm happy to be his mum if he wants that. If I'm just a friend, that's fine too. You can't force respect or love. You can only show respect and give love."

When I was recording the first season of the podcast, I wanted to start with people I felt comfortable interviewing. Mez was an obvious early guest, as were my good friends Awad and Abdulazez, who you will meet later. I knew my mum also had an interesting story to tell, but I felt nervous to share our episode, perhaps because she didn't have lived-experience of displacement, or maybe because it was a story so close to my heart.

But that conversation with my mum about being a mother to eight children from five different countries became one of the most popular episodes of our podcast ever, and her words seemed to not only touch people, but moved many of them to act. I got message after message from those inspired to open their own homes as hosts for newly arrived refugees, or even as foster parents.

My mum's experience will never compare to the incredible stories of those in this book who have crossed land and sea in search of safety. But perhaps her role as a mum will resonate with you, as it seemed to for our podcast audience. It is with this hope that her story holds a special place within these pages.

Mum migrated from Amsterdam to the UK in 1986. Even as a white European, she found it hard to connect with people in those early days – and especially when she moved to a small village in the Kent countryside. She remembers feeling the gaze of the fellow mums in the playground, overhearing them ask, "Do you think she speaks English?".

Right: Oeda, Mez and Jaz
celebrating Mez's birthday;
Page 35: Oeda and Mez
at home in Kent.

"I think it can be intimidating for people to first approach someone who speaks another language," she explained. "That's why many other foster parents don't want to take on foreign kids, and this is the reason why I so much did!"

When my foster brothers first arrived in the UK, mum reassured them with stories from her early days in England, explaining that it had taken her at least a year to make friends. "I felt like I'd never get used to the different ways of doing things and the different humour," she told us. "But I did. It took me and your dad a while to get each other's jokes. 'Is that a Dutch joke?' he'd ask me."

Still now, over 30 years later, mum describes feeling suspended between not being fully British but no longer being fully Dutch either. It is this sense of not knowing where home is that expands the empathy she has for the boys' experiences of integration in the UK.

THE BARGE

I have a memory from the first holiday we ever went on with Mez. He had been in the UK around a year at that point. His English was good, but he was still waiting on his asylum and travel documents, so we stayed in the UK and spent the week on a barge.

I spent a lot of that week lying on the top of the boat, secretly reading emails and replying to Instagram messages when there was enough connection to do so. A few days in, as I lay in my sunny spot, I overheard a conversation between Mez, who was at the back of the boat holding the tiller, and my mum, who had come to sit down beside him, bringing him a cup of tea. After some gentle words exchanged back and forth, I heard my mum say, "You know Mez, we're not only caring for you. We love you. You know that, right?"

These words came as no surprise to me. This fact had become apparent as that first year with Mez had unfolded. My parents had acted in ways towards Mez that were familiar to my biological siblings and me. When Mez wanted to go to the Eritrean church in south-east London, my dad made the long journey with him every single week. After a few times, when Mez insisted that he knew the way and could go

alone, dad would say, "OK. Maybe next week." As the week went on and Sunday drew closer, dad would tell Mez, "Actually, I've seen this great exhibition I want to visit in London anyway... I might as well come with you on Sunday." Mez would roll his eyes, having literally crossed the world alone only to be escorted to church. But in the same way that dad had discreetly stood at the back of gigs I went to as a teenager, it was clear that this came from a place of deep fatherly love and care.

Mum was the same. In the months before Mez started school, they did everything together. She had a dog-walking business at the time, so they would go on long walks together, practicing Mez's English. They laughed a lot. Everything was new to Mez and he was shocked to discover that dogs in the UK had beds, leads and sometimes even raincoats. When he saw a child on a lead in the supermarket his mind

was blown. They didn't need a shared language to burst into joint laughter. "It's like when your kids are little and you understand what they're saying when no one else does," she explained.

MEZ BURNED HIS FINGERS ON THE KETTLE. HE WAS FASCINATED BY THE HOOVER. "SO MANY MACHINES!" HE SAID.

Mez burned his fingers on the kettle. He was fascinated by the hoover. "So many machines!" he said. Mum labeled everything in the house with post-it notes: oven, toaster, fruit bowl. Our favourite game was to reach into the fridge, grab a vegetable and put Mez's vocab to the test. Once he had a word locked in his memory, the post-it would get removed. He learned fast, and mum was dedicated to his progression.

She was fierce in her role as his mother. It wasn't just vocabulary and grammar; she spent time explaining new concepts like sexuality and racism too. When he was refused by the local under 16s football team because he had no proof of his age, she didn't give up until they reversed their decision and let him play. If any of us made a joke around the dinner table that Mez didn't understand, she'd make us painstakingly repeat it and explain it until he did.

Mez came home from school one day utterly heartbroken and confused that a boat full of Eritreans had drowned in the Mediterranean and none of his classmates had any idea. Mum called his form tutor to explain, and the next day the tragedy was acknowledged and discussed by his class.

She was also gentle. Although Mez, copying the rest of us, called her "mum" straight away, she told me: "I'm happy to be his mum if he wants that. I'll let him lead and I'll follow. If I'm just a friend, that's fine too. You can't force respect or love. You can only show respect and give love."

A few months into life in England, Mez was able to call his mum in Eritrea for the first time to let her know where he was, and that he was safe. It had been difficult to maintain contact through a period of particularly bad phone signal in their village. Mez translated between his biological mum and his new mum in England. My mum told Mez's mum that it was an honour for her to have the opportunity to mother her beautiful son.

> **"I KNOW THAT IF THE ROLES WERE REVERSED AND YOU KIDS NEEDED SOMEONE TO LOOK AFTER YOU, SHE WOULD DO THE SAME FOR ME."**

"I felt her pain of losing him," she told me after the call. "My heart breaks for her that she doesn't experience the wonderful person that he is becoming on the day-to-day. At least I was able to tell her that he is safe now. I know that if the roles were reversed and you kids needed someone to look after you, she would do the same for me. I feel blessed to have her blessing."

THREE MORE BROTHERS
Never did we expect Mez to be the first of four boys we have had the privilege to welcome into our home. About one year after Mez, Arash from Afghanistan joined our family, soon followed by Bego from Sudan, and finally our baby brother Z, who arrived at the age of 13, and whose identity I will keep protected. I only share as much about each of them and their stories as they actively want to.

Mez slipped into the role of big brother instantly, and was a huge help in their integration into life in the UK. I remember a moment when my mum was texting Arash about picking him up after a visit to our local mosque. He had sent her a message saying: "Pray fish." Confused, she showed it to Mez who

immediately deciphered it to mean "prayer is finished", prompting my mum to jump in the car to go and collect him.

Dinner times have grown better and better. We have vegetarians, vegans, meat eaters; Mez, who says a prayer before dinner; Bego, Arash and Z, who eat Halal; and mum and dad, who have displayed an incredible ability to adapt. The opposite of being stuck in their ways, I notice the subtleties of the separate glasses now solely used for alcohol, the addition of bread with every meal and the online orders of ingredients we had never previously heard of.

These changes have come with incredible benefits. Not only have the boys cooked and shared their traditional dishes with us, but the enriching, varied and dynamic dinner conversation makes sitting around that table my favourite place in the world. It's where I've learned that you don't need to have the same views, religion, language, upbringing or belief system to have deep respect and profound love for someone.

One of the biggest challenges of supporting my brothers came with navigating their four asylum applications. When Arash's claim was denied and he received a letter detailing his deportation flight to Kabul after almost two years of living with us, he was not alone in his anguish. It was difficult for all of us to witness his mental health deteriorate back to the depths of where it had been when he first arrived. We rallied together, comforting him during those dark nights in the run up to the appeal, and driving in convoy to the courtroom when the day came.

My mum stood up as a character witness and testified to the incredible effort Arash had gone to to integrate: going to college, learning English and overcoming some of the severe PTSD with which

Oeda and Mike on their wedding day.

he was suffering. His nightmares and panic attacks had begun to subside, and he was loved, settled and thriving.

> **WHEN ARASH'S ASYLUM CLAIM WAS DENIED AND HE RECEIVED A LETTER DETAILING HIS DEPORTATION AFTER ALMOST TWO YEARS OF LIVING WITH US, HE WAS NOT ALONE IN HIS ANGUISH.**

At the end of a tense couple of hours, the solicitor representing the Home Office stood up and quoted directly from my mum's statement, twisting it to fit her narrative, highlighting how, if Arash was so adaptable, he would have no problem re-starting his life in Kabul. I will never forget mum's face, her eyes closed in horror at the idea that she might have said the wrong thing and be implicated in Arash's deportation. Thankfully it wasn't long before the letter came that we had all been waiting for: Arash's

appeal was successful and he was granted five years leave to remain in the UK.

My mum is no stranger to comments from friends and acquaintances like, "Those boys must be so grateful to you."

"No." She replies. "Would you be grateful if you were forced to leave your family and your country as a child? If you had to risk your life just to go to school? If you have to fight for your right to just be, anywhere? No, it is me who is grateful."

UK

SUDAN

IBRAHIM

"I love the difference in traditions. It is something amazing that makes you aware of human diversity."

During my time working in the Calais Jungle I built my strongest friendships in the Sudanese area of the camp. The hospitality, generosity and kindness I experienced from this community was like nothing I have ever known. It is worth reflecting briefly on why people are fleeing Sudan. The country has been in the midst of civil war since 1989, when Omar al-Bashir seized power and proclaimed jihad against the non-Muslim population of the south. He deployed the Janjaweed, a violent militia group, to begin a campaign of ethnic cleansing against the non-Arab population, resulting in the deaths of hundreds of thousands of civilians. South Sudan eventually became independent from Sudan in 2011, but there were still regions in Sudan – like Darfur – where the fighting was ongoing, displacing over 2.5 million people.

I met many wonderful Sudanese people in Calais, but one particular person had a big impact on me. He was a man named Ibrahim. Ibrahim is the embodiment of goodness. He radiates a pure, gentle warmth that you can't help but feel enveloped by when in his presence.

I always assumed Ibrahim was slightly older than most of the men in the camp (in their early 20s) by the way he carried himself and his apparent wisdom. Always putting others first, Ibrahim stayed in Calais much longer than many of his friends and acquaintances. He spent years living in the shelters, tents and mud of northern France, but never let this situation stop him smiling.

Ibrahim's stoic smile had the ability to warm my heart and break it simultaneously. I knew he was hiding the pain of the undignified situation in which he was forced to live. He smiled his way through multiple winters spent outside, huddled around fires, burning whatever was available to keep warm. Inhaling the toxic fumes of curling plastic and smoking rubber seemed a necessary trade-off for a tiny bit more heat.

> ## HE SMILED HIS WAY THROUGH MULTIPLE WINTERS SPENT OUTSIDE, HUDDLED AROUND FIRES, BURNING WHATEVER WAS AVAILABLE TO KEEP WARM.

It always felt a few degrees colder in Calais than it did in London. The bitter, icy winds coming off the sea meant that for sure the coldest I have ever been were winter days spent in that camp. I'll never forget leaving the camp to head home to the UK one especially freezing December. Grateful to be back in the car and cranking up the heating, I watched Ibrahim wave me off through the rearview mirror.

As someone from England, I'd been living through these winters my whole life, yet I could not spend another moment out in those elements. I was concerned I would never get the feeling back in my fingers and toes, and I knew I had the ability to go inside somewhere and get warm. I couldn't imagine how it must feel for that cold to seep into your bones, reach your core, take hold and not let go.

Ibrahim has a beautiful way with words, always following each of my visits with a poetic message. That evening, as I neared London, I received this text:

"Hello my dear sister. I know how big and generous your heart is for all people. I am always proud and happy because you are in my life as my beloved sister. I hope to be worthy of this generosity, brotherhood and great love. Thank you for everything. I wish you with all my heart good health and happiness."

As hot air blew into the footwell, slowly bringing my feet back to life, I thought about Ibrahim in his tent, writing that message with fingers debilitated by the cold.

The next morning, Ibrahim sent me a photo of his camp's table and chairs covered in snow. For many of his friends in the camp, this was the first time they had ever seen snow. These men, mostly from the horn of Africa, many of whom wore only the sweatshirts or oversized jackets donated by grassroots oganisations doing distributions, were enduring something truly grueling. As a result, many of them showed severe vitamin D deficiency on their medical upon arrival to the UK. But the sight of snow still gave Ibrahim a reason to smile.

Snow covering the tables and chairs outside Ibrahim's shelter in northern France.

Ibrahim inside his tent in northern France.

CHRISTMAS

A week or so later it was Christmas Day. We celebrated at home in our normal way, exchanging presents around the table over breakfast then beginning the preparation for Christmas dinner. Nothing had changed, but I was seeing everything through different eyes. I had changed.

I had seen things that first year in Calais that I couldn't unsee, and learnt things that I couldn't unknow. My little London bubble had expanded so much it had burst, shattering my heart into pieces that now lay with the new friends I had made. I knew these friends, just an hour or so away, were suffering.

I excused myself from the celebrations and went upstairs to lie down. Burying my face in a pillow, I let that feeling engulf me. I cried a lot. I began to grieve the previous, blissfully ignorant version of myself who no longer was and would never return. This felt like a turning point in my work, an important recognition that what I was embarking on was going to change my life and my outlook forever. But though this realisation brought sadness and confusion, I also felt incredibly lucky to have had these experiences, to have expanded my perspective and met inspiring people like Ibrahim.

WALES

Ibrahim lived in the informal camps of northern France the longest of anyone I know. One morning, the day finally came that I received a photo from him surrounded by boxes in what looked like the back of a lorry. Next thing I knew, I was meeting Ibrahim in the maze of Victoria coach station in London. Neither of us could believe it. We sat in Pret and took it all in, then I brought him along to an open mic night in south-east London to watch my brother perform. He stayed at my flat in Peckham that night and made my housemates coffee with cardamom the next morning.

Ibrahim's stint in northern France had taken its toll, and he suffered from various health problems in the years that followed. After he was relocated to Swansea, he started college and threw himself into developing his English. One time, after coming over for a Sunday afternoon BBQ, he wrote me this message, thanking me:

"You and your wonderful family deserve an honor worthy of your position, and your morals. Your humanity is unparalleled, especially through this difficult and crazy time. Preserve what you are doing on this path, for the highest human values in this life are to be of use to your family, your friends, and to people around you like me."

I share this not to give myself a pat on the back, but to share Ibrahim's poetic use of English and to highlight his powerful wisdom. The highest human values in this life are to be of use to your family, your friends and the people around you – and it is Ibrahim who paves the way in exactly this.

UK

GREECE

BRENDAN

"I was suddenly struck by the people power that had brought me here. This would not have happened if we left our governments to it."

ALAN

On 2 September 2015, a young Kurdish family boarded an overcrowded rubber dinghy on the coast of Turkey. Parents Abdullah and Rihanna hoped to reach the nearby shores of Greece, dreaming of a safer future for their two young boys, four-year-old Ghalib and two-year-old Alan.

Just hours later, the world woke up to the devastating photographs of Alan's tiny body lying face down on a Turkish beach. Not long into the short journey between Turkey and Greece, the boat had capsized, drowning Alan, his older brother and his mother in the Aegean Sea. The short distance (a crossing that takes 30 minutes and costs €20 on the ferry for some) had cost them their lives.

The images of Alan, half in the water, his velcro trainers still on his feet, made front page news across the globe. It was the wake up the world needed. For the first time, even the most conservative of newspapers could share only the utter desperation of the situation. For the first time, these 'migrants' had a face, and one that no one could be scared of. Many saw their own sons, nephews, grandsons and brothers in little Alan, who had his whole life ahead of him. Many experienced the quiet realization, as they looked at these photographs, that no-one would risk this journey unless it truly was the only option.

It was one of the most profound moments in changing the mainstream rhetoric toward refugees. It was the catalyst that galvanized an incredible wave of people to take action in support of families like Alan's. One of those people was Brendan Woodhouse.

A father of two himself, Brendan felt Abdullah's pain. Brendan had already made the decision to support refugees six months earlier. In August 2015, he came across the viral Facebook post I wrote about my first trip to Calais, and decided to begin volunteering there. By the time Alan's story made the news, Brendan was well aware that two children drowned in the Aegean Sea every single day.

As a firefighter, Brendan knew his experience could be helpful in working in search-and-rescue missions. So he booked a flight to the Greek island of Lesvos, one of the so-called 'asylum hotspots' where more than half a million refugees arrived over the summer of 2015.

"I looked at my annual leave, found a spot in December, and by December, I was in Lesvos," he told me, both of us marvelling at the unfair simplicity of this journey for those of us who won the birth lottery. "The scale of it was utterly phenomenal. To describe it is nigh-on-impossible."

Several of the people in this book have made this journey and experienced some of the horrors that Brendan witnessed firsthand. To learn more about crossing the Aegean Sea, read the stories of Hassan, Yusra and Sara (pages 86, 96 and 104).

"There was one boat that [was sinking] when we arrived. There were people in the bottom deck that was filling up with water. There were people smashing the windows with their fingertips trying to get out. The people on the top deck were trying to kick the windows in to get them out. As our speedboat got closer, they were throwing their babies into [our] boat."

"Can you imagine throwing your child into a boat?" Brendan asked me with a wobble in his voice. "It's just... it's beyond words. They were saying to us, 'Please just take the child. I can drown myself, just take the child.'"

"People say, 'They should come here by legal routes.' You tell me what legal routes they've got. They've got none. Do you not think they've thought of that? Do you think they're getting on a boat because they thought, 'Do you know what, there's a legal way, but I'm gonna chance my arm a little bit, because it sounds a little bit more risky and I'm a bit of a chancer.' They're not doing that. They're getting into those boats because they have to."

"I tried to look at the positive stories of people that we've helped," he smiled. "Those stories are beautiful. But it's a scandal and a disgrace that no one in our government stood for what we should all stand for. I can't believe that we had people drowning, children drowning on our beaches and there wasn't a government response. Would that have happened if it was my family? No way. I'm white. I'm English. I'm European. It wouldn't have been allowed."

SEWIN

After two intense weeks on Lesvos, Brendan was due to fly home on the 23 December, just in time to spend Christmas with his family. His final shift that morning was based out of a lighthouse called Korakas. Surrounded by treacherous rocks, it is one of the most dangerous places for boats to land on

the island. Despite the lighthouse existing as a warning for the dangers that lie beneath, many refugee boats mistook it as a beacon to head towards, leading them directly into the perils of the rocks below.

Peering through the binoculars he used for his watch, Brendan's eyes focused on a small boat coming in fast.

"It was 5:50am. It was pitch black, there was a moon in the sky and I saw this boat way in the distance, like a pea on the horizon."

As the boat grew closer, Brendan began to see the lights of the passengers' phone torches waving in the air, and hear their cries for help. Then a loud bang echoed through the night.

The inflatable boat had hit the rocks, piercing its flimsy rubber tube and sending its passengers into panic. The torch lights flew into the air, soon disappearing into the dark sea. The screams grew louder and louder.

Brendan woke the rest of the team and pulled on his wetsuit as fast as he could, knowing they didn't have much time before the passengers would succumb to the cold water. He ran to the sea, ditching his jacket along the way, and swam toward the distant cries.

"You could hear children shouting 'Mamma! Pappa!' over and over. You could hear mothers shouting for their children… 'Hassan! Hassan!' I just remember this one voice, the little boy must have been called Hassan. I could hear it over and over. And you could hear other children's names being called. In the background of all this, there was one woman screaming over and over. You could hear people trying to locate each other. It was in a different language but you could tell people were trying to organise each other to self rescue."

Out of the darkness, Brendan found himself approaching an elderly woman. "She was in her mid-70s, maybe 80," he told me, "and I remember her face when I swam up to her. She thought I was coming to save her, but then I could hear children and I just swam straight by her." Brendan saw the mixture of fear and relief in the woman's eyes as they met his own, but in that moment he had a difficult decision to make. Knowing he didn't have time to save everyone, Brendan continued to swim straight past this woman, in the hope of rescuing a child. "You make your calls in those moments, and you live with them," he told me, visibly pained at having to do so.

He swam on, towards the cries of a woman that rang out above the rest. He heard her before he saw her. All the other passengers from the boat were scrambling towards the Greek shore but this woman was looking back. Facing the Turkish land they had left with her arms outstretched, she was screaming over and over again.

"There's only one reason a woman screams like that," Brendan explained. He swam on, past the screaming woman, whose sister was trying to drag her towards the shore, until he came across another

Page 44: The UK media coverage of the death of Alan Kurdi; Above: Brendan during his time volunteering for Sea-Watch.

pile of what looked like bags. He turned over the bundle. Inside was a baby who had been lying face down in the water.

"It's every volunteer's worst nightmare," he told me. "I had a baby in my hands and she wasn't breathing. Her eyes were in the back of her head, her lips were blue, she was really pale. I pulled her close to me to see if there were any breath sounds at all, there was nothing. I lay on my back and started swimming towards the shore, the baby on my chest, both of us facing up towards the stars."

As Brendan continued his story, I sat back, open-mouthed.

"As I swam, I realised I could probably do some compressions on the baby's chest [at the same time]. I pushed her little chest up and down, willing it to work."

Brendan got closer to the shore and tried to reach the sea bed with his feet, one army boot on and one off.

"My foot landed on a rock and I realised that I could probably get on my tip toes and turn the baby's head just out of the water, my head's just out of the water. I know from my training that I had five rescue breaths to try and breathe some life back into this child. I pinched the baby's nose, and blew into her tiny mouth."

Nothing.

Brendan blew once more into the tiny mouth. This time the baby coughed and spluttered. She choked up water and began to cry.

"She started to sick the water up. The sea water. Foam came out of her nose and the next second she's screaming. That is incredible. That was an incredible moment. I'll never forget it. This little girl [was] so important. [She had] the rest of her life still ahead of her and it was so nearly all taken away. The relief was just unbelievable."

Brendan began to swim again. It wasn't far before he met another of the volunteers who took the baby from him and ran with her to the medic. Brendan coughed and spluttered his own way back to shore, exhausted. There, on all fours, panting on a rock, he saw another volunteer helping the older woman he had swum past. He knew there were more people out there needing help, but he'd done all that he could. "My thighs were burning. I knew I couldn't do any more," he told me.

Brendan headed to the lighthouse where he expected the baby might be being treated. He found her in the safe hands of Freeha the doctor, who showed him how to gently squeeze the oxygen bag to aid the child's breathing.

"As I sat there, I looked down to the equipment in my hands and noticed that the oxygen was donated by The White Lion – a pub [local to me] in Beeston, Nottingham, who had had a pint glass on the bar saying 'to help refugees'," he told me.

A child's shoe is washed up on the shore of Lesvos.

In the corner of the room was a pile of donations Brendan had brought over himself. His daughter had given him some hats and baby blankets, and he used them to dress the tiny baby in front of him.

> **"TANGIBLE INDIVIDUAL CONTRIBUTIONS HAD MADE THAT DIFFERENCE. IT WAS AMAZING. IT WAS BEAUTIFUL."**

"I was suddenly struck by the people power that had brought me here," Brendan told me, full of emotion. "From Derbyshire Refugee Solidarity who had paid for my flight, to the oxygen I was using to support this baby's breathing, to the clothes I had wrapped her in. I was there at the spearhead, seeing how fundamental and important each of those different aspects was. Tangible individual contributions had made that difference. It was amazing. It was beautiful. I remember having that moment of thinking, this would not have happened if we left our governments to it."

Brendan was joined in the room by the baby's mother. "She saw me squeezing the bag and of course she thought I was trying to save her baby's life. She dropped to her knees and started praying." Realising that she didn't know that her baby was alive, Brendan removed the oxygen mask to allow the little girl to cry. Her mother fell to the floor.

"She turned into a ball of emotion," said Brendan. "[She] cried her heart out. Eventually an ambulance turned up and off they went."

Brendan and I would love to share more information here about the lives and futures of this mother and daughter, but unfortunately we know little more. But there are others in this book who have made similar journeys, and it is from their stories that we have some understanding of what life is like as a refugee in Greece. Murtaza's story is a good place to start (page 148).

It was a few hours after Brendan's shift was supposed to finish. Distracted by the morning's events, he'd forgotten he needed to be at the airport. He rushed there, arriving mere minutes before his plane home was due to depart. Brendan hadn't even had a chance to retrieve his jacket from Lesvos beach, let alone process what had just happened. "I run up the [plane] stairs, I sit down, I put my head in my hands and feel that my hair is still wet."

Brendan's phone had been in his jacket pocket which he had lost en route to the sea, so he asked the man next to him if he could borrow his pen, and he began to write what had happened on the back of the plane sick bag from the seat pocket in front of him. Intrigued, his neighbour asked what he so urgently needed to document, and Brendan began telling him the story.

"Stop," the man said, handing Brendan the sick bags from his own seat, and his wife's too, "write."

As Brendan wrote, his neighbour translated the words on the sick bags into Greek for his wife, and all three of them sat across their row, sobbing.

When Brendan landed in the UK and managed to borrow a phone to check Facebook, he had a message waiting for him that read: "Baby Sewin is five months old. She's alive and well in hospital and she's just been reunited with the rest of her family. Thank you very much."

"WHY DON'T REFUGEES TAKE LEGAL ROUTES?"

Simply put, most people fleeing their homes to seek asylum elsewhere have no legal route available to them. Without access to safe, legal options, those wanting to cross borders are forced to pay smugglers extortionate fees to make the dangerous crossing hiding in a truck or small boat.

These routes are often fatal. Small boats used to cross the sea (usually between Turkey and Greece or Libya and Italy) are not designed for rough waters. Smugglers, taking advantage of vulnerable people, will provide damaged boats and fake life jackets. The boats are overcrowded far beyond their capacity.

When the boats run into problems at sea, coastguards don't always respond to distress signals, knowing that helping refugees ashore will enable them to claim asylum. Instead, NGOs, charities and grassroots organisations powered by volunteers across Europe do what they can to fill this gap, putting their own lives in danger to help people safely to shore.

Since 2014, hundreds of people have drowned in the English Channel and over 25,000 have drowned in the Mediterranean, making it one of the deadliest migration routes in the world. But desperate people will continue to make the crossing until safe alternatives are available.

People crossing the Mediterranean Sea in a dinghy.

49

AWAD

"If you share something with love, you might be the reason someone smiles or feels full, and that makes you feel full in return."

A few years ago, I decided to identify only as a 'learner'. I wanted to be a student of life, taking every opportunity I could to grow and learn from the challenges thrown at me and the people who crossed my path. For me, this is the best way of navigating the difficult school of being a human. Some people, though, are born teachers. Awad is one of them.

CALAIS

Awad and I met in the Calais Jungle refugee camp in 2015. Set back slightly from the road, most of the Sudanese community built their shelters in circles or half moons, with a space in the middle to sit around a fire and drink tea. Someone would gather wood, someone else would be the designated cook, each member of this makeshift family playing a vital role in keeping their living situation as bearable as possible. "If we don't come together, it's going to be harder for every single person living in the Jungle," explained Awad. "Supporting each other is one of the most important things I've learnt."

Whilst most shelters were generally uniform in their palette and tarpaulin construction, Awad's temporary home in Calais was different from the rest. The walls were covered in murals painted not just by him, but by the international volunteer community with whom he was very involved. And that was the incredible part. Despite living in the camp himself, Awad also worked in the local warehouse alongside NGOs, helping sort donations and manage distributions. With his firsthand experience of what the camp residents needed, his help was invaluable to the organisations who began operating in the

Awad on a Christmas Day walk in Kent.

Jungle in 2015. Awad knew better than anyone who had just arrived, who was especially vulnerable and who might be trying their luck to get an extra pair of trainers for the second week in a row. His kindness and patience saw him become an informal leader within the Sudanese community who called him "Rasta", a nod to his recognisable big hair and unique, colourful style.

Awad took this responsibility seriously, serving his community at the expense of himself. "If you give, don't wait to get things back. I want to see you happy because that makes me happy too," he told me. As time passed, many people began to leave the Calais Jungle, either successfully crossing the Channel to the UK or heading somewhere else in mainland Europe that might offer a better life than the camp did. But Awad stayed put, patiently biding his time and maintaining a sense of support for those who remained. "How would you feel if you really needed help and no-one was helping you?" he asked me. "Sharing is not just giving stuff, you can share your time too. That's how we bring people together. How do we know people if we don't share?"

When the French authorities bulldozed the camp in 2016, Awad and the remainder of his community relocated to a clearing among the trees in another area of northern France about 40 minutes from Calais. The conditions were heartbreakingly dire. The nights were freezing cold and without the (albeit minimal) infrastructure that the Jungle had offered, it became harder for NGOs and volunteers to access the communities now dispersed across the area.

Awad took it upon himself to protect the most vulnerable. When he overheard talk of a British government scheme to reunite minors with their family members in the UK, he made it his personal mission to identify and help eligible child refugees scattered across the tented settlements in northern France. His efforts were instrumental in reuniting a group of young Sudanese girls with their families.

Awad stayed living in these harrowing conditions for three years. Just one night like this would impact anyone's mental health. Years of this life is a true testament to the depth and strength of Awad's spirit.

ENGLAND

On 10 February 2017, I got the phone call I had been waiting for: Awad had arrived in Leeds, in the north of England. I was overcome with joy. Finally, his life could begin again. Finally, he could start to reclaim his creativity, his amazing cooking skills, his education. It was his turn to be the learner.

Unfortunately, the journey was not straightforward from that point on, and Awad struggled with his living situation for years. At first, he waited patiently in temporary accommodation as his asylum claim was processed. The relief that came with a positive outcome was tinged with panic: in the UK, once your claim is accepted, you are served notice on your asylum accommodation and have just four weeks to find your own place to rent and a job to afford it. Many people fall through the gaps in this system, and a report from *The Independent*

found that one in four people using night shelters are refugees.[1]

Luckily, Awad was able to stay with friends in Leeds while he found his feet. I visited him during this time. We chopped aubergines together, our arms brushing against each other in the tiny kitchen, and reminisced about Calais and his dedication to his community there.

"You know what, Jaz," he said to me slowly, "if you have today, you might not have tomorrow. When you share with people, do it with your whole heart. If you share something with love, you might be the reason someone smiles or feels full, and that makes you feel full in return."

It seemed to me that Awad had made a huge sacrifice, living in limbo for so long, his life on hold as he witnessed others move forward. But Awad didn't see it that way. "When you truly care about how someone else feels, that's really beautiful," he explained. "You get your joy through other people's joy."

We talked about whether this desire to give so much of yourself amid scarcity was cultural; it wasn't something I saw in my own circles in the UK. Awad said that yes, in Sudan this attitude is upheld in family units. But in Calais, without their families, these groups of mostly single men were having to reimagine their family structures. "When I don't have my brother, I create my own brothers: those standing alongside me. Not a blood family, but a new family," he told me. "We don't want to know where you come from. If you're Eritrean, Ethiopian or Sudanese, we respect you. The people around you become your family. Sharing sorrow is half sorrow. Sharing joy is double joy."

Awad is an amazing cook and we ate a Sudanese feast that evening, sitting on the floor of the dark living room in Leeds, above a chicken shop. It was the first of many times Awad has cooked for me since arriving in the UK.

SCOTLAND

A year or so later, Awad moved to Edinburgh to continue his education (where he lives to this day, working as a carer for adults with disabilities). On one of the occasions when I went to stay with him, we travelled to Glasgow to have lunch with another Sudanese family he had connected with. We got up early to get the bus, skipping breakfast, and my stomach was rumbling by the time we were walking around a beautiful lake near their home. Reaching into my pocket, I found a little packet, and remembered the energy ball I had bought as a snack for the train the day before. I stuffed it into my mouth to keep the hunger at bay. As I chewed, Awad turned to come and walk alongside me. I swallowed quickly, guiltily, but he saw me.

"Aw, what are you eating?" he asked me sweetly. Cringing, I showed him the packet. "Nice," he smiled, but my cheeks glowed red.

As we walked, I sat with that feeling of shame. I knew from experience that however hungry he was, however scarce the food, Awad would never have stuffed that snack into his mouth the way that I just had. In that moment I had the realisation that no matter how delicious the food, it doesn't taste as good if your neighbour is hungry.

For the next three Christmases after arriving to the UK, Awad made the journey across the country to join our family's celebrations, his famous aubergine and peanut butter dip becoming a Christmas Eve tradition. Despite never having celebrated Christmas before, it's no longer the same without him. Awad had become like a big brother to me. Not blood family, but a new family.

"It's eight years since I've seen my family," he told me one evening. "I often imagine waking up in the morning and seeing my mum smiling in my face. Eight years I haven't seen the smile that makes my day. There's nothing better than family."

UK

ERITREA

TESFAY

"Wisdom and ambition are the essence of human victory. Having these two characters, no one can stop you from your target."

Tesfay is one of the first people I met in Calais in 2015. I was in the camp filming a segment for the BBC with a lovely producer called Sarah Burkeman, in an attempt to raise awareness of the human side of a story that was being sensationalised by mainstream media at the time. Sarah was one of the first producers I knew who was dedicated to covering the situation fairly and with empathy. She had approached me after reading my words on social media and I instantly trusted her. She was gentle and considered, and went on to lend her expertise to future films we made about the camp, sitting patiently alongside my brother Fin and I in the attic room of our parents' house as we trawled through hours of footage.

Sarah and I bumped into Tesfay when he had just arrived at the camp, and he was keen to speak to the camera about the journey he had been on to get there – crossing the Sahara Desert and the Mediterranean sea to get from Eritrea to France. He spoke perfect English and was busy enthusiastically looking for a spot to put up the tent he had just been donated. It took a team effort to pitch that tent, but between us and a few other members of the Eritrean community (special mention here to Tesfay's lovely friend Eyob), we eventually had it standing proudly, ready to accommodate Tesfay's first night in the Calais Jungle.

We chatted as we worked, and Tesfay told us he had fled his country of Eritrea because of "no bright future and unlimited national service". The more Eritreans I met over the years, the more I understood that he was putting it lightly.

ERITREA

I came to learn that Eritreans, fleeing a morally corrupt dictatorship, make up the biggest population of refugees in Africa, relative to their small population size. With as many as 5,000 people leaving the country each month and a population of only six million, the proportion of Eritrean refugees to Eritrean citizens is higher than any other country in the world. Despite the misconception pushed by mainstream media that people leaving Africa are economic migrants, coming to benefit from Europe's generous welfare system, Eritreans are in fact fleeing one big prison.

Nine percent of the country's population have been forced to flee, with Tesfay and my brother Mez among them. Most are escaping compulsory, indefinite military service. This military service is essentially unpaid labour and abuse for the duration of your life, in exchange for a meaningless salary of around £20 a month. Refusing to join the military leaves you vulnerable to arrest at any moment. President Afwerki's government controls every aspect of civilian life: as journalist Patrick Kingsley describes in his eye-opening book *The New Odyssey*,

Tesfay putting up his tent in the Calais Jungle.

"citizens cannot move between districts without written permission", meaning "streets are often empty and public spaces are almost lifeless". People fear gathering in groups, speaking to neighbours, or spending too much time outside the four walls of their home. Internet access is rare, and you must apply to a government office to be able to use a mobile phone.

So, many Eritreans continue to take the great risks to their lives – dehydration in the Sahara, drowning in the Mediterranean and organ harvesting in Egypt's Sinai Peninsula – because as Kingsley writes, "Eritrea has become an earthly hell".

THE UK

Tesfay and I stayed in contact as he navigated life in the camp, until one day he called me and said the four words I will never forget: "Jaz... I'm in Liverpool!"

Tesfay had successfully made the dangerous crossing from France to the UK. Arriving with only the clothes on his back, he had been put in temporary accommodation in Bolton, in the north of England.

We took the long drive across the country to visit him, bringing him some clothes, shoes and a phone. We had planned to take him out for lunch, but despite him surviving on the measly government allowance of £5 per day, he had spent the morning cooking for us and served us up a feast of tuna spaghetti.

That first Christmas in the UK, Tesfay explained how he would celebrate back home in Eritrea: "We exchange special gifts among lovely friends and we eat special cultural dinners like shro [ground chickpea stew], zigni [spicy beef stew] and pizza. We also drink with friends and family in our home. We celebrate with a christmas tree, just like in UK."

Tesfay had also mentioned that he had been looking in his local supermarkets for some castor oil for his hair, but had been unable to find any, so I ordered some online, and sent it directly to his

address as a little Christmas present. He received it and thanked me, but sent me a message a week later saying: "Jaz… I have received one 'cotton underwear bralette' and I do not know who is the sender."

I was so embarrassed when I realised that I'd accidently gone on to order all the Christmas presents for my family, straight to his address. I couldn't stop laughing imagining Tesfay holding up the bralette meant for my sister in total confusion.

That week he went on to receive a self-help book for my mum and a pair of trainers meant for Mez. He diligently forwarded them on to me and they arrived in time for Christmas. We still laugh about it now.

It's been a long road for Tesfay to navigate the UK asylum system. The guilty-until-proven-innocent interview process is designed to find holes in your reasons for seeking asylum, jumping on any small discrepancies or misremembrances as an excuse to be denied. Under the UK's current hostile environment policy (which makes staying in the UK as difficult as possible, without leave to remain), this process can take years. Having to live in limbo and repeatedly recount traumatic memories can leave a big impact on the individual's mental health.

> **I WAS VERY PROUD TO ATTEND HIS GRADUATION CEREMONY AND SEE HIM AWARDED FIRST CLASS HONOURS.**

Once Tesfay finally got his documents, he was accepted into London South Bank University to study Computer Systems and Networks Engineering. Affording university accommodation in London was another challenge, but this is where the power of our community stepped in. Not only were we able to house Tesfay throughout his degree, but also to

Jaz and Tesfay at his graduation ceremony.

fundraise for him to go on to do his masters in cyber security. I was very proud to attend his graduation ceremony and see him awarded first class honours. Tesfay went on to meet his lovely wife and have two beautiful children. They live together in the north of England, and we stay in regular contact.

SARAH

A while after our first meeting, Tesfay and I found out that Sarah, the producer of the piece we made together for the BBC, had been quietly receiving cancer treatment while we were filming. Despite being in the midst of chemotherapy, she had never said a word about her diagnosis or feeling unwell as we spent hours sitting around in the camps. As her health deteriorated, she had no choice but to tell us, and Tesfay often messaged to ask me, "How about Sarah, how is she? Is she getting better?"

Devastatingly, Sarah passed away in October 2016 at the age of 34. Tesfay and I would like to dedicate this story to her.

"WHAT HAPPENED TO THE CALAIS JUNGLE?"

The Calais Jungle was an informal refugee settlement east of Calais, in northern France. At the peak of Europe's so-called "refugee crisis" in 2015, when over 1.3 million people sought asylum on the continent, more and more people found themselves in northern France, hoping to cross the channel to the UK. They lived in a shanty town of tents and makeshift structures, the camp gaining media attention as it grew to accommodate the rapidly increasing population. As well as residences, the Jungle contained shops, restaurants, hairdressers, schools, places of worship and even a hammam.

In 2016, a Help Refugees (now Choose Love) census recorded over 8,000 people living in the camp, many of whom were unaccompanied children.[2] The camp's residents were supported by activists and volunteers from grassroots organisations providing food, clothing, medicine and legal aid.

In September 2016, the Jungle was demolished at the orders of the French government, causing mass protests among camp residents and outcry from activists and allies. Despite the camp being officially demolished, many people still live in the area, just without the infrastructure the camp provided.

A man walks through the Calais Jungle, 2015.

59

ROB

"I wasn't scared. I wasn't nervous. I felt confident in my heart that I had shown an extreme form of humanity."

ANNE FRANK

When I was a kid I was obsessed with the story of Anne Frank. I read her diary over and over again, documenting her life whilst in hiding in Nazi-occupied Amsterdam, between the ages of 13 to 15. I visited the secret annex where she lived with her family, behind a bookcase in the building that her father had worked in, on the Prinsengracht. I thought a lot about the lady who risked her own life and safety to help Anne and her family, bringing them food and supplies. Miep Gies her name was. She was Anne's father's secretary, and she was my hero.

Would I have done that? Would I have jeopardized my own family and future for someone else's? She wasn't Jewish. She didn't need to. Why was it her responsibility? As a child, I liked to think I would. As I grew older, I was no longer so sure. When

I drove back to the UK after days spent in Calais, my car boot empty and unchecked as we cruised straight through security, I felt the ache of what I could have done. The ache of the unfulfilled dreams, the unmet potential and the nights spent shivering in the camp, of those imagining life in the UK.

In 2016, a story hit international headlines that posed the same question to all of us working in Calais at the time... "What would I do?"

The story was that of Rob Lawrie, an ex-soldier from the UK who had been caught attempting to smuggle a four-year-old Afghan girl into the UK.

Rob had been volunteering in Calais when he met little Bru, who was living in the camp with her father

Reza. They had all become firm friends, Bru following Rob around the camp like a shadow as he went about his distributions.

Rob loved this little girl. He explained how much it broke his heart to see Bru living in conditions that were not fit for animals. Even those who didn't know the camp as well as we did would agree that the cold and mud were no place for a child.

The thing is, Reza and Bru had little choice but to stay in Calais, despite having family already in the UK. Jumping onto a moving lorry or scaling giant barbed wire fences was hard enough for an adult man, and certainly not an option for a child. Smugglers inflated their prices hugely when it came to children, recognising the increased risks they posed should they make noise or cry.

On 24 October 24th 2015, with winter fast approaching, Reza and Rob made a plan. Rob was heading back to the UK in his van, having brought it over full of donations. Above his head, when he sat in the driver's seat, was a compartment designed especially for sleeping, which Rob referred to as the cab. They decided to hide Bru inside, and reunite her with family in the UK. Here, she could live in safety and comfort until Reza successfully made his own journey to the UK by some other means.

> ## "IF MY CHILD WAS LIVING LIKE THIS, WOULD I WANT SOMEONE TO DO EVERYTHING THEY COULD TO GET HER OUT OF HERE?"

"If I was in a car I wouldn't have done it," said Rob. "But the cab had a pillow and blanket. I would never have put her life in danger, or even caused her any discomfort."

I asked Rob if he was nervous to take such a risk.

"You know what Jaz, I asked myself.... If my child was living like this, would I want someone to do everything they could to get her out of here? And the answer was yes, I would."

Rob planned to get a late night ferry, knowing from experience that there would be shorter queues and minimal security checks. But as he waited to board the ferry, his van caught the attention of some sniffer dogs, who had alerted the border patrol that something wasn't right.

Unbeknownst to Rob, two young Eritrean men had seen the opportunity to hide in the back of his van when he had been parked in the camp that very same day. When the police officers at the border asked him to open up the back of the van, he was as shocked as they were to see two sets of bright eyes staring back at him.

Rob protested that he didn't know anything about the young men hiding in the van, and the border police claimed to believe him. Thinking he was going to be allowed to board the next ferry, Rob stayed quiet about Bru. Rob was taken by the border police to another building, who told him there was some paperwork to fill out. As soon as he was on French soil, he was arrested, charged with people smuggling and thrown into a French police cell. Without knowing how long he'd be held there, he had no choice but to alert the authorities to the fact that Bru still lay sleeping in the compartment in the van. The little girl was taken straight back to the camp and reunited with Reza, but Rob was not going home any time soon.

THE COURT CASE

Rob's case was ground-breaking. His story had global publicity, from the *Washington Post* to the front of the *LA Times*. 'Dad who tried to rescue Afghan girl from migrant camp' and 'Ex-soldier faces prison for trying to save child from Calais refugee camp,' wrote

The Mirror. 'The Leeds aid worker helping desperate refugees,' wrote ITV. His story divided opinion, with comments calling him everything from 'hero' to 'criminal' and everything in between. He faced up to five years in prison. "I'd made a decision from the moment they found Bru, to tell the truth in as much detail as I could," he told me. "I wasn't scared. I wasn't nervous. I felt confident in my heart that I had shown an extreme form of humanity.

"It's never been in my mindset to look at what I did and say I did wrong. My goodness me... what have we come to in our society if helping a four-year-old innocent little girl is a crime?"

Rob believes that the intense media coverage put pressure on the French authorities to show leniency, and in January 2016, he was spared prison, his actions labelled 'a crime of compassion'. Rob has gone on to use his platform to advocate for refugee rights across the world and continues to work in the sector.

At the end of our interview for my podcast, Rob said, "I always know when the interview is coming to an end because the interviewer always asks me the same question, and you've failed to ask it..."

"Go on..." I replied, intrigued.

"They always ask me, 'Would you do it again?'"

"I think I already know the answer to that."

"Damn right I would," he smiled.

The story of Reza and Bru did not end with the judge's decision. Several years later, Bru was reunited with her mother Goli, who was misreported as dead. Goli had made the treacherous journey to Europe with her newborn baby to find her little girl. Their story is a whirlwind of twists and turns, of which Rob's actions were just a small but important part. You can hear more of the details of what happened in the BBC podcast series *Girl Taken*.

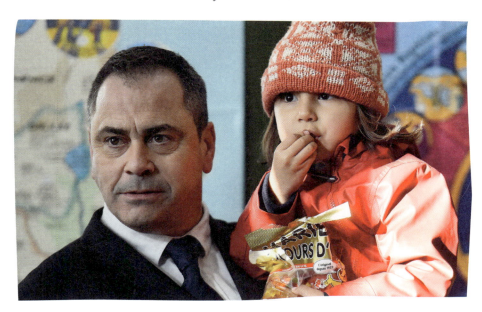

Rob and Bru at a press conference after his trial.

BELGIUM

SYRIA

ABDULAZEZ

"Life is about trying. Nothing is easy. Everything is hard at the beginning. Have you ever seen a baby come into this world running?"

I met Abdulazez in 2016 when he was just 17, in the refugee camp in Greece in which he lived. He had left Syria at 16, lived in Turkey for a year and a half, and arrived in Greece not long before his 18th birthday, with his parents and siblings.

"We left as six but arrived as seven," he smiled, referring to the fact that his sister in law had had a baby during their time in Greece.

The family had left Syria after losing their home several times over, surviving months of being internally displaced, living with no electricity, no phone connection and struggling.

"It was hell," explained Abdulazez. "We were fed up. We tried going to Jordan but were pushed back, so we tried instead to go to Turkey using smugglers. At the time the Turkish government was taking harsh action against Syrian workers. My brother had

opened a small shop in Turkey and they took it from him, telling him it was illegal." He sighed. "People can come and turn your life upside down, taking not just your things, but your dignity, at any point. We decided to go to Europe in search of that dignity."

A key transit country for anyone fleeing Africa or central Asia for Europe, Turkey is home to the highest refugee population in the world. Turkish communities and aid organisations do incredible work to support the ever-growing refugee population, but the brunt is too much for a single nation to bear. Far from sharing the responsibility equally, the EU has been happy to treat Turkey as a buffer to keep irregular migration at bay, reaching an agreement in 2016 whereby Turkish authorities are paid to prevent people entering Europe. With services buckling under the demand of the high refugee population

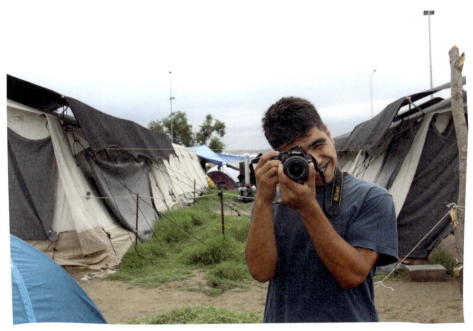

Abdulazez in the Greek camp where he and Jaz first met.

and authorities employing hostile anti-refugee policies, life as an asylum seeker in Turkey is often unforgiving.

"In northern Greece we found ourselves stuck with 13,000 other people near the [North] Macedonian border. It was all a big mess. I remember being grateful just for having a tent pitched on concrete instead of one in the middle of the mud."

Abdulazez used his time in those camps to volunteer as a translator for several international NGOs and he seemed to know everyone.

"I went up to every volunteer asking if they wanted me to show them around," he told me, "like the camp tour guide. There was nothing good to show them, I just wanted to make friends. And I did, from all over the world. Spain, America, the UK, Germany, France. It was fun to discuss things with them and expand my mind."

Abdulazez's limited English didn't hold him back. "I only knew 20 percent of English at the time, but it

was 20 percent more than most people in the camp," he told me years later, sitting on my sofa in London to record a podcast episode together. "I didn't really understand what I was translating but no one else did either, so I got away with it."

"Fake it till you make it," I replied, adding a new English expression to his repertoire.

This was exactly how Abdulazez lived his life. Resourceful, positive, creative and funny, he never let his circumstances hold him back; in fact, quite the opposite.

"I have special memories of that time in Greece," he told me. "Living in the camp for five months, they were some of the hardest but most important moments in my life. There I learnt that you can choose to think positively or negatively about a situation but in both cases the world still goes on. It

will not wait for you. If I sit in my tent and cry, people are not going to care. It's only my time that will be lost. That's when everything began..."

Abdulazez is referring to his art. After being given his first camera by an Italian volunteer with whom he was working as an interpreter, he began combining powerful photography with digital art to document life as a 'refugee'. Over the years he has built a large online following on Facebook and Instagram using the name Through Refugees' Eyes.

"People laughed at me at first," he said, "but it was important to me to show the real stories of these journeys people were taking. I didn't want to sugarcoat it, I wanted to tell the truth. Yes there are thieves, criminals, good and bad people in these camps, like in every community but a small percentage of people doesn't represent everyone."

Abdulazez's can-do attitude continued throughout the difficult process of finally being relocated through a resettlement programme to Belgium with his entire family.

"It took a year and a half," he explained. "I tried to make the best of that time and use it for learning, volunteering and creating art, so as not to think about it all too much. My dad was very sick so we were some of the lucky ones who were evacuated through the United Nations High Commissioner for Refugees (UNHCR).

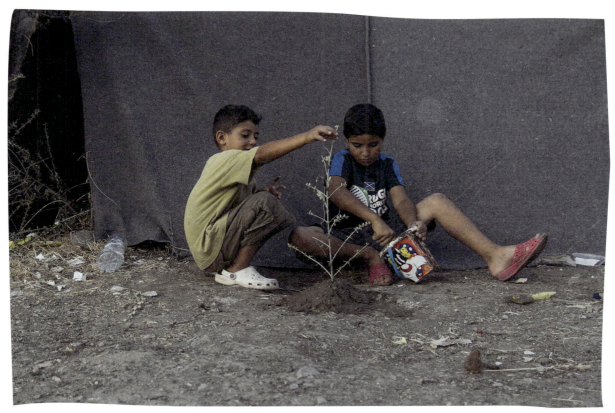

A photograph taken by Abdulazez in Lesvos, 2018, as part of his Through Refugees' Eyes project.

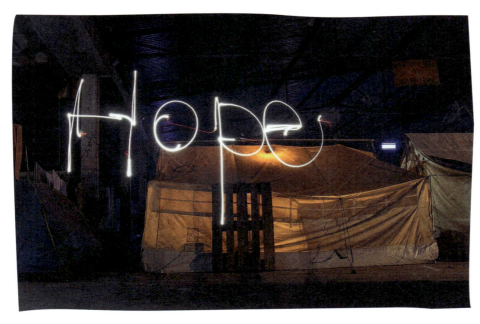

Page 68 and 69: A photographs taken by Abdulazez in northern Greece, 2015, as part of his Through Refugees' Eyes project.

"When we found out we were going to Belgium, I researched which language they spoke there and was shocked to find out that there were three. I picked French, thinking it was the most international, and started learning it. Then we found out we were moving to the Dutch part!"

So Abdulazez learnt Dutch too. When we've caught up in recent years, I've been amazed to hear him putting my own Dutch to shame, (and I've been speaking it with my mum since I was a kid!).

"Language is about trying and failing, and not having a fear of failing," he told me on our podcast episode together. "The first time I got on a bus in Belgium, I called the bus driver 'miss', instead of 'mister'. Everyone laughed so I corrected myself and never made that mistake again. I also always get desert and dessert confused when I'm trying to tell people about my story!"

Abdulazez and I discussed whether his opportunities come as a result of luck or effort.

"You know Jaz, life is about trying," he told me.

"Nothing is easy. Everything is hard at the beginning. Have you ever seen a baby come into this world running? There's no quick fix. You have to take it step by step. Patience."

INTEGRATION

Since moving to Belgium, Abdulazez has not only excelled in his education and is studying artificial intelligence, he has relentlessly advocated for refugee rights and continues to amplify voices through his photography and art. He recently invited me to speak at the closing event of an incredible exhibition of his portraits in a beautiful church in Brussels, focussed on the topic of integration.

"Integration does not equal contribution," Abdulazez explained to me as we walked through the chapel, taking in the powerful photographs that lined the walls. "You don't have to do something extraordinary when integrating into a new culture – like saving lives as a doctor or becoming famous. Just living your everyday life in a new place, sustaining

yourself within that culture, that's integration. That is enough to make you worthy."

> **"JUST LIVING YOUR EVERYDAY LIFE IN A NEW PLACE, SUSTAINING YOURSELF WITHIN THAT CULTURE, THAT'S INTEGRATION. THAT IS ENOUGH TO MAKE YOU WORTHY."**

Abdulazez's exhibition about integration led me to an epiphany. The cruellest, most unfair expectation that we as a society put on refugees and asylum seekers is piling the entire burden of integration upon them. How can we expect people to 'integrate' into our culture if we don't open the door? Instead of outsourcing the problem and solution to the new arrivals in a country, we could and should treat the process more like a dance – a two-way, mutually beneficial process from which everyone learns and expands.

Abdulazez continues to create art around the themes of migration, community and integration. I have visited his exhibitions in both London and Brussels and spoken at an event with him in The Netherlands – things we could only ever have dreamed of when we first met.

"I don't want to leave this world without leaving something behind of value, but that doesn't mean changing the world," Abdulazez said. He finished the conversation for our podcast episode together with these powerful words. "Even if it's impacting just one person... maybe that one person is you. Many people have died. Many people who are in prison or not able to talk or tell their story. That's what I'm here for... to represent them."

GULWALI

"The small things that people did for me went a long way. The people who believed in me, championed me, even those who smiled at me."

"I have a lot of responsibility as a refugee, but very few rights. The right to travel, the right to participate in elections," Gulwali Passarlay told me when we recorded our first podcast episode together in 2019.

That feeling of responsibility is what led Gulwali to write his incredible book at the age of 20. *The Lightless Sky* shares his story from life under the Taliban to crossing the world, alone, aged just 12, hoping to find safety in the UK. Gulwali has been a prominent advocate for refugee rights ever since.

Gulwali's book had a profound impact on my family and I, who all read it around the time that my own Afghan foster brother Arash joined our family in 2016. The book helped us understand the context in which Arash had grown up, and the circumstances under which he left Afghanistan, which he was not yet able to verbalise due in part to his English and in

part to his trauma. Gulwali shared his powerful, personal account of the day-to-day fear of living through war and being under threat from the Taliban, as well as his experience of being fostered in the UK, which helped us support Arash in his integration, and understand our own culture through the lens of young Afghan eyes.

It wasn't just his life in Afghanistan or his journey to the UK that threw up challenges for Gulwali; it was also what he experienced once making it to the UK. Navigating the asylum system, life in a foster family and having to dispute his age all took their toll.

"There is a lack of solidarity and understanding when it comes to Afghans," he told me, "and this is

reflected in the asylum process. People are sympathetic to the Syrian plight, but us Afghans get the highest refusal rating of any other nationality of asylum seekers across the UK and Europe."

This was certainly the case with Arash. Whereas my other three foster brothers had their asylum claims accepted the first time they applied, Arash had a different experience. After almost two years of living in England with our family – learning English, going to college, integrating and slowly grieving the loss of his family at the hands of the Taliban – he was sent a letter refusing his claim and detailing a deportation flight back to Kabul on his 16th birthday. We were shocked.

Arash was not alone in this experience. As the Taliban took control of Afghanistan's capital city Kabul in 2021, the UK Home Office's immigration figures showed that more than half of the Afghans claiming asylum that year were refused any form of protective status.

"Twice the Home Office threatened to deport me," Gulwali said, "but to where? They didn't believe I was from Afghanistan. They didn't believe my age. It's guilty until proven innocent in the asylum process."

"TRAUMA AGES YOU. I HAD TO GROW UP FAST. MY CHILDHOOD WAS TAKEN AWAY FROM ME."

Gulwali does look older than he is, something I've always put down to the fact that I've only ever seen him dressed in a full suit, whatever the occasion. People often place him around 30 and have done so since his early twenties. This is a common problem for young asylum seekers, who are eligible for much less support once they turn 18.

"You would look older too if you had been through what I had as a child," Gulwali explained. "Trauma ages you. I had to grow up fast. My childhood was taken away from me.

"If you go to the Foreign Office they say, 'Do not go to Afghanistan – it's not safe'," Gulwali continued. "It's all red, the whole map. But then for us asylum seekers, they say it's safe."

Over the years, I have met many Afghans living in camps across Europe who worked alongside the British and American armies during the war, often as translators. They were persecuted by the Taliban as a result, but were never provided with protection, and were even actively unwelcomed when they fled to the UK in search of safety.

AFGHANISTAN

Afghanistan has been affected by decades of conflict, beginning in 1979 with the Soviet invasion and continuing with civil wars between the Afghan government, the Taliban and NATO troops. NATO troops fully withdrew from Afghanistan by 2021. But just months after their withdrawal, the Taliban regained control, bringing with it more human rights violations, including severe restrictions on public life for women. The human cost of these conflicts has been staggering. Since 2001, about 243,000 people have been killed in Afghanistan, more than 70,000 of whom have been civilians. Afghans have been massively impoverished by the conflict, with 92 percent of the population facing food insecurity. The UNHCR recognises 2.6 million Afghan refugees, with a further 3.5 million people internally displaced.

But Afghanistan is so much more than just a war-torn country. "It's a wonderful, very historical place," Gulwali told me. "There is archeological evidence that people were living in Afghanistan up to 5,000 years ago. In the heart of Asia, between the great powers of Russia, India, Persia and China, Afghanistan is very diverse. We have more than ten different ethnic groups and about eighteen different languages. We are known for our poetry and proverbs, music, delicious fruits and nuts – melon, pomegranate, pine nuts. Afghanistan is a

Gulwali as a child in Afghanistan.

mountainous country. Alexander the Great struggled to conquer us and Genghis Khan also had a tough time. We are freedom-loving people. We want peace.

"The country is in a dark place now because of extremism, because of the West abandoning and betraying us over and over. It's heartbreaking to see us being taken back to the tenth century, with girls being refused education. But I want the world to see beyond the war and conflict. I want the world not to forget Afghanistan. I want the world to stand in solidarity with Afghan girls and women. Sadly not in this era of terrorism, but in the past Afghanistan has exported philosophies, ethics, religious studies, famous scholars and many other people who have changed the world."

GULWALI'S JOURNEY

Gulwali grew up helping his grandmother in her role as the community midwife in rural, mountainous Afghanistan. When life under the Taliban became too dangerous, his mum made the heartbreaking decision for her two young sons to leave Afghanistan without her. "She sent us away to save us, but at the same time she also lost us," explained Gulwali.

Like many others, his journey is a patchwork of smugglers and prisons. Gulwali was separated from his older brother and did everything he could to find him again. "Being apart from my brother was very painful, but in hindsight it was a positive thing because I would have struggled to see him experience so much hardship, and it also spurred me

73

on to find him and made me more determined to continue," shared Gulwali. "My mum told us to look after each other, to hold each other's hands."

So Gulwali pushed on by himself, making his way across Europe in the backs of lorries. Travelling this way is precarious at best, life-threatening at worst. Hiding in the back of one lorry transporting hazardous substances, Gulwali suffered chemical burns to his face. To cross the English Channel, he hid in the back of a refrigerated truck.

"Thankfully, the driver didn't turn the fridge on," he said. We looked at each other, our minds on the 39 people who died from suffocation and hypothermia in the back of a refrigerated lorry in Essex, UK, in 2019.

"Was your lorry empty?" I asked Gulwali.

"No, it was full of bananas. I tried to eat them but they weren't ready – too green!" he laughed.

"YOU'RE OFTEN NOT GIVEN THE FULL STORY BY SMUGGLERS, SO YOU FIND YOURSELF IN MANY SITUATIONS THAT ARE OUT OF YOUR CONTROL."

It was Gulwali who defined for me the difference between smuggling and trafficking. "Smuggling is if you choose to make a journey and you pay for it," he explained. "Trafficking is when it's against your will. The thing is, these become blurred along the way. You're often not given the full story by smugglers, so you find yourself in many situations that are out of your control. We were treated as a commodity by smugglers who made money out of our desperation. We didn't really have a choice. We passed through beautiful cities like Istanbul but we were kept in basements most of the time. At 12 years old, I found myself in prison alongside drug dealers and murderers. My only crime? Trying to find safety."

THE UK

Once he made it to the UK, Gulwali was housed in supported accommodation alongside other young asylum seekers. One day, the boys were taken on a trip to London, but as a punishment for being naughty, Gulwali was not allowed to go. Upon their return, Gulwali's friends had some big and exciting news to tell him. They had bumped into someone who looked just like him... his brother! Gulwali couldn't believe it. Finally, after many long months of worry and pain, the siblings were reunited, having both made the journey to the UK separately. But the story doesn't have a fairytale ending.

"My brother saw things on his journey that I had not," Gulwali told me when I asked how his sibling was doing. "He's not mentally well, and he's going through tough times. I advocate for refugees, but it makes me sad that I can't even help my own brother."

It's not only Gulwali's brother who still suffers from the repercussions of the journey. "I still have nightmares. I wake up at night. On Sunday there was a bombing at a wedding in Afghanistan and many people died. Those things have an emotional impact on me. Keeping myself busy helps me. Being active and engaged in things keeps me going."

And that is exactly what Gulwali is doing. He has two degrees, has given talks about his journey to the UK, and written a book (in his fifth language). "It's not just my story. It's a story of friendship, hope, optimism and overcoming adversity," he explained. "The small things people did for me went a long way. The people who believed in me, championed me, even those who smiled at me."

Gulwali is on a mission to dispel the common myths around refugees and asylum seekers through his advocacy work. "People hate me without knowing me. People hate refugees without meeting

a refugee. That doesn't make sense. I don't hate anybody. They think we take their jobs, we take their benefits... but how can we do both?" he laughed. "Unless we're very clever".

"THEY THINK WE TAKE THEIR JOBS, WE TAKE THEIR BENEFITS... BUT HOW CAN WE DO BOTH?"

"I want people to be aware and educated that I'm not taking anyone's job or money, but it's also not about my contribution, or the contribution of refugees. It's about what is right and what is our obligation under international law. We should welcome refugees not because of what they can bring, but because it's morally correct to support those in need.

"If I could go back to Afghanistan, I would. I would choose my family over any money or work opportunities. My grandmother died last year and I wasn't there."

Gulwali got married and went on to have a baby. "I would have loved to share that with my family. I would love them to meet my daughter Zoha one day," he smiled.

Gulwali left me with a traditional Pashto saying that underpins the work that we both do to highlight the beautiful, positive impact of migration and coming together in support of one another: "There's not enough time in this world for love. I wonder how people find time to hate."

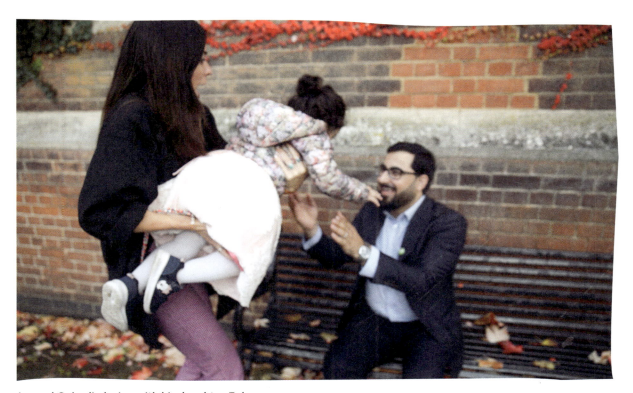

Jaz and Gulwali playing with his daughter, Zoha.

Food donations from a fundraiser Gulwali organised to support impoverished families on his recent trip home to Kabul.

After I'd written the above piece about Gulwali, I went to visit him with my friend and photographer Sequoia, to take his portrait for this book. It was a long drive, too far to go there and back in one day, so I'd booked us a hotel nearby. Gulwali was affronted by this. "You could have stayed here!" he exclaimed, waving his arm across the living room of his flat. Despite his wife being days away from having their second baby, and his sister-in-law also visiting to help with the birth, he shared another beautiful Pashto saying: "No place is ever too small if the heart is big enough."

I was reminded again of Gulwali's big heart as he told me about another Afghan man who had recently arrived in the UK and, like many new arrivals, had been temporarily housed in a disused hotel. "I had heard about him through friends," Gulwali explained. "They told me he had an infection in his foot and he was struggling so I made the journey to visit him, thinking I could help him get hold of some antibiotics." But when Gulwali arrived at the hotel, he was shocked.

"His whole body was infected. He couldn't move. He couldn't walk down the stairs at meal times and none of the staff had bothered to bring him food. Nobody cared. When he had asked to see a doctor, they told him to walk for an hour to the local hospital. When I told the hotel staff he needed an ambulance, they said it was a 'waste' of public money. It broke my heart."

Gulwali helped this man get treatment and he made a full recovery. "But it makes me so mad," he

told me. "People think asylum seekers are staying in five star hotels, but the reality is so far from that."

HOME

Gulwali had other news for me. After a 14-year struggle, he had finally been granted British citizenship. Once you get refugee status in the UK, you can apply for travel documents, but you are forbidden from going back to the country from which you are seeking asylum. Once you are a British citizen, you can travel with the same rights afforded to any other citizen. This meant Gulwali could go home.

"After 16 years, I could see my siblings and my mum," he told me. "I went from the UK to Dubai, Dubai to Kabul. It was a risky, scary thing to do. It wasn't the right time," he continued, referring to the recent Taliban takeover of his country. "But when is the right time? I went on my own and I'm glad I went. It was incredible, but hard. The hunger and extreme poverty in the country had a profound impact on me.

> **"AFTER 16 YEARS, I COULD SEE MY SIBLINGS AND MY MUM. I WENT FROM THE UK TO DUBAI, DUBAI TO KABUL. IT WAS A RISKY, SCARY THING TO DO."**

"I was very worried about the British government revoking my citizenship for making the trip," he sighed. "There's new legislation that allows the Home Secretary to revoke someone's citizenship without warning, for all sorts of reasons. They don't have to justify it or even tell you. Particularly brown and ethnic minority people. After all these years of living here, I'm still not safe."

The trip left Gulwali feeling confused about where 'home' was for him. "I don't feel Afghan anymore," he explained. "In Afghanistan, people see me as westernised and liberal, but here in the UK

> **"IN AFGHANISTAN, PEOPLE SEE ME AS WESTERNIZED AND LIBERAL, BUT HERE IN THE UK – EVEN NOW I'M A CITIZEN – MANY PEOPLE DON'T ACCEPT ME AS BRITISH."**

– even now I'm a citizen – many people don't accept me as British. I'm a product of both."

As we chatted, Gulwali's two-year-old daughter Zoha climbed all over us and he paused a few times to address her lovingly. "I came to this country with nothing," he said as he stroked Zoha's hair. "Now I have a family. That's what everyone wants, right? That's what we all want. Safety for our family, and for our family to be together."

Gulwali, Jaz and Lord Alf Dubs, who fled Nazi Germany as a child and now advocates for refugee rights.

"WHY ARE ALL REFUGEES MEN?"

Some European countries receive more asylum applications from men than women. Mainstream Western media coverage tends to highlight this fact as a reason to invalidate asylum claims, suggesting that these aren't refugees in need of help, but young men who are migrating for economic reasons.

This is not true. According to the United Nations High Commissioner for Refugees (UNHCR), women and girls make up roughly half of any refugee population.[3] But the journeys made by people fleeing their homes in search of safety are often incredibly dangerous, and women can face particular risks of rape and assault at the hands of smugglers and border guards. As Matthieu Aikins writes in *The Naked Don't Fear the Water*, "the harsher the border, the greater the risk. The profile of the typical 'illegal migrant' – an able-bodied young man – is often cited to justify strict border controls, but it is in fact a consequence of such policies".

Some of the reasons people flee their countries also disproportionately affect men. In Eritrea, men are at risk of compulsory military service; in Afghanistan, they are targeted for conscription to the Taliban. In these instances, men might have more reason to flee to find safety.

Children playing in a refugee camp in southern Greece, 2016.

79

LEBANON SYRIA

RAWDA

"You build people before building nations."

I have a (relaxed) rule, that I like to share food with every guest I speak to for the podcast. This is a partly selfish promise, because it means I get the opportunity to eat delicious food from all over the world. But I also realised, during the early days in Calais, that sitting around a fire with people from multiple nationalities, all of us dipping bread into the same pot of lentils, somehow connected us. We didn't need words, or even the physical closeness of our shoulders brushing against each other as we leaned towards the steaming pot – we needed nourishment. We all needed to eat. That in itself was a reminder of our shared humanity.

It was many years later that I met two people, Nour and James, who had taken this realisation and made it into something incredible: an organisation called The Great Oven. They introduced me to their

friend and colleague Rawda, who made a lasting impression on me. This story belongs to Nour, James, Rawda and all the other wonderful Great Oven volunteers.

THE GREAT OVEN

I met Nour and James in Lebanon's capital of Beirut in 2022, on one of my multiple visits to the city over the past few years. I'd been told about them by friends working in the humanitarian space, and had arranged to connect with them at their headquarters in one of the city's most happening neighbourhoods, Gemmayzeh.

As I walked down the tree-lined street towards the location they had specified, it came into view – the most beautifully, ornately painted building I have ever encountered. Through the windows was the

iconic, original oven. Painted by an incredibly talented artist who goes by the name of Shrine, their headquarters and that founding oven were truly a sight to behold.

We sat down over tea with some members of The Great Oven's core team, and Nour and James explained their aim of using the power of cooking, art and music to provide food relief and creative community building. "When we say 'food relief', we definitely don't mean in the traditional sense, like temporary handouts. The ovens we build and donate are designed to enable communities to feed themselves," said Nour.

In Lebanon, a community oven is no new concept. Historically, most towns have a shared oven around which the women would gather to chat. "Whenever I would speak about someone else, my grandmother would tell me not to speak like the women of the oven," Nour smiled, explaining that this old Arabic saying alludes to the ovens' status as places to meet and gossip. But beyond being a place to build connections among the community, they were also places for sharing. Many people with no oven at home would bring food and use the communal oven to cook their dinner; others, who had no food at home, would come and eat from the communal pot.

"THE OVENS BRING PEOPLE TOGETHER REGARDLESS OF THEIR NATIONALITY OR RELIGION, AND FORGE CONNECTIONS WHICH RUN DEEPER THAN OUR SUPERFICIAL DIFFERENCES"

Both images: the colourful Great Oven HQ in Beirut, Lebanon.

James (far left) and Nour in Beirut.

"As hubs for cooking, teaching and sharing a meal, our ovens bring people together from disparate backgrounds who would otherwise not have the opportunity to meet," explained James. "They bring people together regardless of their nationality or religion, and forge connections which run deeper than our superficial differences."

THE BEQAA VALLEY

A few days after we first met, I got up early to join Nour, James and their team on a visit to one of their ovens in the Beqaa Valley on the Syrian-Lebanese border. It was so cold that I had to buy a full ski suit for a couple of pounds from a flea market in Beirut

the day before, and it only got colder as we grew closer to the border, snowflakes falling softly on the windows of the car.

After a couple of hours on the road, we began to see the recognisable UN-branded tarpaulin forming rows of temporary shelters, stretching as far as the eye could see. Thousands of Syrians have fled across this border over the last 11 years and stayed in the area, many hoping to return home as soon as it's safe to do so.

Life here in the Beqaa Valley is tough. Lebanon is in the midst of an economic crisis, and even the local Lebanese are struggling for work, let alone the Syrian and Palestinian refugees. In 2019, as Lebanon's

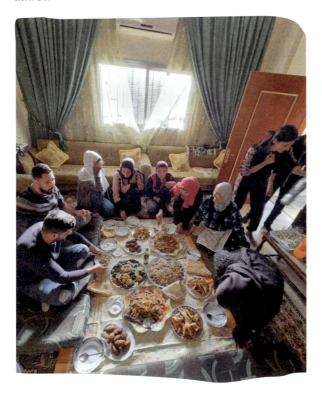

refugee population grew, pressure mounted on local infrastructure and social services. The already fragile economy collapsed, with growth shrinking to 1% and the Lebanese pound plummeting in value. The situation was exacerbated by the pandemic, and then worsened dramatically by the explosion in Beirut's port in 2020, when nearly three tonnes of ammonium nitrate exploded, injuring thousands and displacing over 300,000 people.

The result of the economic collapse has been crushing, with up to 40 percent of the population unemployed and 75 percent of people living in poverty. Refugees fleeing Lebanon cite reasons such as no access to medicine and an inability to afford food despite working 18 hours a day.

We were welcomed by the warm arms of Rawda, a Syrian mother to five girls, and leader of the small team of local women running the community's oven. These five women are the reason that 350 local Syrian, Palestinian and Lebanese families have access to food every single day. We were lucky enough to experience one such lunch time, observing the calming warmth radiating not only from the oven but from the women chopping, mixing and lovingly preparing food. A long line soon formed along the path leading up to the oven, people waiting patiently with empty tupperwares in hand. When everyone had been dutifully served their fill of steaming hot, home-cooked food, we too sat around the fire in Rawda's home to eat. We feasted on hand-cut chips, vegetable pasta, fresh salads and big flatbreads, and I chatted to Rawda about the incredible work she is doing to support her community.

Rawda left her home in Homs, Syria to escape the civil war. She faced some of the toughest years of her life after this, living in a shelter with no door and zero privacy or safety for her daughters. Seeing how the people around her were also struggling, she decided to take action.

"You build people before building nations," she said, speaking the Arabic phrase that inspired her work.

"None of the top ten best meals I've ever had are from Michelin-starred restaurants with shouty chefs," James smiled as he ripped off another chunk of bread. James works closely with celebrity chef Nigel Slater, so has had his fair share of high-end dinner experiences. "They're all in camps, by Rawda, or Nour's mum.

"In London we can order whatever cuisine we want, whenever we want, but we eat alone. And we throw so much food away," he continued. "The Great

Oven is about sharing resources, and recognising how much we have in common when we sit around a table. Each oven is a symbol of peace."

> **"THE GREAT OVEN IS ABOUT SHARING RESOURCES, AND RECOGNISING HOW MUCH WE HAVE IN COMMON WHEN WE SIT AROUND A TABLE."**

I thought about my own life in London and how being invited to someone's house for dinner is often a big deal, planned well in advance. I reflected on our give-and-take mentality, which I too am guilty of: how we alternate who hosts or cooks, and are quick to feel that it's 'our turn next' once we've been invited somewhere.

My experience in other places has been very different. Despite knowing it's unlikely that the favour will ever be able to be returned, I've been welcomed with unwavering hospitality and told over and over, "Eat! Please eat!" I've literally been force fed by the hands of multiple Syrian mothers and grandmothers, offered tea in tents in Calais and served food until I'm so full I've had to lie down. I've been humbled and inspired by this generosity, despite challenging circumstances, and feel that my own culture and country would do well to adopt such values.

I left Rawda with a saying in English, that I endeavour to live my own life by, and with which I knew she would resonate: "If you have more than you need, build a longer table, not a higher wall."

Page 84: mealtimes from the Great Oven; Above: the women running the community oven in the Beqaa Valley.

HASSAN

"If my story can challenge one person, or five people, and make them think about the topic differently, then that is success for me."

I was sitting in the third row of chairs inside a conference centre in central London when I first laid eyes on Hassan. It was in the early days of me doing this work and he was the first Syrian I ever personally heard tell their story. He did so beautifully. Later, he went on to write these words in his memoir: "I can personally testify to the fact that conquering prejudice is all about education. People are afraid of what they don't understand."

By sharing his experience firsthand, Hassan disrupted the homogenous image of a Syrian refugee that I had subconsciously formed in my mind, courtesy of the mainstream media. Hassan added a personality to this image: a face that was open and relatable and a character that was motivated and, most of all, hilarious. I saw parts of myself reflected back in him and I began to understand the power of

a story. Human to human. Heart to heart. He connected me to something that had felt far away. He stirred emotion in me that transformed into a strong desire to take action, because how could I not? If this was his experience and he was standing here sharing it with me, it was now also a part of mine.

"There's bread and salt between us," Hassan said to me years later, over dinner at my family's house in Kent. "It's a Syrian saying meaning that we've shared food and time together, that we're connected."

Hassan grew up in the Syrian capital of Damascus, where he worked as an English teacher and spent his free time at gigs or on road trips with friends. When

Syrians, fed up with years of corruption and hardship, began protesting in January 2011, he wasn't initially affected. "Everyone took to the streets because they wanted change. But I wasn't too bothered because I had a comfortable life," he said.

> ## "SECURITY ISN'T JUST ABOUT BEING SAFE FROM IMMINENT DEATH. IT'S ALSO ABOUT HAVING A FUTURE, OPTIONS, THE AUTONOMY TO BUILD A LIFE OF YOUR CHOOSING."

His peace didn't last long. "Things changed for me when the secret police arrested six kids for writing a slogan on the wall of their school and tortured them. I was a teacher and I saw my own [students] in them."

Hassan joined in the protests, which by this point were growing into a full-scale civil uprising. He was arrested twice, and spent two gruelling stints in prison, where he too was tortured. In July 2012, after his second arrest, he realised he had to leave: "you either live or you die. Little did I know this would be the last time I would ever see home.

"You see, security isn't just about being safe from imminent death," he told me. "It's also about having a future, options, the autonomy to build a life of your choosing."

SYRIA

Protests in Syria began in 2011, when people took to the streets to challenge President Bashar al-Assad's regime, which had worsened inequality and alienated rural and working class citizens. Assad responded with a violent crackdown, using water cannons, tear gas and even open firing at crowds, killing some protestors. Tens of thousands of people were arrested and tortured. The unrest escalated into a civil war between the Syrian government and

various foreign forces who were also fighting among themselves.

The UN estimates that more than 400,000 Syrians have been killed since 2011, with 6 million internally displaced and more than 5.6 million fleeing the country – the largest population of refugees in the world.

When Hassan left Damascus he had the foresight to document his journey to the UK using his phone and a go-pro. This powerful footage was later used in the BBC documentary series *Exodus*, which saw Hassan win a BAFTA.

For most viewers, I imagine the scenes of Hassan in the water, holding on to the side of the rubber dinghy in the Aegean Sea between Turkey and Greece, were the most impactful visual representation of the horrors of his journey. But there was another profound moment that has stayed with me ever since watching Hassan's footage. After three long months of attempting to reach the UK – hiding in lorries, running from police and finding places in the park to sleep where there was no dog mess – Hassan got his hands on a fake Bulgarian passport which he planned to use to fly to Britain.

He filmed himself on his phone at the airport. The tension was palpable as he passed through security and made his way to the gate. You could hear the fear in his voice and my own throat tightened as I watched him board that flight.

On the plane, Hassan had his phone in his lap, filming his face from below. He only spoke a few words but his face said it all. The plane took off. My stomach was doing flips as I watched, almost forgetting that this was *his* experience and not mine.

When the plane landed, a member of the cabin crew made a routine announcement: "Welcome to London Heathrow. The temperature outside is 21

Both images: Hassan crossing the Aegean Sea in a dinghy. Hassan filmed his journey and the footage was used in the BBC documentary *Exodus*.

degrees Celsius... we wish you a pleasant onward journey." The words faded into insignificance as Hassan's face crumbled with relief, overcome with emotion. Even thinking about his expression brings tears to my eyes.

"That moment was closely followed by another moment," Hassan told me. "When I was travelling, I was a traveller, but the second I faced border control, I would become an asylum seeker. I never imagined, growing up, that I would be saying those words."

Hassan then approached passport control and told the man behind the desk, "I just flew in on a fake Bulgarian passport. I'm Syrian and I would like to seek asylum."

"Oh," said the officer. "Oh dear."

THE UK

In 2021, Hassan published his memoir, *Hope Not Fear: Finding My Way from Refugee to Filmmaker to NHS Hospital Cleaner and Activist*. "I used to tell stories when I was a teacher in Damascus but I never imagined I would be telling my own," he said. "My story is my weapon. I don't really like that word. We should live in a world where stories are the only weapons. That would be a good world. Telling my story gives me agency. It gives me a seat at the table. I don't want people to speak for me.

"TELLING MY STORY GIVES ME AGENCY. IT GIVES ME A SEAT AT THE TABLE. I DON'T WANT PEOPLE TO SPEAK FOR ME."

"For so many years I felt like I had no voice, or I had a voice but it was hijacked. It's not just my story, it's my witness statement. I was a witness to war crimes. To some incredibly sad moments, people dying, but also happiness and joy. Getting that book deal is a privilege that comes from years of hard work. It took thousands of days, months, years of

Jaz and Hassan in the Calais Jungle, 2016.

campaigning, talking to people. I've received thousands of messages and emails saying that it's changed people's lives. That's what this is about. All my work is about impact. I want to do meaningful work and encourage people to do good things in life."

Hassan's book is a raw account of his life, including many intimate moments. "I mean... I wrote about the first time I had sex!" he laughed. "I'm not writing a refugee story, I'm writing a human story. Food, sex, music. These details mattered to me. Vulnerability is the gateway to empathy. I gave myself the permission to be vulnerable in my book because I desperately wanted people to walk in my footsteps. There's scientific evidence that our brains can connect through a story. You're connecting on a level that is scientifically proven. You're there. You're with me on the way.

"I wanted to write a how-to, a guide to conquering prejudice, using my personal story as an

example. I used to be racist. I used to be homophobic. I had some really awful views, but I explained why I had these views – not to cut myself any slack but I had to give some context so I could write about what changed those views and the person I have become as a result.

"Especially now, politically speaking, the level of anti-migrant, anti-refugee hate is on the rise and there's so much misunderstanding and ignorance around refugees and migrants. So I was like, if my story can challenge one person, or five people, and make them think about the topic differently, then that is success for me. It comes with a responsibility. I had a very unusual journey through Britain because of appearing in the film and going to all these events and publicly sharing my story. I got to travel and it was good, but it was also really hard. I got diagnosed with complex PTSD and a symptom of PTSD is survivor's guilt. Every time I was doing something really good, in a room full of influential people, I would instantly feel guilty. I would think of everyone back home who didn't have the chance to be in that room.

"I'm proud of what I've achieved but it wouldn't have been possible without the people I have met here. Giving me a room for a year, rent free. Taking me home for Christmas. I was away from my family and I wanted to be around other families. The people that I've met here have been an incredibly positive part of where I am right now.

"Home is the place that offers you security and peace of mind. I used to say that I was uprooted because I left my home country, but now I like to say I have roots in many places, and one of them is London."

LONDON

When the Covid-19 pandemic hit, Hassan began volunteering as a cleaner in his local NHS hospital.

"This is an important part of my story because it

was the first time that Britain went through a crisis since I've been here and as someone who has fled a crisis, I wanted to regain some control over the situation. London really feels like home now. I am a Londoner. I wanted the hospital to be clean and disinfected and to help my community. I think me being Syrian and a refugee, taking a job as a frontline worker said something about people coming here and making Britain their home.

"SIX YEARS AGO, I WAS STANDING IN A QUEUE IN CALAIS, WAITING TO GET A JUMPER OR SOME FOOD HANDED TO ME BY THE VOLUNTEERS. SIX YEARS LATER I'M IN THE HOSPITAL, CLEANING AND HELPING OTHER PEOPLE."

"I feel like I've come full circle. Six years ago I was standing in a queue in Calais, waiting to get a jumper or some food handed to me by the volunteers. Six years later, I'm in the hospital, cleaning and helping other people. I'm incredibly proud that I helped my home. My new home."

Working in the hospital, surrounded by people on their deathbeds, Hassan reflected on what is important. He wrote in his memoir:

"We stress a lot about work, we stress about where we're going to go on holiday, money in the bank, what car we're driving, what we're wearing. Of course, it's good to make money and live a comfortable life, but it's not money that gives you comfort; it's health. So if you're healthy, you have a roof over your head and you have access to your family – you're living an amazing life."

AHMED

"Things will get better. There's always a light at the end of the tunnel. It's there, you just need to believe."

Cooking, eating, sharing food: I keep coming back to this as a key cornerstone for connection, and it's definitely what brought me and Ahmed together, through the London-based NGO Migrateful.

Migrateful run cookery classes led by refugees, asylum seekers and migrants, and the classes are amazing. They provide the teachers with ideal conditions for learning English and accessing employment, as well as promoting connection and cultural exchange within the host community of that person. Not just this, but as a participant you learn something new and get to eat what you make. It's a win-win, and right up my street because they bring together everything I love – cooking, eating, learning and meeting new people from all over the world.

I've been to a few Migrateful classes over the years, both in person and online. When I forgot to bring a takeaway box for my leftovers from a Sri Lankan cookery class, I made it my mission to eat so much that there weren't any. By rare coincidence, the in-person classes were held in a beautiful old church, walking distance from my house in London, and I remember ambling, very excitedly, to a Lebanese class to make vegan moussaka and tabbouleh, taught by the wonderful Ahmed.

Ahmed learnt how to cook when his parents passed away when he was young. "My dad died when I was seven and my mum when I was 17," he told us as he introduced himself to his students the evening of the cookery class. "I had to learn how to cook. It became a hobby for me and I enjoy it."

AHMED

In Lebanon, Ahmed worked in emergency response as a team leader of paramedics for the Lebanese Red Cross. He left his country six years ago, after being shot on two separate occasions, leaving him with partial damage to his spinal cord. His injuries mean that he now uses a wheelchair.

Ahmed didn't share too much more about his life that night, but the visible pulsations through his body made clear that he is constantly reminded of his reason for leaving Lebanon. "I'm in massive pain so bear with me," he warned us before we began chopping.

The day after the class, Ahmed came over to mine for an interview and we talked more about his story. "The first time, I was shot with two bullets from a distance less than seven metres," he explained to me then. "In the beginning, they told me I would never feel anything from the waist down again, but with time, physiotherapy and intensive training, I've started to slowly enhance my movement. I'll keep working to build and gain muscle but we'll see... no one knows whether I'll ever walk again." He downplayed the dedication and positive mindset that has already seen him come so far.

> ### "WHEN I WAS SHOT FOR A SECOND TIME, I KNEW IT WAS TOO DANGEROUS FOR ME TO STAY THERE, NOT JUST FOR ME BUT FOR MY FAMILY."

"When I was shot for a second time, I knew it was too dangerous for me to stay. I can't go into more detail for fear of repercussions for my family but I can say that Lebanon is getting more and more dangerous as the financial situation gets worse. The country is having one of the worst economic crashes in the world right now. People can't get their money out of the bank so they are hungry, and desperate people will do desperate things."

In 2011, as the crisis intensified in Syria, more and more Syrian refugees escaped to neighbouring Lebanon, making it home to one of the highest refugee populations per capita in the world. Forced to bear the brunt of the crisis, pressure mounted on Lebanese infrastructure and social services. The already fragile economy collapsed, with growth shrinking to 1% and the Lebanese pound plummeting in value. The situation was exacerbated by the pandemic, and then worsened dramatically by the explosion in Beirut's port in 2020.

Ahmed held the room beautifully during our class together. He is one of those teachers with whom you are quiet and listen. He commanded the space and held people's attention with his every word. He was also very patient, especially when I inadvertently slipped into the role of class jester and kept getting everything wrong. "Put them IN THE POT," he told me firmly. "Get her another onion!" He asked an assistant. "Chop them LONG Jaz. No! Don't cut!" etc., etc. (You get the idea.)

This terrible cooking continued into the next day when I tried my very hardest to impress Ahmed by baking him vegan cookies that went very wrong. He hadn't yet been impacted enough by British culture to hide his true feelings, and said something very direct about them being 'Ok'. I appreciated the honesty and it definitely broke the ice before getting deep into his story.

THE UK

"I came to the UK by aeroplane six years ago, and applied for asylum at the airport," he explained. "The asylum process has been really hard so far, and I'm still in the process. This is my first time in the UK and things have been up and down. Sometimes I'm very down, but at other times I try hard to be optimistic

and do my best to contribute to this society."

Aside from the arduous process of applying for asylum with the Home Office, Ahmed's experience of British people has been positive. "I had this idea that British people were mean," he smiled, "but to be honest I was totally wrong. When you're in a wheelchair and going uphill, people offer help, on the road, in the supermarket... even people I don't know. It means there is hope for humanity."

Ahmed has also found love in the UK. "I have an amazing partner here," he said. "God sent her to me in a time where I needed her the most. If I didn't have her in my life right now, I'm sure that I wouldn't be in this place mentally. She's British, and she's an angel to be honest."

This kindness, love and care towards Ahmed has not only come from individuals. "I want to mention the beauty of having charities that help people with integration. Migrateful really helped me and has become a family to me. At one point I was about to become homeless and Jess, the founder of Migrateful told me, 'No member of Migrateful will ever be homeless. Worse case scenario, you'll come and live in my house.' Her saying that felt as if she gave me a mansion. Her words were really supportive to me. When I needed her the most, she was there."

This new family has been a light within the huge void left by Ahmed's biological family. "I haven't seen my family for six years," he told me. "I've only seen my sister who lives in Canada, but if my two brothers want to come to visit from Lebanon, they will not be given a visa.

"I reached a phase in the last six years where I have no idea where home is anymore. As if I lost a sense of being connected to a place. You can say this place 'feels like home'; it's nice, it's beautiful, but it's not home. I'm here, but it's not home. It's a conflict that keeps going round and round, as if you're looking for the exit but you can't find it. It's not in your hands to become a human being once

Ahmed in London, UK.

again. Your life is in the hands of someone else who says, 'OK let him become a human being again.'"

"I'M HERE, BUT IT'S NOT HOME. IT'S A CONFLICT THAT KEEPS GOING ROUND AND ROUND, AS IF YOU'RE LOOKING FOR THE EXIT BUT CAN'T FIND IT."

On 31st January 2022, Ahmed messaged me on Instagram to let me know that after a six-year-long battle, his asylum claim had finally been accepted and he had been granted refugee status. Finally, Ahmed's life could begin again; he was now able to legally work and build a future in the UK.

GERMANY

SYRIA

YUSRA

"We didn't know we were strong enough to do it until we did. I was shy when I was younger... Now I'm an ambassador at the UN."

I was on a flight to Hamburg, just days before the world went into lockdown, and I was excited. I'd known about Yusra Mardini for years. I'd shared her story on our social media to an overwhelmingly positive response. Yusra was the poster girl of 'overcoming adversity', eloquent and extraordinary in what she'd already achieved. I guess you could say I was a bit star-struck to be meeting her; to me, she was the epitome of a hero.

I'd first connected with Yusra's big sister Sara. Her fiery, spontaneous character was relatable to me, and we became friends via Instagram. Sara had invited me to come and visit them both at Yusra's flat in Hamburg, and I hadn't wasted any time in booking a flight. I slipped into their sisterly vibe with ease. Their bond reminded me of the way I interact with my own siblings – mildly irritated but predominantly

loving in their tone. Sara made us special Syrian tea and I sat down first with Yusra to interview her for the podcast, while Sara pottered around in the bedroom next door.

SWIMMING

"Since I was little, I knew I was different," Yusra told me. "I wanted to do something different. I didn't know what, but I knew that I wanted people to remember me as someone who has done something. Changed something."

Yusra and Sara grew up in Darayya, a suburb of Damascus, Syria. They lived a comfortable life, punctuated by intense swimming training from a young age. They were coached by their father, once a swimmer representing Syria himself, and it was his dream for his daughters to represent their country in

the Olympics. Yusra didn't always share this ambition.

"I used to hate swimming," she told me. "I hated waking up at 6.30am every day to train. I would always cry because the water was too cold. It was only when I was about 12 or 13 that I realised that I was better than everyone else my age, and even kids five years older than me. I remember thinking, 'OK... I'm good at this.'

"Then when I started going out and hearing other teenagers talking negatively about each other, partying and not having a goal in life, I knew in my heart that wasn't for me. I didn't want to be a person that just lives."

"WE BECAME SO BUSY TRYING TO WORK AND SURVIVE, THAT WE FORGOT HOW TO LIVE."

So swimming became her North Star. The goal on which Yusra could focus as things began to change around her.

In 2011, pro-democracy protests challenging the Syrian government's authoritarian regime erupted across the country. Yusra was 13. "I was on the school bus when I first started to understand," she said. "Some kids wrote 'freedom' on the wall and the teachers got angry."

Things escalated quickly and life in their suburb of Damascus became increasingly difficult to navigate, culminating when an unexploded bomb landed in Yusra's training pool.

"We became so busy trying to work and survive, that we forgot how to live," she told me.

LEAVING SYRIA

By 2013, lots of the girls' friends had started to leave Syria for countries like Sweden and Germany, making the treacherous journey to Europe via smugglers. Sara pushed for her and Yusra to also be allowed to

go, but their father's answer remained a firm no. Eventually, he began to see that the options for his daughters' future were rapidly slipping away, and he agreed to let the girls travel with a family member that he trusted.

"I never actually believed it would happen," said Yusra. "We booked flights to Beirut, then to Turkey. We left everything behind, we only had very small bags. I left my clothes and my medals. I tried to take one necklace but I lost it in the sea. We arrived here with nothing except our memories. I was 17 and Sara was 20."

Take a minute to imagine this. Many people taking a week's holiday would struggle to select the baggage option that only allows for a small bag under the seat in front of them. I know I've been on weekend trips where I've not been able to condense my luggage into less than one of those little wheely cases – and I knew I'd be returning home within a matter of days. What would you pack if you weren't sure you would ever see any of your things again? How do you maintain that freedom of expression, that representation of yourself along the way?

Yusra and Sara said goodbye to their parents and little sister Shehad at the airport before flying to the Turkish city of Istanbul.

"It was harder for them than for us because we were leaving them behind," Yusra told me. "My sister didn't understand what was happening until we got to the airport. That's when she realised we were actually going. When she started crying, that set us all off."

I asked Yusra why the family didn't leave together.

"We didn't want our mum, dad and baby sister to go through something like that," she explained. "Sara and I could sleep on the floor or go for days without eating, but we didn't want that for our mum

Yusra during a training session in Berlin, 2016.

and sister, and we needed our dad to stay and look after them.

"We didn't know we were strong enough to do it until we did," she continued. "Sara always said I was the spoiled kid because I was the youngest for nine years. No one ever thought I would be this powerful. They would never have imagined that I would have this strong voice. I was shy when I was younger... Now I'm an ambassador at the UN."

Yusra and Sara's journey across the Aegean Sea made international headlines.

"In Turkey they took us on a bus to the coast," explained Yusra. "Our parents had downloaded the app, Baby Tracker, to follow where we were, but we couldn't always charge our phones. On the fifth day in Turkey, we got on the boat. The smugglers told us that it would take 45 minutes to travel the 10km to Greece."

How wrong they were. The sisters hadn't been in the boat long before the engine stopped and it started to fill with water. The small boat was way over capacity with the 18 men, women and children crammed inside, and was beginning to strain under the weight. The passengers had no choice but to work together to avoid ending up in the sea.

"First we threw everything overboard," said Yusra. "Our bags, shoes, everything. My sister was the first one to stand up and get into the water." As two of the only people onboard that could swim, Sara had decided to reduce the weight in the boat by tying herself to it with a rope, and jumping overboard. "She didn't want me to get in too, she was worried about me," Yusra remembered. "I have so much respect for that woman."

"MY SISTER WAS THE FIRST ONE TO STAND UP AND GET INTO THE WATER."

I saw it was hard for Yusra to put into words the trauma of this moment, but but she radiated with the pride she felt.. She was quick to follow her lead.

"No. Get back in the boat," Sara screamed at her sister in fierce panic and protectiveness over her little sibling.

"She had already told me before we set off across the sea, 'If anything happens to me, you just swim. You leave everyone and everything, and you swim towards Greece.'" Yusra's voice wobbled. "I didn't take her seriously at the time and it hurt to hear my sister have to say those words."

The sisters attempted to stabilise the boat by holding onto the sides and kicking as much as they could. They stayed in the water, swimming alongside the boat as they edged closer to Greece.

"The media always makes out that I'm the one with the rope around my waist, swimming the boat to shore," smiled Yusra, rolling her eyes at the memory. "That's not true. My weight is 51 kilos and the people in the boat probably weighed more than 300. Please, guys, understand that I did not do that. I'm a normal human!"

Yusra was being modest. What she did in this moment was pretty super-human in my book. Not

Yusra and fellow members of the Refugee Olympic Team pose in Brazil, 2016.

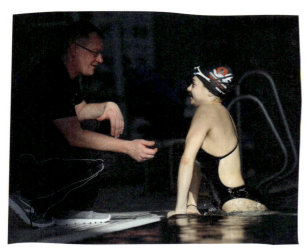

Yusra speaking to her coach Sven during a training session.

only was she busy keeping herself and others alive, she was also trying to distract a kid on the boat from the horror that was unfolding around him.

"His father had gone into the water and he was so scared. I would never wish that on any kid. I was almost drowning but I was trying to make him laugh by pulling funny faces at him at the same time. I didn't want him to feel what was happening."

Eventually, the Greek island of Lesvos came into sight. Yusra and Sara dragged themselves, exhausted, onto the shore. They had made it, and because of their bravery, so had everyone else on the boat.

"Did you have fun? Did you like the trip?" Yusra asked the small boy who had been crying, with a forced enthusiasm.

"No," the boy replied, straight faced. "I don't want to go in the sea again."

GERMANY

On making it to the safety of dry land, the sisters spent the next 20 days travelling across mainland Europe to Germany. "We didn't really care [where we ended up]," Yusra explained. "We just wanted somewhere we knew we would have rights and where it was peaceful. We wanted water, electricity and a life. And I'm not going to lie, I also knew Germany were good at swimming," she added, after a cheeky pause.

> ## "EVEN IN MY DARKEST TIMES, I WAS THINKING ABOUT SWIMMING. NOW WHEN I LOOK BACK, I WONDER… AM I CRAZY!? IT'S WHAT KEPT ME GOING."

"Even in my darkest times, I was thinking about swimming. Now when I look back, I wonder… am I crazy!? It's what kept me going."

"Hungary was terrifying. It was humiliating. I didn't feel like a human. I'm going to be honest… I felt like a rat," said Yusra about this part of the journey. "I felt like I was there to steal something. We would go to the store with €100 in cash, and they would kick us out. Hotels would let us stay without showing a passport, but they would charge us €200 per night. We lost €300 each on fake train tickets sold to us by the people working at the train station. The train never came. For some people that was everything they had. For Sara and I, our dad was still working and could send us money. Others, they had nothing. People think refugees are poor and don't have money – well it cost us €10,000 to get to Europe. In 25 days. That's heavy. People sell everything they have to make these journeys.

"Some girls were raped along the way," continued Yusra. "That was my biggest fear. We got to know around 30 people in Turkey and we travelled in a group. We shared food and protected each other the whole way. The men surrounded us while we slept. It would have been hard without them. I'm forever thankful to them."

At one point in Hungary, Yusra and Sara were arrested and sent to jail. "We had been on a train,

pretending to blend in as Europeans. A lady opposite us had heard us speaking Arabic and called the police. Before we realised this, we had offered her some of our food, and she had started crying. 'I didn't know you were nice,' she said to us. We were taken off the train, put into a police van and taken to a stable. Literally a stable made for horses, and we had to stay there."

But they found goodness in people wherever they went. There was one taxi driver, also in Hungary, who drove like a maniac because he knew that the buses were coming to pick us up and take us to Germany. He understood what we'd been through."

With the help of the speeding taxi driver, the girls made it onto the bus to Berlin – part of a German government scheme to assist refugees who had fled to Europe for safety. Once in Germany, they found themselves living in a camp.

"I hated Germany in the beginning. I thought it was really cold and grey and the buildings were so ugly. I just wanted to go home. Life in the camp was frustrating. Someone deciding for you when and what you eat, and when you can shower. I didn't know that life would get better."

But it did. With nothing to do except wait for their asylum claims to be processed, Yusra approached the coach of a local swimming team and asked him to train her for the Olympics. Sven was blown away by her talent and technique. He became a firm family friend, and, shocked at the noisy, chaotic conditions of the refugee camp, let the girls secretly live in the swimming team's clubhouse.

"One time I asked him, 'why are you helping us?'" said Yusra. "He told me that helping us made him feel happy. I learnt a lot from him. I learnt that you can help people without expecting anything in return. I

Yusra as a UNHCR Goodwill Ambassador.

now know that no matter how little I have, there are people with less, and that I can support them in return for nothing."

Despite Yusra's lifelong goal of the Olympics, when Sven heard about the formation of a Refugee Olympic Team, she was at first reluctant to apply.

"I'M PROUD TO BE AN OLYMPIAN *AND* A REFUGEE. AN OLYMPIAN *DESPITE* EVERYTHING I'VE BEEN THROUGH."

"I wanted to represent my country. Syria," she explained. "I didn't want people to look at me with pity or to think I was only chosen for the team because I nearly died on my journey to Germany. I said no at first. My parents thought I was crazy. 'If you don't remember how hard you've worked for this, we remember how hard we worked,' they told me, so I applied and got the scholarship.

"The moment I felt proud was when we entered the stadium and everyone cheered. Now I'm not just proud to be an Olympian, I'm proud to be an olympian *and* a refugee. An Olympian *despite* everything I've been through."

"My sister and I want to share our story in the hope of encouraging people to appreciate what they have, because we didn't realise what we had, until we lost it," said Yusra. "We want to motivate people, but to also show that you don't always feel motivated, and that's OK too. Sometimes I don't want to train, but I'm doing it for the end result. Sometimes you have to sit through the pain and struggle to get to where you want to be. If our story gives someone the courage to do something, no matter how small, I will feel proud. Life is not always easy or good. Sometimes terrible things happen, but you have to

Yusra (left) with Nathalie Issa, the actress who plays her in *The Swimmers*, a dramatization of her and Sara's journey to Europe.

stand back up again because life will not stop for anything or anyone. No matter where you are and what you're doing... keep going, it will pay off."

"Old ways won't open any new doors," she continued. "There is no place in the world where we're not mixed, full of cultures. Nowhere. Tell me any city where there are only white people or Black people. That's crazy, we're in 2020. Give refugees or newcomers a chance. Go with them to a cafe. Ask them how they are. Please try to get to know us before you judge us. Or don't judge us at all. We did not choose to have war, we just want peace. I would never wish what I've been through on anyone. When you think about refugees, think about your kids. What would you want for them? How would you want them to be received?"

GERMANY

SYRIA

SARA

"Saving lives is not a crime. And if helping others is a crime, then we are all criminals."

Sometimes your gut feeling is quiet and subtle, easy to mask with day-to-day distraction, and sometimes it takes over your entire body. When I first heard Sara's story, my instinct spoke loud and clear. What was happening to her was fundamentally wrong, and that needed to be known.

"I want to forget many times that my name is Sara Mardini, and just go out and have fun, but then I get an email from my lawyer, and it ruins my day," Sara told me, referring to the huge emotional toll that the events of the last few years have taken on her life.

While Sara's younger sister Yusra always had her sights set on swimming in the Olympics, Sara felt lost after arriving in Germany. She spent a year learning the language, getting her asylum accepted and doing her best to integrate, but something was missing. Then she got an email that changed her life. A volunteer working on the Greek Island of Lesvos (where the girls themselves had arrived in Europe by boat), messaged her with the following words: "I know you're really famous and you probably won't hear this, but I'd like to invite you to come and volunteer, because you've inspired us and you're a beacon of hope for us."

Sara knew she had to go.

LESVOS
Within a year of arriving on the shores of Greece herself, Sara went back. This time she was volunteering with the International Rescue Committee (IRC).

SARA

"I felt like I was needed," she said. "I'm a professional swimmer and a lifeguard. Everything I know was useful there. I had a purpose. It felt so easy. Everything I had learned in my life had led me there. I was just a volunteer. It didn't matter, me having a name, it was just humans helping humans," she continued. But Sara's personal experience did set her apart from the other volunteers. Not only was she able to translate, she was able to relate.

"It made me careful not to make any mistakes," she said. "In my very first rescue there was an injured kid and I cried so bad. I wanted to go to the hospital [to visit them], and my coordinator told me, 'When you come to work, come with your head, and use your brain, not your heart. You won't survive like that.' I wanted to be as effective as possible, so I listened."

What Sara saw and experienced on Lesvos was hard. People who reached the safety of the shore were often deeply traumatised by their journey, and many didn't make the crossing, with some arriving with fewer family members than they had left Turkey with. Despite the familiarity of this grief and pain deepening its impact, Sara faced it head on.

In 2018, after two and half years, she decided to leave. "It was time to go home. I was tired, burnt out. But you don't leave Lesvos empty handed," she paused with a grin. "I had a cat with me! I brought so many cats home from Lesvos."

As Sara and her cat stood at the check-in counter at the airport, preparing to board their flight back to Berlin, they were approached by two policemen. They showed her some paperwork and told her to come with them. Unable to read Greek, Sara couldn't understand what they were asking of her. She had no choice but to follow them to the local police station. Here, she called her friend and fellow volunteer Sean Binder to join her for moral support.

"We sat there for hours. I missed my flight, but they told me, 'Don't worry, we'll get you a new flight and you'll go home.' We weren't taking it too

Sara Mardini advocating for refugee rights.

seriously," Sara said, until "they handcuffed us to each other.

"We testified. They asked us *so* many questions. I kept on asking if we could go home and the lawyer told me 'I don't think you will. I think they'll keep you for a few days.' Then they told me, 'You will be detained until the trial and you will have the right to appeal in five days.' I just broke down. I had no idea what was going on."

Sara and Sean were accused of money laundering, smuggling, trafficking, espionage and more. "To be honest I start forgetting them," said Sara, pulling a face at how ridiculous the extensive list of charges is. "Fraud and being part of a criminal organization!" she continued, her eyes widening. "I didn't take any of this seriously because there's no evidence. They said we were on the shoreline smuggling people [into Europe] when Sean was at his graduation ceremony in London, and I was in class in Berlin. We didn't even know each other then. I had hope. I thought, I'm in Europe, there's democracy here."

JAIL

Despite this European 'democracy', Sara was held in jail in Greece for four months. There was no evidence against her.

"I met so many people in that jail who told me they were innocent, and they were. They're all free now," Sara said. "There is so much injustice and I wish I could speak about it more. I believe I was sent there for a reason."

She was finally released on bail and reunited with her family in Germany, but the trial and the threat of 25 years in prison hangs around her neck. Reintegrating into society after her time in prison was hard. "I never wanna be the victim, so I did a lot of partying and tried covering it up," said Sara. "Then we started with the talks and campaigning."

Sara and Sean have become spokespeople on the criminalisation of humanitarian work, gaining the support of Amnesty International and other global solidarity organisations. Tirelessly sharing the injustice of what happened to them, they have drawn attention to similar cases all over Europe, where authorities commit a slew of procedural rights violations to try and discourage humanitarian action. Another high-profile example of this criminalisation of solidarity is the Proactiva Open Arms rescue ship, which was impounded by Italian authorities in March 2018 after rescuing 218 people off the coast of Libya. Three crew members were placed under investigation under suspicion of enabling illegal migration.

> **"THEY'RE NOT CROSSING BECAUSE WE'RE GOING TO GIVE THEM A BOTTLE OF WATER AND A BLANKET. THE REFUGEES CAME FIRST, THEN THE VOLUNTEERS CAME, NOT THE OTHER WAY AROUND."**

"The underlying reason for these types of prosecutions – and they're happening across Europe – is not to find us guilty (they never do find us guilty). It's to cast a shadow of doubt over the legitimacy or the ability to do search and rescue and humanitarian

activity," explained Sean on the Instagram account set up to support their case, @FreeHumanitarians.

"By stopping volunteers from coming, they think they'll stop refugees from coming," added Sara. "But when I came in 2015, there was no-one volunteering on the shoreline. I never thought about volunteers. I came anyway. They're not crossing because we're going to give them a bottle of water or a blanket. The refugees came first, and then the volunteers came, not the other way around."

Sara and Sean's trial began in January 2023. Though a decision hasn't been reached at the time of writing this, they are confident that the lack of evidence behind any of the accusations will mean the judge rules in their favour. But in the meantime, the years of waiting have taken their toll.

"I'm tired of saying the same exact thing over and over again," said Sara. "We're stuck in the middle of a hurricane. I also have to find funding for my case. I have a lot of support around me, but I just wanna forget about it."

Despite the desire to move forward with her life and leave these accusations behind, Sara continues to find the strength to share her story through international talks, online campaigns and most recently the dramatisation of her life in the film *The Swimmers*.

"We can't change the world, but we can change one person and it's a ripple," she says. Through her time as a refugee to a rescuer, a prisoner to a hero, Sara is powered by her experience. "The word refugee is a weapon: someone who has lost everything and can start from any point in life. Tell me what you find more powerful than this." She looked at me passionately, and I could not agree with her more.

"WHY ARE ACTIVISTS BEING CRIMINALISED?"

Across Europe, individuals and organisations assisting asylum seekers with humanitarian aid, preventing deportations and rescuing people at sea have faced restrictions on their activities, intimidation and harassment, and arrest.

In a report published in 2020, Amnesty International documented instances of criminalising solidarity in at least eight countries across Europe, resulting in hundreds of people being targeted for their activism.[4] Many of these instances involve volunteers and aid workers facing charges of "facilitating irregular migration" for helping refugees at border crossings. Often, just documenting violent human rights abuses from border guards or offering food and water to refugees is enough to warrant such charges.

Human rights defenders who have been criminalised for their activism include the crew of the Iuventa ship (responsible for rescuing 14,000 people from drowning in the Mediterranean), a 73-year old woman who gave a severely frost-bitten and traumatised Afghan man a lift over the border between Italy and Switzerland, and a pastor who sheltered a Togolese man named Joseph in his home.

Children in a refugee camp in southern Greece, 2016.

USA

SOVIET UNION

KARINA

"We are not just a collection of sad stories. Yes, there's sadness in there, but that's not just who we are."

During the pandemic, a lot of us experienced unprecedented restrictions on travel and spending time with the people we love. Holidays spent apart from our families and not visiting elderly relatives was tough, but we trusted that the lockdowns and quarantines would pass and that life would eventually return to normal.

Imagine those kinds of limitations being your daily reality. Imagine not being able to get a job, open a bank account, learn to drive, go to the doctor or get married, when everyone else around you can. Imagine watching your friends live their lives as normal while you are imprisoned by an invisible barrier, knowing that on paper you don't even exist.

This is the reality for an estimated 200,000 people in America and up to 45 million people worldwide who fall into the category 'stateless'.

These numbers are difficult to track because many countries don't even count these people. Many people might not even know they are stateless. Personally, I didn't understand what it meant to be 'stateless' until I met Karina, a founding member of an organisation called United Stateless. Based in the US, United Stateless is run by those affected by statelessness and dedicated to advocating for their right to a nationality.

STATELESSNESS

"From my personal experience, statelessness was never presented to me," explained Karina. "For a long time I didn't even know what it was, and I am this person. There is such a huge knowledge gap. I want to educate as many people as possible. People need to know that this happens and that there's a name

for it. I didn't have a passport. I had nothing. That's when I started realising, wow, that's what I am. I'm stateless.

"The world is governed by 196+ states and you have to be a national to be a part of domestic, international or local law. To travel anywhere, you need a passport. To work, you typically need a driver's license. If you're stateless, you don't have any of that. It's a person that's in limbo, not recognised by any country."

"But how does that happen to someone?" I asked.

> ## "SOVIET UKRAINE DECIDED THAT FOUR-YEAR-OLD KARINA WAS NOT THEIR NATIONAL. THROUGH NO FAULT OF MY OWN, I BECAME STATELESS."

"There are lots of ways," Karina replied patiently. "Firstly, through the dissolution of a state like the Soviet Union or Yugoslavia. That's what happened to me. I was born in Soviet Ukraine in the former Soviet Union. I left when I was four to try and seek asylum in Canada or the US, but both of them denied my claims. Meanwhile, the Soviet Union ceased to exist and I was left without a country. Soviet Ukraine decided that four-year-old Karina was not their national. Through no fault of my own, I became stateless."

Karina went on to explain other ways you might become stateless. You can be born stateless, if there is no way for your parents to register your birth, and there are many gaps in legislation that lead to statelessness. There are over 20 countries in the world where women are not allowed to pass their citizenships to their children. Border disputes in places like Ethiopia have left people stateness, as well as nationality laws specifically targeting the Rohingya in Myanmar, leading them to also becoming stateless. Other examples of stateless people are the

Karina as a child in Soviet Ukraine.

Kurds (the largest population of people without a state), the Romany people and, arguably, the Palestinians.

"Stateless people in the US come from 35 different territories and countries," said Karina. "It's quite a melting pot. Statelessness touches practically every corner of the world."

"But what's the difference between being a refugee and being stateless?" I asked Karina, still confused by the definition.

"A lot of experiences are shared," she nodded, and then continued. "In the US a person that is designated as a refugee is able to enter the US with a path to citizenship. A stateless person can also be given refugee status, the same as an asylum seeker who is applying for the same refugee protections while on US soil. At the moment in the US there is no path for protection for a stateless person solely based on their stateless status."

Statelessness is a problem because it leaves people without a state to administer their rights,

unable to access things that many of us invariably take for granted.

> ## "AS I'M GETTING OLDER, I'M REALISING THAT IF I DON'T ADVOCATE FOR MYSELF AND OTHERS, I MAY VERY WELL LIVE STATELESS FOR THE REST OF MY LIFE, AND DIE THIS WAY."

"For me, statelessness has given me some of the most traumatic experiences of my life and it hasn't been resolved," Karina says. "I'm still stateless. I don't think I've ever settled anywhere. I am living within a system that doesn't recognise me. As I'm getting older, I'm realising that if I don't advocate for myself and others, I may very well live stateless for the rest of my life, and die this way."

Karina with her sister and parents. The family fled Soviet Ukraine before the dissolution of the Soviet Union.

KARINA'S STORY

"I am Armenian and Ukrainian, born in the Soviet Union. I was four years old when we left because it was a dangerous place for us. My father suffered discrimination and frequent beatings in Odessa, where we were living at the time. My mum suffered a miscarriage from an extreme beating in the streets, so we had to leave. I remember a train, a big boat and a plane. The trauma of migration when it's forced on you stays with you, even as a child. It leaves an impact on your life.

"When I was eight years old, we applied for asylum before US immigration authorities and our claim was denied three times. By the time the final claim came through, six years had gone by and we were put under removal proceedings to self deport."

Self-deportation is an approach to addressing an individual who has exhausted all available options for relief which orders a person to voluntarily leave the country in which they have been denied asylum.

"It felt like the country I had been living in, that I thought was my home, rejected me. I just didn't understand what that meant. I internalized a lot of my trauma into an eating disorder because it made me feel like I was in control. I was ashamed. I never talked about our immigration issue, I kinda hid it. I buried my head in the sand for so long because of the embarrassment that comes with not having any kind of nationality, recognition and passport. It's unheard of. It's misunderstood. People are unaware that this is a thing that happens. You feel lonely in the world.

"My parents weren't open about it either. They knew how people treat immigrants, and they didn't want us to have to go through that, so they didn't talk about it outwardly. They even discouraged us from speaking Russian at home. They didn't want us to have an accent. At the time I was confused – I was like, oh man... I'm not as bilingual as I wish I was! – but now I get it. That was their trauma, and their way of

protecting us. I definitely witnessed the trauma in my family. Being in and out of immigration courts and lawyers meetings played into my life from eight years old to 13. Coming home, feeling my parents' nervousness, their anxiety. Feeling the tension. Waiting for an answer. Being denied. Let's do this again. Let's try this again.

"When they were denied that third time, there was a part of them that died. My mum, that year, went through the trauma of having her parents die back home, and she wasn't there for them. I feel a sense of responsibility to carry that torch for my family through my advocacy work. It's a sense of motivation. It's like, no Mum, I'm not giving up on us."

Karina took a moment to pause and looked down into her lap. "Thank you for letting me become vulnerable," she said softly, before continuing with her story.

"I'm in my 30s now and, looking back, it gives me some perspective to be kinder to my younger self. To have more compassion. As these things are unfolding there's a lot of self blame. It's interesting how I internalized this to blame myself. Now, looking back, I'm like, oh my god, how innocent was I?!

"IT'S LIKE THE COUNTRY IS TELLING ME, 'WE DON'T WANT YOU HERE – WE DENY YOUR ASYLUM CLAIM – BUT WE DON'T KNOW WHERE YOU SEND YOU AND YOU NEED TO FIGURE IT OUT.'"

"I was 13 years old when I was placed under removal proceedings. I am now 32 and I am still under removal proceedings to self deport. It's like the country is telling me, 'we don't want you here — we deny your asylum claim — but we don't know where to send you and you need to figure it out.' If I ever leave the US I will be deporting myself and triggering a 10 year ban from the country."

Left: Karina on her wedding day; Page 115: Karina at home in the US.

"Of course I've had happy moments in my life," Karina clarifies, "but this was always in the background. It stopped me in every single part of my life."

When Karina was 24 she met the love of her life and decided to get married. They hoped that by marrying a US citizen she could adjust her status and access the freedom she craved. But unfortunately they were wrong. "Marriage to a US citizen doesn't necessarily give you a direct path to citizenship, but it does protect me in a very small sense. I would say that's a common misconception. Just get married and you become a citizen! But that's not the case. At all. It's actually really complicated."

UNITED STATELESS

Karina was 28 when she first met someone else outside of her family who was living stateless in the US. It was a life-changing moment. "We decided that we wanted to use our stories to advocate for ourselves and each other. It's the 'each other' part that is the strength we use. It's solidarity that we've built. It's motivation for each other and this unspoken bond that we have. We are a family and we believe that our stories and our experiences warrant us as experts in this field. By coming together with people that have the same experiences as me, that have been through the same thing, we hold an unspoken understanding of each other's pain. That's given me so much healing, motivation and strength. We are not just a collection of sad stories. Yes, there's sadness in there, but that's not just who we are. Statelessness is not only who I am. I am many other things."

Together with six other stateless individuals from around the world, Karina set up United Stateless to raise awareness and advocate on behalf of stateless people in the US. United Stateless is a community building a movement to end and prevent

statelessness in the US. Karina recognises her privilege within this group of co-founders.

"Statistics show that most immigrants that are deported are people of colour. I'm a white woman with no accent, and that's a privilege I do not take for granted," she said firmly. "I was never detained at 16 years old and placed into a detention centre, but there are other people in our group of the same age that were.

"My life experience should never have happened. It should never happen to anybody regardless of background," she said as our conversation drew to a close. "I often ask myself, what is the meaning of all this? Why? I've come to the conclusion that it's my responsibility to make sure that this doesn't happen to any child in this world. That's my meaning. That's the strength I find in all this."

EL SALVADOR

UK

MANUEL & CRUZ

"Ours is a great love story. It was always meant to be."

While writing this book, I sought to expand my knowledge, understanding and awareness of migration beyond the regions that my work has organically taken me so far (mainly Europe, Asia and East Africa). So when I met Manuel and Cruz in a temporary accommodation centre in London, I listened carefully as they shared a story I was less familiar with – their journey from El Salvador.

EL SALVADOR

El Salvador has been named the most dangerous country in the world outside a war zone. Over one million people were displaced during the civil war of the 1980s, and, since then, non-state armed groups have filled the power vacuum. El Salvadorian men and boys – including young children – are often recruited to fight for these armed groups, and women and girls can be subject to rape and sexual slavery. The country is marred by ongoing territorial conflicts between different militant groups, with civilians caught in the middle. Since internal displacement is not recognised by the El Salvadorian government, it is impossible to know exactly how many people have been forced to flee their homes, but up to 300,000 people are thought to leave the country each year in search of safety. Many head north in hope of crossing the border into the USA, while others, knowing how difficult and dangerous it is to travel this route overland, seek other options.

Manuel and Cruz flew into the UK from El Salvador four years ago, at a time when they didn't need a visa

(just a lot of money for the flight tickets). Although their physical journey may seem straightforward in comparison to some of the others in this book, their emotional journey has been a long and painful one.

We sat in the clinical living room of their Home Office accommodation, Manuel and Cruz side-by-side on the sagging sofa, and Sequoia – my photographer and friend – and me on the floor under the stark strip light, as Cruz shared their story. We used Cruz's phone and Sequoia's intermediate Spanish to translate, but even without understanding the words she spoke, the emotion in her voice was palpable, and we took several breaks for Manuel to hand her a tissue and give her leg a squeeze.

"It was my daughter and my son-in-law who came here first," explained Cruz, when I asked her why they had left El Salvador. "They had sold their house, and the gang members wanted a percentage of the sale. This is what the gangs do. They demand money from people who own businesses or buy and sell property and my daughter didn't want to pay them, so they threatened her. That's when she and her husband decided to come to the UK.

> **"WHEN THE GANG MEMBERS REALISED THAT MY DAUGHTER WAS GONE WITHOUT PAYING THEM, THEY THREATENED ME."**

"When the gang members realised that my daughter had left without paying them, they threatened me. I talked with my son and my daughter, and we made arrangements for me and my husband to come here too."

She glanced over her shoulder at Manuel who looked directly ahead, a grim expression on his face.

Things have changed since Cruz and Manuel made this journey, and El Salvadorian nationals now need a visa to enter the UK, which is not easily granted.

"My son has tried to come since," explained Cruz, but he was denied a visa. "The borders are closed now because of the situation in El Salvador. Lots of people are trying to leave.

"Our journey was about 18 or 19 hours," she continued. "And it was very expensive. They detained us at the airport for 24 hours. I thought they were going to make us go back, but no, thanks to god, they let us pass."

Cruz and Manuel had hoped to join their daughter in Scotland on arrival in the UK, but instead they were placed in accommodation in London while their asylum claims were processed. Unable to relocate, work or afford travel while awaiting their status, they are left feeling stranded and alone.

In the UK, asylum seekers are not allowed to work until they are officially granted refugee status, which can take years. Manuel and Cruz have been living on the allocated allowance of a paltry £5 a day for four years, and at the time of writing this, are still awaiting a decision.

"For those who entered the country in the last year, they can get even less than this," added Manuel.

"Yes," said Cruz in agreement. "It's really hard. I have some health problems and every time I go to the hospital for an appointment, it costs me £10 to get there and back."

Cruz had been a hairdresser in her country. When Sequoia and I complimented her bright red hair and colourful nails, she grinned. "I can do your nails or cut your hair whenever you want," she offered before adding, "for free of course because I can't work!"

It was clear that living like this was becoming increasingly difficult for them both.

"In our country you earn very little, salaries are very low, but at least you can have a job. Here, I can't work and, being older, we are very fearful. We don't

Manuel and Cruz in their Home Office accommodation in London, 2022.

want to break the rules. When they say to us that if we work we could go to prison for six months or get deported, we won't do it. We don't want to break any rules. Imagine being imprisoned!"

Manuel and Cruz had already had their asylum denied once, and were waiting on their appeal in the next couple of months. It had left them in a fearful state of limbo, not wanting to put a foot wrong.

"I forget things," explained Cruz. "I got traumatised and now I forget things. For example, when I went to the first interview with the immigration [office], they were questioning me for almost five hours and I couldn't take it anymore. Maybe that's why something's wrong.

"Sometimes I do regret coming here," she continued, tears rolling down her face. "I came to be with my daughter because I thought I would never see her again, but I did the clumsy thing of coming here, only to suffer more. Speaking frankly, it was my daughter telling me good things that made me gather the courage and think, 'Well, maybe there is something better waiting for me over there.' But also, we didn't know of another option than to grit our teeth and try."

We hugged them both, wishing them luck for their appeal and truly meaning it. No one deserves to be held in this cruel, endless limbo, simply for wanting to live in safety. It's not the first time I've worried that, even if a positive outcome is eventually reached, it might be too late to undo the irreparable damage of these years of distress.

The sky outside was just as grey as their home office accommodation. "When we first came, he was telling me he thought he was going to get hypothermia," Cruz laughed, gesturing to the weather and then to Manuel. "It's very tropical in El Salvador. It's more summer than winter, but the storms... we get thunder and lightning!"

Manuel didn't say much during our visit but his presence next to Cruz was quietly supportive. When Sequoia took their photo, they embraced lovingly.

"Ours is a great love story," smiled Cruz. "He was my first boyfriend but I got married to someone else. I was with my husband for 13 years and then he had a fatal accident and died. After that, I redid my life. I met Manuel again as an adult and we got married. It was always meant to be."

I asked Cruz if they had made any Spanish-speaking friends since arriving in the UK. She shook her head. With their little English, inability to travel far, and with no wifi in their dismal accommodation, they only had each other to get them through the endless days of uncertainty in which they were living. As I put my shoes on to leave, it struck me how incredible that was: that their love and connection stood so firm in the face of their storm.

UK

PALESTINE

YARA

"I want us to sing and dance and laugh, instead of cry. I want people to have their basic human rights. I want peace for everyone."

GAZA

"Imagine being 20 years old and living through four different insane aggressions," began Yara when we sat down together to record a podcast episode about her home country of Palestine.

I couldn't imagine but I wanted to try. My interest in Palestine had begun during my teenage years, when my first boyfriend played for a Sunday league football team that raised money for projects in Palestine. At the time, I knew nothing about what was happening there, having not learned about it in school, so I began my own explorative journey. I watched *The Promise*, a TV series about a young British girl who visits Palestine, and went to Open University lectures in London. I created a timeline of key moments in the history of Israel/Palestine relations and stuck it to my bathroom wall so anyone

sitting on the toilet would read it and learn. But it wasn't until I heard Yara's story first-hand that I began to understand the human cost of these events.

Yara is from the Gaza Strip, a small area of Palestinian land bordering Egypt and Israel, home to around 1.85 million people. Gaza has been under a permanent Israeli blockade since 2007, causing unemployment to rise to 40 percent, and depriving people of food, water, medical supplies and more, with no freedom to leave. Since the blockade, there has been almost constant conflict in Gaza, displacing and killing thousands of civilians. According to the UN, there are at least 58,000 people in Gaza who are internally displaced, many of whom have lost their homes to Israeli bombardment and now live in refugee camps. Yara was one of these and grew up in a camp called Il Bereij until she left

121

Left: Yara in Il Bureij refugee camp, Gaza; Right: Yara and her brother Feras.

Gaza at the age of 16 after winning a scholarship to a boarding school in Wales, UK. She now studies International Relations at the University of Edinburgh. She also travels across the UK to raise awareness of the Palestinian cause. But leaving Gaza was not easy, emotionally or physically.

"Nearly two million people are trapped in a small, very densely populated strip," explained Yara. "There has been a blockade by land, air and sea for more than 15 years [since 2007], so it was almost impossible for me to leave. You can't get in or out. So many children and so many of my friends have [won] scholarships to study [abroad], but they couldn't leave. We don't even have an airport. The only way to leave Gaza is through Egypt, and the border with Egypt is closed." She paused. "We don't know what the real world looks like but we still dream of it."

Yara uses social media to amplify the stories of people impacted by the Israeli blockade. We first connected after I saw a video of hers on Instagram which had a lasting impact on me. Facing the camera, distraught, she explained through tears that she had heard that her neighbour's house had been bombed and she didn't yet know whether her own family had survived the attack. This hugely vulnerable video brought the reality of living in a conflict zone into sharp focus. It hit me hard, and I wasn't the only one; it was seen by half a million people.

"I'M TALKING FOR ALL THOSE GENERATIONS WHO LOST THEIR LIVES, WHO LOST THEIR VOICES."

"Talking about my trauma is one of the hardest things I've ever had to do, but I did it on social media because I thought, this is for you Palestine," Yara explained. "I'm talking for all those generations who

lost their lives, who lost their voices. I feel a responsibility to show the whole world what happened. Palestine is a struggle for every human being who believes in freedom. It's not a struggle for Palestinians only. I'm documenting history."

Yara's family survived that bombing, but returning to Gaza to visit them is near impossible. When I interviewed Yara for our podcast, she hadn't seen her family in five years. "That alone is traumatising," she told me, with a wobble in her voice. "[I'm] constantly worrying whether my family are dead or alive. And I'm only talking about my family. I have a whole childhood of friends, bookshops, memories, places, the beach – my whole existence. It's my home and I can't go back. I haven't been back since I left. I feel so angry at the world for allowing this to happen. For five years, I haven't seen my baby brother who has suddenly grown up. I haven't seen my pet tortoise, Casper, and he just died in a bombing." She paused to correct herself. "Actually, he was murdered.

"With all that pain comes responsibility. We're born to be activists just by being Palestinians. In a parallel universe I'd be studying art or cinema, but our reality drove me to do this. I realised how underrepresented we were as Palestinians and that's why I feel this is my mission. I managed to learn English and expose what's happening in my home. I'm sharing stories of what's happening to my friends and family. I'm not being political in the sense that I'm supporting a political party in Palestine. I'm just conveying what's happening. Real people. Real stories. Real humans, just like me and you."

GROWING UP IN GAZA

During Yara's childhood there were three aggressions in Gaza — in 2008, 2012 and the most difficult one in 2014.

"I don't even know what word to use," said Yara, referring to the word 'aggression.' "I refuse to say it's a war now that I have more knowledge of the English

Yara at home in Gaza with her mother and brother.

language. When you say it's a war, you imply that there are two equal sides. But what's happening in Palestine, it's an oppressed and an oppressor. What's happening in Gaza is not a war. Israel has one of the most advanced militaries in the whole world, facing children with rocks. It's really unfair. To me, the word 'attack' seems too small to describe the pain my friends and family have endured."

Yara witnessed the bloodshed of these aggressions firsthand, with her family fleeing the Il Bureij refugee camp after it was shelled by the Israeli military.

"I witnessed death in front of my eyes. Blood. Pieces of humans, not even whole people. We escaped my camp because the whole neighbourhood got destroyed again. We escaped to where my grandparents lived because we thought it would be safer. I saw people dying in the street in front of us. [I was] running with my brother. It breaks me every time I think about his crying face. He was eleven. He was running and he had just a bag of marbles. I took a book with me I think. Just one book.

"It doesn't get easier talking about this," she said, a wobble in her voice. "I get teared up because it still affects me as if it happened yesterday. The trauma of it is beyond words.

"That attack changed my life forever. Luckily we survived. My best friend's house was bombed. I didn't know if she was alive for two days. She was under rubble. She lost her dad, her grandad and other relatives. When I called her, she was in the hospital and we stayed on the phone for 30 minutes, just

Yara working to amplify the situation in Gaza.

crying, no talking, just crying, thanking God that she was alive."

It was only once Yara made it to the UK that she understood that she was suffering from PTSD. "Trauma is barely talked about in situations of conflict or war zones," she explained. "I was so anxious, I couldn't leave my mum. I was really unwell for a while. It wasn't until I left, and I met people in the UK, that I realised it's not normal to be 14 and to see your best friend killed before your eyes. It's not normal to be imprisoned and tortured as a Palestinian child. I managed to get back on my feet, but 95 percent of Gazan children are dealing with heavy trauma. It's not PTSD because it's still ongoing, it's still happening.

"You know trauma can be inherited through generations?" she continued. "When I found this out I was shocked. When I have kids, even if I live outside of Palestine, the fact they could be born with trauma because of my trauma breaks my heart. That's why we have to stop what's happening now. It stops here. It has to. We've had enough, more than enough.

"Over the past ten years, 3,000 Palestinian children have been killed – and I'm just talking about children. Seventy-three years of oppression, and even before that. The British mandate of Palestine was more oppression, more colonialism. We've been fighting for the liberation of our land since we existed, but we can't do this alone. We're angry because we're hopeful that there's another reality."

When I asked Yara what her dream was for the future of Palestine, she said: "I want basic human rights for my people. I want no child to be scared that they might lose their family any minute or any second. I want no child to be held at a checkpoint just because of their nationality. I want children to have their basic movement rights. We're talking

Yara in London, 2022.

"I WOULD NOT WISH WHAT WAS HAPPENING TO PALESTINIANS ON ANY ISRAELI CHILD OR ADULT. I WANT PEACE FOR EVERYONE."

about literally just having a normal life. That's what I want for my people. I want every Palestinian to be able to go back to their home feeling safe, and not to be kicked out any moment just because they're Palestinian. I want no child to feel like they're less, just because they're not Israeli. I want us to sing and dance and laugh, instead of cry. I want people to have their basic human rights. I would not wish what was happening to Palestinians on any Israeli child or adult. I want peace for everyone."

PHUONG

"I want to let people know that people like us – victims of trafficking – came here with a reason, so treat us like normal and understand us more. Everyone has a story."

On 23 October 2019, the bodies of 31 men and eight women were found in the trailer of a refrigerated lorry in Essex, UK. Ten of them were teenagers, and two were only 15 years old. All 39 of them had died from hypothermia and suffocation. The police and media initially identified them as Chinese nationals, but it was soon clarified that they were all Vietnamese. They were believed to have either been victims of human trafficking or to have paid smugglers to make the trip to the United Kingdom, or both.

The family of 26-year-old Pham Thi Trà My, who lost her life in this lorry, shared the last text message she sent to her mum as she was dying. It read: "I'm sorry Mum. My journey abroad hasn't succeeded. Mum, I love you so much! I'm dying because I can't breathe... I am sorry, Mum."

Heartbroken and horrified by this news, my mind was full of the people I knew who had made their way to the UK the very same way, narrowly escaping the very same fate. But over years of working in camps in Europe, I hadn't met anyone from Vietnam. This incident left me with questions about why they were leaving and the journey they had made.

Phuong went to college with my brother Arash, and his foster carer was a friend of my mum's. When I first met him he had only recently arrived in the UK and spoke very little English, so we spent an afternoon playing table tennis in the garden. I knew very little about him, other than that he had been trafficked to the UK. Not long later, he moved away from the area and I didn't see him in years. After what

happened in Essex, I got his number from my mum's friend and gave him a call.

I was not only amazed by Phuong's English, but also by his immediate desire to share his story. I went to visit him at his home in the midlands, set up the microphones and we started from the beginning.

"I had a good life in Vietnam," Phuong began, as we sat together on the fluffy carpet on the floor. "I could go to school with all my friends. I have three sisters. My parents had money because they owned businesses, but then they got into debt." His voice tailed off.

"I was 16 when I left my country, so quite young. I was facing big fears in Vietnam with the debtors that my parents owed money to. They wanted to kidnap me to make my parents pay the money. It was then I realised I had got into big trouble and I had to leave. It's the most difficult decision I ever made, but I had to. I had no choice. My parents had been in hiding for a while and my grandma couldn't take care of me anymore. I was the only boy in the house, so they were targeting me. My grandma was worried about that so she decided to let me go."

What Phuong was telling me didn't square with my experience of Vietnam. Having backpacked across the country in my late teens, I knew many Westerners shared my experience of the country as an appealing holiday destination.

"It is," agreed Phuong. "But deep somewhere you can't see, poor people live a horrible life. Vietnam is a beautiful country but you don't see what's inside."

"I guess as a backpacker or traveller you don't hear about those things," I thought aloud. "Did you have to pay smugglers to leave Vietnam?"

"No," said Phuong. "The debtor kept coming to the house to threaten me and try to kidnap me, so my grandma decided to try and find somewhere for me to go to avoid all the debtors, and she got into a trap with the traffickers. They said they would take me out of the country – not specifically to the UK,

but somewhere safe. They would offer me a job and I would be able to stay in that country. They said my grandma wouldn't have to pay; I would pay them back when I get my job and my salary. Then they brought me all the way to the UK."

"Do you think some people chose to come to England for a better life, and paid money to make this journey out of choice? Or were most people fleeing something scary?" I pushed Phuong on the question that I knew some people would be wanting to know the answer to. Were these people leaving for economic reasons?

"I think most people had a fear, then they got in the trap with the traffickers," he replied. These traffickers, exploiting the desperation of Phuong and others like him, find vulnerable people and promise to help them leave the country. And in a country with high levels of poverty like Vietnam, there are many people at risk of exploitation.

"I know one person who wasn't fleeing a debtor, but it was because of his religion. He was fighting for his religion and then he got in trouble with the government. Political reasons as well," Phuong explained. "There are a few reasons but the main reason is traffickers trying to trap people who are vulnerable like me and my grandma at the time."

The traffickers bought Phuong a passport and a flight ticket to Russia.

"There was a man who met me at the airport, and he brought me to a van and put me into the back of it, and drove me very far, to a rural village," he continued. "There was a house there with quite a few Vietnamese people inside. I thought that was my destination and that I would live and work there, but no. That was just a stop.

"I stayed there for a few days, then they put me into the back of a van again. The journey was about

A vigil in Kent, UK, to remember the 39 Vietnamese people who died in the back of a lorry while being trafficked into the UK.

seven hours and they took me to Ukraine. In Ukraine there was another house in a rural village. I had to stay there for about a month. After that they put us back in the van to go to Poland. From Poland, we went again in a van to France. In France they put us in the Jungle in Dunkirk, where all the camps and different people from different countries are. There was a camp of Vietnamese people there. The traffickers forced us to stay in the camp. We're not allowed to use our phones or talk to people around the camp, just stay there. We had no idea where the next destination was."

Though Phuong and the other Vietnamese people were living in the same camp as refugees from all over the world, the traffickers prevented them from leaving the camp or interacting with anyone else, including the volunteers. He was kept here for about a month. "You can't imagine how hard that time living in France was. I couldn't take a shower. We didn't have enough food to eat.

"The traffickers threatened us every day. I saw so much violence. In France, they told me straight away: Now you're here, you work for me. You have to listen to me. When you get to the UK, you have to pay the debt. Otherwise you and your grandma will die.' I didn't know how long I had to work for them. It was a very hard time for me. It was more dangerous than the situation I had left in Vietnam. I was miserable. I was 16 and crying all the time, but you know, I couldn't do anything. I couldn't speak the language. I wasn't allowed to talk to the people around me either. When the traffickers left we talked a bit and made each other feel better, supported each other and kept thinking positive. They were all young like me... 16, 17, 18."

Eventually, Phuong and the others were bundled into the back of a lorry. "It was completely dark inside," he said. "But I made it to England the first time. I was lucky."

The news of the 39 lorry deaths in 2019 came as a shock to Phuong. "I was in the same situation," he told me, almost disbelieving. "When they said the people were Chinese on the news, I knew they were

Vietnamese. Chinese people don't come here that way. I know lots of Vietnamese people are waiting to come from France or Belgium. When they said the lorry came from Belgium, I knew."

"I was shocked too," I replied, in agreement with Phuong. "In camps in France and Belgium I've met Syrians, Sudanese, Kurds, Eritreans, Somalis, Ethiopians, but never Vietnamese people. Now I understand your situation was more hidden, and your traffickers kept it that way. Your lorry wasn't refrigerated though was it?"

"It was," Phuong replied. "But that day they didn't turn the fridge on. The lorry was completely sealed, though, so we were out of breath – 35 people. If the police came ten minutes later, we would have all died. That's why I had the same feeling as the 39 people in that lorry. That's why I was shocked. It brought back the memory of that day.

"We got into the lorry at about 3am in the morning. It started driving at about 6am. After about four or five hours, at maybe 11am, the lorry arrived in the UK. We were screaming, banging on the doors, banging on the sides of the lorry to let the driver

A portrait of Le Van Ha, among the 39 people found dead in a truck in Essex in 2019.

know. The driver didn't stop. People screamed so much they were out of breath. There was not enough oxygen in the lorry.

"Later, I found out he had called the police and found the nearest service station. By that point I had passed out. All the people around me had passed out. The police opened the back of the lorry. I woke up with all the ambulances and police around. I was tired and panicked. I couldn't think about anything."

After leaving the police station, Phuong was placed in care. He borrowed an iPad from someone else in the home and logged onto Facebook. "As I did that, someone texted me to tell me I needed to leave that place," Phuong told me. The traffickers had found him. "They would come to get me. If they didn't find me, they would kill my grandma.

"I was really really scared. At that time, I didn't know anything about foster families or care because no one explained it to me. The smugglers came to pick me up from the foster home and drove me to a house. I wasn't allowed to go out or use a phone.

"They told me they had found me a job. They put me in the back of a van again and drove me to an old farm. They took me to a warehouse there. I know now that it was a cannabis farm."

As shocking as it sounds, Phuong's experience isn't unique. According to a 2017 report from the Anti-Slavery Commissioner, Vietnamese boys under sixteen make up the biggest proportion of those trafficked to work in the UK, where they are most often forced to work on cannabis farms.[5] By contrast, the majority of Vietnamese girls trafficked to the UK are forced into prostitution. It is not unusual for Vietnamese minors to go missing from UK foster homes, with traffickers making contact on social media and coercing them into leaving.

"They forced me to stay there. They threw me my food and they taught me how to look after the plants. They locked all the doors and windows and then left. I was really really scared, screaming all

night. The next day they came, they brought me some more food and they asked me if I did all the work they told me to do, but I hadn't done anything. They started beating me very, very badly, then they left me. They came again and beat me again. They beat me nearly to death. I lay on the floor for nearly two days. After two days, I decided to escape."

Phuong paused for breath and I sat in silence, shocked that what he was telling me had happened in the UK. I'd met many people who had been enslaved and exploited abroad, but even the English foster home wasn't a safe place for him. It was a stark reminder of how our different backgrounds can inform our different experiences of the same place; of how while a country can be safe for white Westerners with citizenship, the reality can be very different for someone without the same privilege.

"I got out of the warehouse and I kept running through the night," Phuong told me. "When I woke up I was in front of a supermarket. I didn't speak much English but I just said 'help me'. A homeless person took me to a phone box and called the police for me. The police came and took me to the police station, asked me some questions and then took me to my new foster home.

"I was scared for two years. I forced myself to think positive things. *You're safe. You're at college. You have friends, you have a foster family.* I lived with that fear for nearly two years after I escaped the warehouse. It took me two years to get my confidence back again. I deleted my Facebook and I haven't used social media since then."

"You're a hero," I told him. Phuong just laughed. "Everyone would do that!"

Phuong is now the manager of a nail and hair salon. "I'm on reception," he told me. "I take care of all the customer services. It's a good job and I really enjoy it.

We get paid and treated well."

Phuong has also been able to attend college and learn English, though he hasn't been able to make contact with his family. "I think it could have been dangerous for me, and for them as well," he said. "The debtors are still looking for me and my parents, so at the moment I think I'm not going to do that, to save myself and to keep my parents safe as well. Hopefully, fingers crossed they're safe somewhere in this world. I hope they're still alive. I'm trying to settle myself down here, keep myself safe for now. Then one day I will go back to Vietnam. I don't want to talk [to them] on the phone. I'll wait until I can go back to my country, then I'll go straight to my grandma and ask her [where my parents are].

"I THINK I WILL FIND MY FAMILY ONE DAY. I THINK THEY ARE STILL SOMEWHERE."

"When I think about it, it makes me sad," he continued, "but I had to go through those sad things to get me here. I think I will find them one day. I think they are still somewhere. But this country is like a big support. The government is helping a lot, so I really appreciate that. If I didn't have the government to support me, I wouldn't be here today. England is my second country."

Phuong finished with some important words: "I want to let people know that people like us – victims of trafficking – came here with a reason, so treat us like normal and understand us more. We are asylum seekers, but we're not as bad as people think. We're not here for money. Everyone has a story."

Phuong's name has been changed to protect his identity.

night. The next day they came, they brought me some more food and they asked me if I did all the work they told me to do, but I hadn't done anything. They started beating me very, very badly, then they left me. They came again and beat me again. They beat me nearly to death. I lay on the floor for nearly two days. After two days, I decided to escape."

Phuong paused for breath and I sat in silence, shocked that what he was telling me had happened in the UK. I'd met many people who had been enslaved and exploited abroad, but even the English foster home wasn't a safe place for him. It was a stark reminder of how our different backgrounds can inform our different experiences of the same place; of how while a country can be safe for white Westerners with citizenship, the reality can be very different for someone without the same privilege.

"I got out of the warehouse and I kept running through the night," Phuong told me. "When I woke up I was in front of a supermarket. I didn't speak much English but I just said 'help me'. A homeless person took me to a phone box and called the police for me. The police came and took me to the police station, asked me some questions and then took me to my new foster home.

"I was scared for two years. I forced myself to think positive things. *You're safe. You're at college. You have friends, you have a foster family.* I lived with that fear for nearly two years after I escaped the warehouse. It took me two years to get my confidence back again. I deleted my Facebook and I haven't used social media since then."

"You're a hero," I told him. Phuong just laughed. "Everyone would do that!"

Phuong is now the manager of a nail and hair salon. "I'm on reception," he told me. "I take care of all the customer services. It's a good job and I really enjoy it.

We get paid and treated well."

Phuong has also been able to attend college and learn English, though he hasn't been able to make contact with his family. "I think it could have been dangerous for me, and for them as well," he said. "The debtors are still looking for me and my parents, so at the moment I think I'm not going to do that, to save myself and to keep my parents safe as well. Hopefully, fingers crossed they're safe somewhere in this world. I hope they're still alive. I'm trying to settle myself down here, keep myself safe for now. Then one day I will go back to Vietnam. I don't want to talk [to them] on the phone. I'll wait until I can go back to my country, then I'll go straight to my grandma and ask her [where my parents are].

"I THINK I WILL FIND MY FAMILY ONE DAY. I THINK THEY ARE STILL SOMEWHERE."

"When I think about it, it makes me sad," he continued, "but I had to go through those sad things to get me here. I think I will find them one day. I think they are still somewhere. But this country is like a big support. The government is helping a lot, so I really appreciate that. If I didn't have the government to support me, I wouldn't be here today. England is my second country."

Phuong finished with some important words: "I want to let people know that people like us – victims of trafficking – came here with a reason, so treat us like normal and understand us more. We are asylum seekers, but we're not as bad as people think. We're not here for money. Everyone has a story."

Phuong's name has been changed to protect his identity.

FARIDA

"I know it is my responsibility to turn this pain into something powerful and prevent this kind of thing from happening again."

Farida is a Yazidi girl from a village called Kocho which lies at the foot of Mount Sinjar in Iraq, with the Syrian border to the west, and the Iraqi city of Mosul to the east. Before 2014, Farida lived a happy life with her family in Kocho, spending most of her time studying.

In June 2014, when Farida was only 19, ISIS militants seized Mosul. Things began to change, and Farida's community feared that it wouldn't be long before they too were under attack. They were proven right. On 3 August 2014, ISIS fighters began the systematic slaughter of the Yazidis, a minority ethnoreligious group indigenous to Kurdistan (an area including parts of Iraq, Syria, Turkey and Iran). Yazidis have been accused of heresy and persecuted for centuries, and ISIS militants viewed them as a threat to their ideology. Just under two weeks later,

fighters surrounded Kocho, rounding up its inhabitants and gathering them in the local school.

What happened next is deeply shocking, but Farida told me her story slowly, bravely and matter-of-factly, almost as if it wasn't her own experience.

"They took the women and girls upstairs and the men and boys downstairs," she began. "They took all the belongings we had, and then they asked us, 'Who wants to convert to Islam?' We said no. We said, 'This is our religion, we grew up like this. We don't want to convert.' And that's when they started killing us.

"They started killing the men. Approximately 450 men, including a lot of the men in my family – my brothers, my father and one of my uncles. All the

women were then transferred to another place where they started separating them by their age. They killed the older women and the pregnant women, even though those babies had done nothing wrong; they were foetuses in their mum's bellies."

Farida continued her story, unwaveringly and courageously taking on the responsibility of sharing it with the world.

"I KEPT ASKING MYSELF, WHY? WHY WOULD THIS HAPPEN TO US? WHAT HAVE WE DONE? WHAT HAVE I DONE TO DESERVE THIS?"

"I kept asking myself, why? Why would this happen to us? What have we done? What have I done to deserve this? We Yazidis pray first of all for everybody else in the world, and then for ourselves. We have always been peaceful and we have never hurt anybody, so it was a hard feeling, not understanding why I had to go through this, and why this would be my reality."

Along with 46 other girls, Farida was then taken to a slave market across the border to neighbouring Syria. Here, ISIS fighters would come and choose the girls they wanted to buy, with those newly-arrived labelled as 'fresh goods'.

"We were beaten and taken by force. We found other Yazidi women along the way who were captured too. We were kept in a dark room. We didn't know if it was day or night, or what time of day it was. We were sold over and over again from one man to another. I tried to take my own life. I cut my wrists hoping to die, but that didn't happen.

"We were beaten often. We were just like toys in a supermarket, or like animals, sold and bought with money. As much as I could try and tell you how it feels, I can never put it into words. What happened to me is something I would not wish on anyone.

People die once but we died every day."

The girls drew strength from each other, and Farida and her friend Ewan stuck together and gave each other hope.

"We saw each other being beaten but we knew we had to get out of there," she told me resolutely. "There was also a nine-year-old girl with me. I was 17 and she was nine but she would call me mum. I was beaten up for her so many times. I promised her if I ever escaped I would take her with me, and I did. I took her with me and reunited her with her family."

Farida managed to escape this living hell on a night when a few horrible circumstances aligned in her favour.

Farida's dad was known for being in the army and was referred to by the ISIS fighters as a 'Khaffa' (an infidel). One evening, the fighters told Farida that they would kill her the next day as a punishment for being his daughter. "I told my friends, that's it, I'm going to go. I can no longer do this. I'm going to die anyway, what's the point of waiting here?"

Farida was locked in a room with eight other girls. Two of them were taken by ISIS fighters that evening. "We waited until 1am, hoping we could all escape together but they didn't come back, and we knew we couldn't wait any longer," explained Farida.

The camp was quiet as many of the men were engaged in fighting that day, and those left behind in the camp were distracted by the two girls they had chosen to spend the night with.

"We had tricked the guards into thinking they had locked our door. When the time was right, we started to run. We even had to run from the dogs. My feet were bleeding and we hadn't walked for a long time so we were weak, but we knew we couldn't be out in the light, and we had to find somewhere to hide before the sun came up."

Farida and her friends found an abandoned house in which to shelter while they were no longer under the protection of darkness. From here, they watched another house close by to see who was coming in and out. When Farida felt confident that it belonged

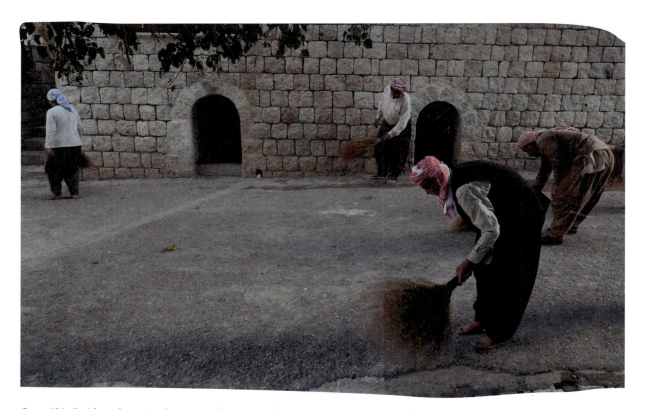

Page 134: Farida at home in Germany; Above: Yazidi men clean the grounds of the Lalish temple in tribute to the jihadists' victims from the village of Kocho.

to a normal family, she approached them, knowing that they couldn't last much longer without food or water. Thankfully, the door was opened by a kind man who welcomed them inside. "I'm not with ISIS," he told the girls. "I work in a factory nearby. We're just like you. We're oppressed too."

"We were there for three days," said Farida. "He told us he had shared lots of meals in Yazidi houses before. That's why he wanted to help us."

Farida had stolen a phone from the ISIS fighters while on her cleaning duties and she used this to call one of her surviving uncles. He paid for some smugglers to take the girls past the ISIS checkpoints and back into Iraq. Desperate to find her surviving family members, Farida was placed in a refugee camp. Here she was reunited with an uncle and one of her younger brothers.

"When I escaped, my mum and brother were still captured. My dad and other brothers were killed. [But shortly after] I escaped, I was reunited with my brother who was 15, and had also managed to escape. My mother escaped six months later.

"I was very happy and very sad at the same time. We were living in a very difficult situation in that camp. My brother and I were both minors so we couldn't do anything for ourselves. When my mum escaped, we felt like we finally had somebody again, but the saddest thing was that my father was no longer there, and my brothers."

I asked Farida if her family were able to talk to each other about what had happened to them.

"They didn't ask," said Farida. "They didn't need to. They saw what happened with their own eyes. We were all too overwhelmed to share what had happened to us."

GERMANY

While Farida was living in that camp, the German government made a commitment to bring 1,100 Yazidi women and survivors of ISIS legally to Germany. Farida registered for the programme and was accepted. She arrived in Germany first and was soon followed by her mother and brother.

"After coming to Germany, a lot of things have changed in my life. I learned German, I'm studying to become a dental assistant and I've started my own organisation called Farida Global, which campaigns for the memorial of the genocide."

Not only this, Farida went on to share her story in her incredible book, *The Girl Who Beat ISIS*.

"While I was captured I thought I could never tell people what was happening to us, but now I know it is my responsibility to turn this pain into something powerful and prevent this kind of thing from happening again – not just to any Yazidi, but to any human around the world.

"It's hard. It's tiring to keep speaking up again and again but I will keep doing it to get support and recognise what is happening to the Yazidis. To show the world who the Yazidis are and what we went through. It's a really rewarding feeling, even when it's small. But however hard I work, I still think I could do more for my people.

"I'm so grateful for this experience because I have now travelled to more than 20 countries to tell my story. If Germany [hadn't done] this for us I wouldn't have been able to tell my story and speak up for my people.

"I'm not alone in this advocacy. There are other girls that do the same like Nadia Murad. [The most famous member of the Yazidi community, Murad won the Nobel Peace Prize in 2018, putting the Yazidi genocide on the map for many people]. No matter how hard it is, we want to deliver this message and we will deliver it no matter what.

"I will only be good when the Yazidi people get international protection, when the Yazidi genocide gets international recognition, and when I am sure that nothing like this will ever happen again," she vowed.

Iraqi Yazidis take part in a ceremony during the exhumation of a mass-grave of hundreds of Yazidis, killed by ISIS militants in Sinjar, 2019.

"Before, my dream was to become a maths teacher, but my dream has changed. My dream is to see ISIS members getting punished for what they did to us and our community. I will only be good when I know my people are doing good.

"IT'S TIRING TO KEEP SPEAKING UP AGAIN AND AGAIN BUT I WILL KEEP DOING IT."

"My hope is that our villages are rebuilt again and we can live a normal life, not in camps. I want to see the mass graves opened, and for Yazidis to be recognised and respected as a religion in Iraq and in the world. I want people to know we are peaceful and that we need a lot of help to be internationally recognised."

At the time of writing this piece, no Islamic State operatives have been prosecuted for their crimes against the Yazidis. According to the UN, ISIS massacred over 5,000 Yazidi men and kidnapped over 7,000 women and girls. Thousands remain in captivity. This story is dedicated to every Yazidi who lost their life, experienced torture or still lives under ISIS control.

BANGLADESH MYANMAR

KHUSHI

"It is only through acts of bravery and facing the unknown that we can make change."

THE ROHINGYA

Growing up, I knew very little about the Rohingya people or the injustices they have faced for decades. Described by the United Nations as the most heavily persecuted ethnic minority group in the world, it feels important to cover the following information about their history before sharing this next story with you.

In south-east Bangladesh, in the small town of Ukhia, 12km from the Myanmar border, lies the world's largest refugee camp. Spread across five square miles (or roughly 2,420 football fields), Kutupalong camp accommodates over 600,000 Rohingya refugees.

The Rohingya people have found themselves at the door of genocide for reasons shared by a large number of the 89 million displaced people in our world today – religion and politics. The Rohingya are indigenous to the area of Rakhine State, formally known as Arakan – a state that became one of the divisions of India under British colonial rule and fell inside what was then allocated as predominantly Buddhist Burma (now Myanmar). Myanmar then claimed the Rohingya, a Muslim minority, to be immigrants who illegally migrated from Bangladesh. The Rohingya maintain they have a heritage in Myanmar for over a millennium.

In 1982, the Burmese military enacted a citizenship law that did not list the Rohingya as one of the 135 'national races' of Myanmar, leaving them stateless in their historic homeland of Arakan. From 1991 to 1992, military operations targeting the Rohingya people led to over 250,000 of them seeking refuge in Bangladesh. These refugees became the original settlers of Kutupalong refugee

camp and, as of writing this, have sought refuge in Bangladesh for 31 years.

This, however, was not the last or the largest exodus of Rohingya into Bangladesh. On 25 August 2017, a 'clearance operation' (as described by the Myanmar military), was carried out against the Rohingya. The devastation can only be described in one word – genocide. Killings, sexual violence and arson attacks forced more than 700,000 Rohingya to flee Myanmar and seek refuge in neighbouring Bangladesh. During the genocide, at least 25,000 people were killed and roughly one million displaced.

This crisis is what originally prompted me to journey to Bangladesh. During my time there I met thousands of Rohingya people, who embraced me as their own. Some have lived in the camp since the early influx in the 1990s, and many have fled more recently. This is just one of their stories.

This opening section was written by my friend and fellow humanitarian, Millee Johnson.

I spent some time in Kutupalong refugee camp at the end of 2019. I was accompanying my old friend Millee, who had been working there since 2017 with

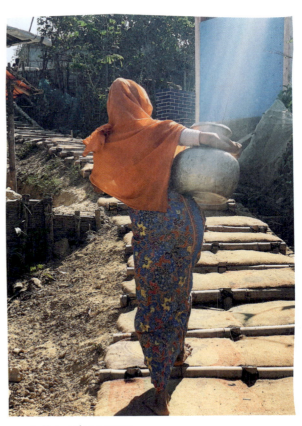

Left: children playing in Kutupalong refugee camp; Right: a woman in Kutupalong camp.

several aid organizations. Millee introduced me to her many friends and connections in the camp and the surrounding community, and I have fond memories of sitting on the floors of shelters and homes, trying delicious new foods. One of the people I was most excited to meet, having heard Millee speak about her in awe, was a Rohingya girl named Khushi.

"I first met Khushi when I had just arrived in Kutupalong and was overcome by the size of the camp and the magnitude of the operation that was happening," explained Millee. "I was inspired by Khushi's vast knowledge of human rights and her passion for fighting injustice. Her energy was infectious and despite being displaced herself, she dedicated her time to helping volunteers like me with translation."

"I wanted to ensure that the communication between international aid organisations and the Rohingya community was clear and respectful," Khushi explained.

"Khushi is one of those people who instantly feels familiar, and when you are faced with a situation as overwhelming as the Rohingya refugee crisis," said Millee, "finding home among the chaos can create an unspeakable bond. The name Khushi means happiness and joy in Hindi, and I couldn't think of a better name for this young woman."

KHUSHI

Khushi has only ever lived in Kutupalong refugee camp. Born in Bangladesh to two Rohingya refugee parents who had fled Myanmar in the early 1990s, she had never experienced her native home or the freedoms that would have come with living there prior to 1982.

As a child, she was unaware of her stateless status or of the restrictions that her place of birth and ethnic group would ultimately have on her. Being a refugee meant that Khushi was unable to access

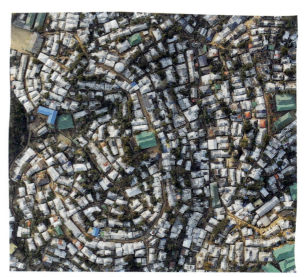

Kutupalong, the world's largest refugee camp.

formal education outside of the camp, so her early education came from volunteers who had set up basic schooling within the camp's confines. It was here that she got her taste for education. Through learning, she discovered freedom, rights and the power of knowledge.

"I ALWAYS WANTED TO REPRESENT THE POWER OF EDUCATION."

"I always wanted to represent the power of education, for not only boys but also for girls within my community," she told Millee and me.

Undeterred by the restrictions upon her, Khushi figured out a way to go to school. Disguising herself as Bangladeshi, she attended a local school outside of the camp. Being born in Bangladesh meant Khushi was fluent in both Rohingya and Bangla. As Bangladesh was the only home she had ever known, it wasn't difficult for her to fit in.

Her appetite for learning only grew. It was a desire that, to her, felt as important as breathing.

Khushi's mother, not having had an education herself, supported this drive, but Khushi's father had other plans for his daughters. At 12 years old, Khushi learned of his arrangements for her marriage. Determined not to have her future stolen from her, she managed to persuade her father to delay the wedding and allow her to continue pursuing her education. Not only was she fighting the persecution of being born a stateless Rohingya, she was also battling the expectations of a Rohingya woman in a community that valued marriage above education.

Rising above adversity comes naturally to Khushi. The contention with her father only ignited the flame within her further. She began advocating for women's rights, not only within the Rohingya community but also within the Bangladeshi community, becoming a voice for women's learning and education. While other young women in the camp were getting married and starting families, Khushi went from tent, to tent encouraging families to send their children to the free local schools within the camp. She would often tell Millee, "sister, this is my calling."

"I had never met anyone in my life more aligned with their purpose and determined to bring it to life," said Millee of this drive. "If one woman could change the course of education for the Rohingya people, it would be her."

Inspired by this mission, Millee and her colleague helped Khushi apply to and fund her higher education, and she was accepted into two private Bangladeshi universities. In 2019, Khushi began studying law – the very thing that she believed would grant her and the woman within her community freedom of their inherited situations.

"I felt so much pride being one of the few Rohingya women to attend university," she told us, "and I was determined not to take the opportunity for granted."

"I also felt so much pride seeing her flourish," added Millee, "that I forgot the serious risks of her being there. She was enrolled as a Bangladeshi student and if her true identity was ever discovered then her right to an education would be taken from her. Her unwavering positivity made it easy to forget that, in the eyes of the country she was born into, she was not afforded that right."

Then one day, it happened. "I got a call from Khushi to tell me that her identity as a Rohingya refugee had been discovered and that she had been expelled from university," explained Millee. "An article written about her almost a year prior had gone viral, resulting in her university expelling her from her law degree. At the time, she had only attended one-and-a-half semesters. She was devastated. The one thing she wanted in the world had been taken from her. I felt her grief and I felt ashamed that I had actively encouraged her to pursue her dreams despite knowing the risks."

"I had to remind myself that this was not a loss because I had dared to be brave and it is only through acts of bravery and facing the unknown that we can make change," said Khushi.

"THEY CAN TAKE AWAY MY CERTIFICATES, BUT THEY CAN'T TAKE AWAY MY KNOWLEDGE."

Not only did the article get Khushi excluded, it saw her facing death threats and even an attack which left her in hospital. Her mental health spiralled dramatically, but her determination was resolute. "They can take away my certificates, but they can't take away my knowledge," she explained. "I still dream of my education and have full faith that one day I will finish my degree and become one of the first Rohingya women to be a human rights lawyer."

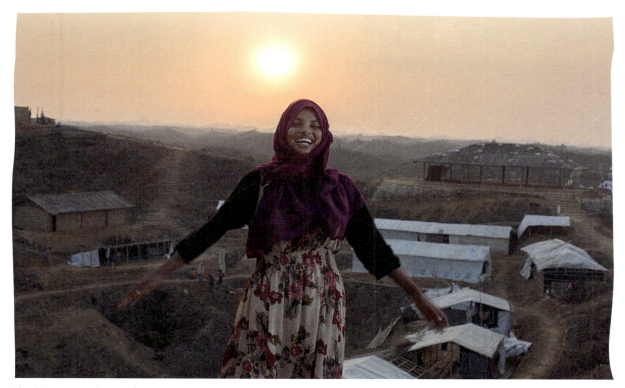

Khushi in Kutupalong refugee camp.

Khushi is still living in Bangladesh and continues to fight for her right to an education.

"I try to remind myself to be more Khushi when I let the weight of the world wash over me," said Millee. "When I feel the urge to complain about work, I picture her face and remind myself of what she has overcome to be where she is today. When I feel overwhelmed, I ask myself, 'What would Khushi do?' It's because of her that I now work as a women's empowerment coach.

"All she has ever wanted to do is inspire and empower women, and her impact on me is having a ripple effect throughout the world with each woman I work with.

"Khushi's faith reminds me that we always have a choice. She could let her dream die yet she chooses to believe it will happen. She chooses to see the good when it would be easy and justifiable to see the bad. She chooses to amplify the voices of the Rohingya community. She chooses her rights even when her environment tells her she doesn't have any, and she chooses to believe that one day all Rohingya women will receive an education. I choose to believe this with her.

"As Khushi would say: *Inshallah*."

NILS

"This isn't even about charity. It's about coming together. It's about feeling true understanding and empathy, standing in someone else's shoes."

In early 2015, I was working in design for an ethical underwear brand in London and my brother Nils worked as a creative in the advertising industry. Neither of us knew anything about the asylum system in the UK.

CALAIS

When I first started to travel back and forth to the Calais Jungle, inspired by my parents' decision to foster a child who had lived in that camp, Nils was there by my side. He helped navigate the response to my viral Facebook post and organised donation drop-off days across London. His house in Brixton was one of these drop-off points, and became so overflowing with tents, sleeping bags and boxes of warm clothes that his housemate had to temporarily move out and stay with her boyfriend to make space.

Nils is just a year younger than me, and although we share a lot of similar interests and the same amazing group of friends, we are also very different. The calm to my fire, Nils has always been able to cut through my hyperactivity with one dry joke. As our social media presence grew, he had the ability to turn hateful comments into a source of comedy and motivation. His mocking of the inevitable anti-immigration vitriol was a constant reminder to find lightness wherever and whenever we could.

Nils and I spent those first few months in Calais making friends and doing our best to listen to them.

"One of the main things that people kept asking for was whether we could hotspot them," remembered Nils from those early days in the camp. "People wanted to call their families back home, to access information about where they were and

where they could go next, but the camp had terrible phone signal. It was hard to even send a WhatsApp sometimes. People often asked to borrow our phones but there were only so many times we could lend them to someone to make a phone call to Eritrea without our phone bills being huge!"

BEYOND FOOD, SHOES AND WARM CLOTHES, THERE WAS A PRESSING NEED FOR ACCESS TO INFORMATION AND COMMUNICATION.

It became clear to us that beyond food, shoes and warm clothes, there was a pressing need for access to information and communication. "This camp needs wifi," Nils and I said to each other. "How hard can that be?" Famous last words.

JANGALA

We went on a mission to build the Calais Jungle's first wifi network. Knowing nothing about technology, we enlisted the help of Richard Thanki (a friend of a friend who had been working with Microsoft to connect rural areas south of the Sahara) and Samson Rinaldi (a sculptor by trade and fellow volunteer in Calais). Led by Rich's ideas, together we used the little budget we had to build access points on top of key areas in the camp, such as the makeshift school and an Afghan cafe.

"I remember so many freezing cold nights in that camp," said Nils with a grimace. "Standing on top of shelters in the dark, turning antennas to try and get the best signal, while you and Rich always seemed to be inside the shelters with a cup of tea and a laptop." We both paused for a moment, recognising the option we always had to go home and get warm, while those freezing nights were an indefinite reality for every man, woman and child stuck in the camp.

Somehow, after months of trying, we got the network working. "We didn't even need to tell anyone," said Nils. "People just started connecting to it. We had 20,000 individual users on that network, and lots of people even shared devices! We were very popular when it was working. People called us the Wifi Guys and kept offering us cups of tea... until it wasn't working," he laughed.

"We called the network Jangala after we found out why the Calais Jungle was named that way. We were told it comes from the Sanskrit word, 'Jangala', meaning barren or rocky landscape. Lots of people assumed 'The Jungle' was a derogatory name given by the media, but apparently it's actually a descriptive name given to the place by the camp residents themselves."

We crowdfunded online through our lovely community to be able to build and maintain the system. The project raised questions from people who were surprised that refugees might own smartphones. There seemed to be a common misconception that the people living in the Calais Jungle were poor or fleeing poverty. Quite the opposite: many had lived good lives in their countries before circumstances had forced them to leave. Many were educated and showed me pictures of their beautiful homes, telling me stories of their jobs as doctors or engineers. Of course they had brought their phones with them; if I was forced to leave my home, my phone would definitely be one of the most important things to bring with me.

The treacherous nature of journeying across Europe meant that these phones were often lost along the way, dropped overboard a small boat or purposefully broken or confiscated by police. Those who had managed to hold onto their phones faced further issues, with some countries refusing to issue SIM cards and data to anyone without a passport. This left many people stuck, unable to access maps, legal aid or even send a "Don't worry, I'm safe" message to loved ones back home.

We set about making our network as effective as possible for the camp environment. Rich had learned a lot about making use of whatever came to hand while working in Sub-Saharan Africa. With his knowledge and guidance, we used gaffa tape and upside down plant pots to make the access points waterproof, and we blocked advertising to make the data stretch as far as possible. Amazingly, our system worked despite the fact it was built from the cheapest equipment possible and used by hundreds of people at a time. Unfortunately though, it wasn't long before French authorities began to demolish parts of the camp, clearing the entire Jungle in November 2016. Our wifi network went with it.

"We had static access points on top of shelters," explained Nils, "so we needed to figure out a way to make our system portable and more rugged. At this point, we were also getting requests from grassroots groups in places like Greece and Serbia to provide wifi in informal settlements there." So the trio went back to London to devise a plan.

Nils, Rich and Samson hired a workshop space in London and began to design their first product – Big Box. Big Box was a purple, briefcase-sized box containing a whole wifi network that could connect up to 100 users. It was created with informal, refugee-camp settings in mind: it didn't need a network engineer to set it up, and could be sent anywhere in the world.

It was a huge hit. The system has gone on to service hundreds of thousands of displaced people in locations all over the world. Jangala went from a Worldwide Tribe project to a charity in its own right, and Nils, Rich and Samson now lead a team of 12.

 ## "WE DIDN'T ALWAYS KNOW HOW, BUT WE ALWAYS KNEW WHY."

"We didn't always know how, but we always knew why," said Nils. "I never expected to be working in tech, but I guess you never know what direction your life is going to take. If you want to get involved in charity, there are so many grassroots groups doing incredible stuff – just give it a go! To be honest, this isn't even about charity. It's about coming together. It's about feeling true understanding and empathy, standing in someone else's shoes, seeing things from someone else's perspective and broadening your own. That's what the lesson has been for me. It's all about connection... that's why we did the wifi!"

Samson, Richard and Nils setting up the Jangala wifi network in Calais.

We set about making our network as effective as possible for the camp environment. Rich had learned a lot about making use of whatever came to hand while working in Sub-Saharan Africa. With his knowledge and guidance, we used gaffa tape and upside down plant pots to make the access points waterproof, and we blocked advertising to make the data stretch as far as possible. Amazingly, our system worked despite the fact it was built from the cheapest equipment possible and used by hundreds of people at a time. Unfortunately though, it wasn't long before French authorities began to demolish parts of the camp, clearing the entire Jungle in November 2016. Our wifi network went with it.

"We had static access points on top of shelters," explained Nils, "so we needed to figure out a way to make our system portable and more rugged. At this point, we were also getting requests from grassroots groups in places like Greece and Serbia to provide wifi in informal settlements there." So the trio went back to London to devise a plan.

Samson, Richard and Nils setting up the Jangala wifi network in Calais.

Nils, Rich and Samson hired a workshop space in London and began to design their first product – Big Box. Big Box was a purple, briefcase-sized box containing a whole wifi network that could connect up to 100 users. It was created with informal, refugee-camp settings in mind: it didn't need a network engineer to set it up, and could be sent anywhere in the world.

It was a huge hit. The system has gone on to service hundreds of thousands of displaced people in locations all over the world. Jangala went from a Worldwide Tribe project to a charity in its own right, and Nils, Rich and Samson now lead a team of 12.

"WE DIDN'T ALWAYS KNOW HOW, BUT WE ALWAYS KNEW WHY."

"We didn't always know how, but we always knew why," said Nils. "I never expected to be working in tech, but I guess you never know what direction your life is going to take. If you want to get involved in charity, there are so many grassroots groups doing incredible stuff – just give it a go! To be honest, this isn't even about charity. It's about coming together. It's about feeling true understanding and empathy, standing in someone else's shoes, seeing things from someone else's perspective and broadening your own. That's what the lesson has been for me. It's all about connection... that's why we did the wifi!"

Content warning:
sexual abuse

GREECE AFGHANISTAN

MURTAZA

"Imagine you are alone and you have nothing. Nowhere to go, no money, no education, nothing. When you face those difficulties, those challenges, people lose themselves."

I first met Murtaza in the leafy, buzzing square informally known as 'Afghan Square' in Athens city centre. We sat outside an Afghan restaurant, where you can buy a chicken biryani for €2 and grab yourself a freshly-squeezed orange juice from the bar a few doors down for just €1. We ordered a feast of pilau and oily veggie dishes – spinach, okra, chickpeas, served with breads piping hot from the clay oven.

Murtaza was full of the youthful energy of an 18 year old, arriving with his backpack high on his shoulders and a big smile on his face. After we'd eaten, we set up the microphones under the shade of a parasol, and he told us his story while we sat back, drinking in his every word.

"My name is Murtaza. I'm from Afghanistan and it's been almost four years since I've been living here in Athens," he began formally. "I left Afghanistan when I was 14. It was a difficult time, but when you face difficulty, you have to find a way," he sighed.

Murtaza left Afghanistan after the death of his father. "When my father passed away, my mother had the full responsibility of taking care of my sisters and brothers. I told my mother I would go to Iran to support my brothers, so they could go to school and continue what they want to do. I went to Iran and worked there for three years... so hopefully I did something. Now my younger brother is an English teacher in our village and he has almost 65 students, even though he is only 17."

It was evident that Murtaza carried the heavy weight of responsibility on his shoulders.

"If you ask any Afghan refugee in Iran, they won't say it was good," he continued. "There isn't any

149

opportunity to work. I was working as a builder in construction and I was working in a chicken factory where you produce eggs. I was working as a tractor driver too. It was difficult but I did it. Of course I missed my family."

When I asked if he was lonely living in Iran, Murtaza replied, "Of course. I didn't have a childhood at all, even in Afghanistan, because the situation was tough."

"I HAD NO OPPORTUNITY TO GET AN EDUCATION. I WASN'T ABLE TO GO TO SCHOOL."

After three years without freedom or opportunity, Murtaza decided to leave Iran. "In Iran, if you go out and the police catch you, they will send you back to Afghanistan," he explained. "I had no opportunity to get an education, I wasn't able to go to school. That's why I left Iran." He pushed onward towards Europe, crossing the border into Turkey, but was caught and imprisoned for 15 days. Upon his release, he decided to make the dangerous journey across the Aegean Sea to Greece.

"We came by boat. It was a scary journey. We were in the middle of the sea with nothing. If something happens, you're gone."

"What were you hoping for when you arrived in Europe?" I asked him. I was fascinated by these huge life decisions he had been forced to make at such a young age.

"The first thing I hoped for was humanity," Murtaza replied. "Freedom. Education opportunities. When I came to Greece everything was different – new people, new places, new language. I didn't know English or Greek at all. Slowly, slowly I got used to it."

GREECE
Murtaza lived in Moria camp, infamous for its

inhumane, overcrowded living conditions. "It was a very tough situation but we handled it somehow," he told me. "I was there for two months."

Moria, situated on the island of Lesvos near the village of the same name, was, at its peak, the biggest refugee camp in Europe. Despite being built to accommodate 2,000 people, there were as many as 20,000 refugees living there in summer 2020 – 7000 of whom were children under 18. It was described by Human Rights Watch as an "open air prison" and Médecins Sans Frontières as "the worst refugee camp on earth". The camp was eventually destroyed in a fire in 2020.

Murtaza finally escaped the camp and reached mainland Greece where he was housed in a centre with other unaccompanied minors, but his accommodation issues were far from over.

"In Greece they have a rule for minors that you have social workers, and you are not allowed to be outside of your accommodation for more than 24 hours. One time I was late by two hours and they kicked me out of the hotel. They didn't even allow me to take my stuff from inside. I had to send my friend to get my stuff. They didn't even think that I didn't have anywhere to go. It was really difficult. I had to sleep under the trash in the middle of nowhere. Then people caught me and put me in prison," he said.

By the age of 15, Murtaza had been in prison in both Turkey and Greece. "Greece was tougher than Turkey," he explained. "We were living with ten people in a room, four-by-three metres. A small place with nothing, just four beds on top of each other.

"I was young, I didn't know anything and I didn't have anyone to help me out," he continued. "It's the same story if you ask any of the refugees who live here. They will have much sadder stories, maybe more than me.

"In my experience the most challenging thing is losing yourself. Imagine you are alone and you have

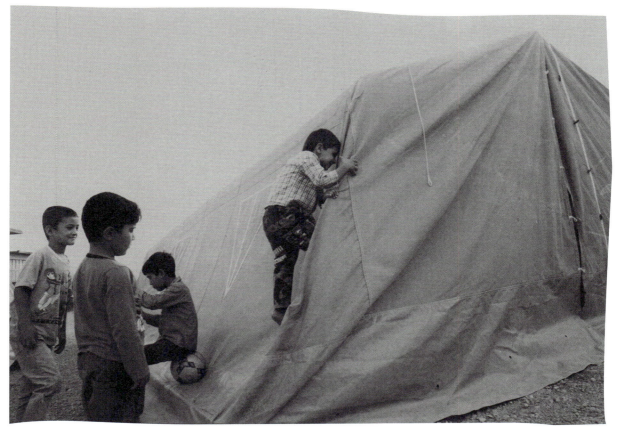

Children playing in a refugee camp, southern Greece, 2016.

nothing. Nowhere to go, no money, no education, nothing. When you face those difficulties, those challenges, people lose themselves. It's sad. You have no one to care about you. No one knows where you sleep, what you eat, what you think or how you feel. This breaks our mental state, our heart. When you're a broken person you can't do anything.

"Living far away from your family when you're young, when you have a problem, you wish you had your mother or your dad beside you, to think about you and take care of you. When you get sick you have no one to say 'How are you? How do you feel? Do you need anything?'"

 "WHEN YOU GET SICK YOU HAVE NO ONE TO SAY 'HOW ARE YOU? HOW DO YOU FEEL? DO YOU NEED ANYTHING?'"

"To look after you and put their arms around you physically or emotionally," I agreed.

"I have only three friends," Murtaza told me. "One of them passed away and the other two are living far away from here. One of them is in the UK and one of them is in Switzerland. We don't have a physical relationship, but we talk over the phone. They're there."

"I'm planning to stay here because I love the Greek people and the Greek weather. I'm learning Greek and I got my asylum," Murtaza said of his hopes for the future. But although he's settled in Greece, he's unable to bring any members of his family to join him. "It's impossible. And I'm not able to travel to Afghanistan," he sighed. "Maybe I will see them one day in a neighbouring country. I hope so."

Murtaza tailed off, but looked up at me as he remembered something else he wanted to share.

> ## "I DIDN'T GIVE UP BECAUSE I HAVE FAMILY, AND I HOPE OF VISITING THEM ONE DAY AND KEEPING THEM SAFE."

"There's another thing, and it's about work. In Greece there are no opportunities, and that makes young people vulnerable to sexual abuse. When I came here in 2020, I slept in this park for two nights. If people come and see you sitting here," Murtaza gestured to the benches in the middle of the square, "they will understand that you have no place to go. They say, 'I will give you this amount of money, and you have to come with me. For sexual things, I will let you sleep in my home.' I have a friend, he didn't have anywhere to go, no house, nothing. He didn't have another choice, he had to do that. After a few weeks he got sick."

Despite the horrors of what he was relaying to us, Murtaza finished our conversation with the English phrase: "If things that are not difficult, and don't kill you, it makes you strong? I think this is the saying." He looked at us across the table and continued. "I didn't give up because I have family, and I hope to visit them one day and keep them safe. My younger brothers and sisters – I want them to go to school. I said to myself, if you want to give up, OK, give up

and sleep on the street. Go and drink alcohol and do drugs – whatever you want. The other option is to do what you can. I choose that option, the second option, to try and learn something. That's how I learnt computer science," he smiled. "I told myself, OK you have to learn something to achieve what you want."

"And what do you want?" I asked.

"My own business and my own family," he replied.

Murtaza's generosity extended beyond his attempts to pay for that lunch, and we spent the next few days together in Athens. We learnt about the projects he volunteers with as a translator and met other members of the Afghan community with whom he was connected. Murtaza had time for everybody, chatting to the kids with a characteristic gentleness. One sunny afternoon he took us on a magical mystery tour of the sights of the city, guiding us with the knowledge and pride of a true local. We hiked the hills around the Parthenon in the afternoon sun, struggling in the unforgiving Greek heat. The incredible views from the top were worth the sweaty struggle.

Above right: Murtaza looks out over Athens from the Parthenon; Below right: Murtaza playing with Afghan children in Athens city centre.

"WHAT IS LIFE LIKE FOR AN LGBTQ+ REFUGEE?"

There is no exact data on the proportion of asylum seekers or refugees who identify as LGBTQ+. For many, disclosing this information could put their lives at risk.

An Iraqi friend of mine who runs a shelter for LGBTQ+ refugees in Istanbul explained, "It's not just painful when people don't accept you for who you are, it can also be dangerous. Many of the residents at our shelter tell us it's the first time they have ever been able to act and behave freely without being judged or attacked. It's the first time they have ever felt safe and free to be themselves."

Another Syrian friend of mine who lives with his boyfriend in Beirut shared with me the moment he was forced to go into hiding after his landlord found out he was in a same-sex relationship and threatened to kill him.

"Being gay in our community is a crime," he explained. "I'm exposed now and I'm in danger. I had to leave immediately. I had to change my clothes, my number and leave everything behind at my house, all the furniture, everything, even my papers. I am now on a protection plan which means I have had to disappear, even from my family. I'm a prisoner, even though I'm not in prison."

The Calais Jungle, 2015.

155

Content warning:
rape, suicide

ABDUREŞID & MUYASSER

"Sometimes we're jealous of the Palestinian people. We're jealous of the Syrian people. Now we are jealous of the Ukrainian people. Why is their voice heard, but us...?"

I have to admit, I was one of these people that didn't know. I'd read a few articles about the Uyghur Muslim minority in China and I knew they were being persecuted, but it wasn't until I met Abdureşid and his wife Muyasser during a trip to Istanbul, that I began to understand the extent of what is happening in the region of East Turkestan, western China, where they are from.

EAST TURKESTAN

"It was in 2014, in the name of anti-terrorism, that China began to say that there are lots of terrorists, Uyghur terrorists in East Turkestan, and they started anti terrorism actions," explained Abdureşid. We were sharing lentil soup and fluffy bread, sitting upstairs in a local Turkish restaurant in the suburbs of Istanbul, where he now lives with his wife and young daughter.

"We began to see lots of men with big guns outside every mosque. They started to ban anything halal. You cannot learn your language in school. You are forced to become Chinese. They were trying to change our identity."

Abdureşid spoke as if he had been waiting for the opportunity to share the horrors his people were living through. Once he began, he didn't stop until we were forced from the restaurant by the staff busily getting ready to close for the night, clearing our table and sweeping around us. We met again the following day for lunch, this time sharing Uyghur food with his wife and daughter in a Uyghur neighbourhood in the city.

"We are from East Turkestan," Abdureşid's wife Muyasser explained to me as she looked at the menu. "West Turkestan is Uzbekistan. I am from a

place in the middle of the desert. It's a really beautiful place and I was really lucky to be born there.

"In my home in East Turkestan, we had lots of grapes and pomegranate trees in the yard. We had fig trees too. And the bread we bake... When we came to Turkey, oh my goodness, the bread was a disaster. It had no taste!" she laughed. "We have lots of bread, lots of types. We like spicy food – we get that really spicy stuff from Chinese culture.

"Our bread reminds me of my childhood. Every time I taste it, I go back to my hometown. My daughter likes pizza, and when she says 'I want pizza', I will say, what about our Uyghur bread? Keeping your culture with your children, it's really important."

The Uyghur people are native to Turkestan, a region in Central Asia which spans several countries. West Turkestan is now known as Uzbekistan, and East Turkestan is part of China (known officially as the Xinjiang Uyghur Autonomous Region).

"A long time ago we were Turkish people and we were speaking Turkish but with a different dialect. Now that dialect has become its own language – the Uyghur language," said Muyasser.

"OUR BREAD REMINDS ME OF MY CHILDHOOD. EVERY TIME I TASTE IT, I GO BACK TO MY HOMETOWN."

Both Abdureşid and Muyasser were patient and thorough as they told us their story and the history of their people, and we hung on to their every word, truly shocked by what we were hearing.

"In 2015, China announced a document that said, there are 75 signs of being a terrorist," explained Abdureşid. "If you have one thing from that list, you may be a terrorist." As we sat round the table we googled the list he spoke of, and read out loud some of the so-called terrorist activities listed in horror. These included having a beard, visiting a mosque, learning a foreign language, visiting Turkey, praying,

Uyghur workers harvesting cotton in China.

fasting, eating breakfast before the sun comes up and even using WhatsApp. The list went on.

"BETWEEN 2014 AND 2015 THERE WERE ANNOUNCEMENTS THREATENING PEOPLE TO THROW AWAY THEIR ISLAMIC BOOKS."

"That same year the Chinese government published a report that said there were a lot of terrorism materials in East Turkestan, like pictures of Palestinians, pictures of Turkey, or something like that," continued Abdureşid. "They gave that report to the international community and told them they needed to do social reform. What does that mean? It means re-education camps. They had to re-educate us in Chinese national identity, also pro-communist policy and Chinese language – basically de-Islamification. We have to be non-Muslim and we have to change our mind about our life and our identity."

"Between 2014 and 2015 there were announcements threatening people to throw away their Islamic books," explained Abdureşid. "They began visiting houses and if they found something, they would arrest you and send you to a concentration camp. They called them 're-education camps'. The environment is like a prison. It is so bad. If you are very ill or sick, the Chinese government doesn't care."

"You know what, in those camps, rape is a sure thing," added Muyasser. "Torture is a sure thing. Abortion is a sure thing."

"So when you say a sure thing, you mean as a woman in those camps you would certainly be raped?" I asked her to clarify, horrified.

"Yes," she replied. "And likely sterilised. Sterilisation was a common thing even before the re-education

camps. They did this a lot. My mother had 10 children and during every pregnancy she had to hide and move around the city. Otherwise you would be captured and even at nine months pregnant they would kill the babies, even after they were born." She paused. "Oh. This is so horrible. That happened all the time. We heard the stories. Lots of people wanted to try and help those women, we tried to rescue them but we were always too late."

I couldn't believe what I was hearing, but Abdureşid continued. "There is also organ harvesting happening in those camps. The Chinese officials are collecting DNA samples of the Uyghur people and taking their organs. They steal them and sell them to someone who needs them."

"Organ trafficking... Oh my God. Oh my goodness. That's one of the things we were always afraid of as children," added Muyasser.

"There is also medicine testing," said Abdureşid. "New medicines. New vaccines. That's how some people are going mad, losing their minds and sometimes losing their life."

Considered by many to be a genocide, the list of human rights abuses against the Uyghur people includes detention in concentration camps, rape and sexual assault, forced labour, forced sterilization and organ trafficking. Up to three million Uyghurs are believed to be detained in 're-education' camps, with the rest living under heavy surveillance.

ABDUREŞID

"I was born in 1994 and I always felt the discrimination," Abdureşid explained. "It was very clear. The police can do anything, they can beat you, torture you. We fear the police as Uyghur people. Even now we have come to Turkey, when we see the police, we think they're someone to punish you, not someone to protect you. At as young as five years old I knew not to make trouble and to get away from the police.

"My family had a clothes shop in the market. From my house to the shop, it was a 20 minute walk. Every time I left the house to go to the shop, my mother was always praying because there were a lot of checkpoints on the way. At the checkpoints, the police can give you a judgement directly, and you can get arrested. One of my friends got arrested for a picture of a man praying on his phone. They said it was something relating to terrorism.

"In 2017, after I had already fled to Turkey, my dad contacted me by WeChat and said 'I am going to the hospital with your brother. I just want to let you know.' We know the hospital was a code word for the concentration camps.

"Later that year, during Ramadan, my dad was arrested with six of his friends, and they were all sentenced to five years in jail. I don't know why. Maybe it's because he was fasting, or maybe because in 2016 he came with me to Turkey and stayed for 10 days. China says that having a relationship with someone outside of China is a sign of being a terrorist. Maybe we are the reason why they are punished. I don't know. The Chinese government doesn't give the reason, only the sentencing."

After this sentencing, Abdureşid was no longer able to contact his family back in East Turkestan. Many social media platforms such as WhatsApp, Instagram and Facebook are banned or restricted, and Abdureşid was using an app called WeChat, but his account was suddenly disabled and he lost contact with everyone back home.

"I am lucky... I have my wife and my child here, but can you imagine? You don't know what's happening to your dad. Is he safe? And what about my mother? What about my brother? Maybe he's also been arrested and I don't have anyone to ask because my friends have also lost contact with their families. You cannot just make a call and ask.

"The most difficult part is the dreams when you sleep. My mother and my father come in my dreams.

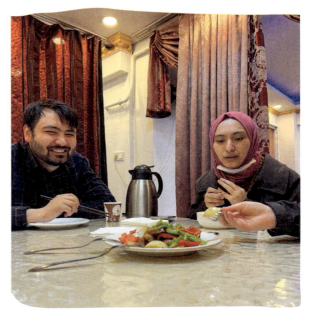

Abdureşid and Muyasser share a traditional Uyghur meal in Istanbul.

Sometimes you are not willing to wake up and when you wake up, sometimes you cry. It's torturous, showing you something but you cannot get near it."

MUYASSER

That afternoon, after our delicious Uyghur lunch of stir-fried broccoli and several other veggie and rice dishes, I took the opportunity to sit down with Muyasser and hear her story.

"HAVE YOU READ GEORGE ORWELL'S *1984*? THAT WAS OUR LIVES THERE, AND WE GOT USED TO THAT."

"Growing up, even inside the house, we were sure that they were listening," she said of the Chinese officials. "Every conversation, every step we took. Have you read George Orwell's *1984*? That was our

lives there, and we got used to that. We were always doing things with caution, looking around the street whenever we walked down it. If we had to talk, we would choose somewhere safe, and never have our cell phones near us when we were talking about gatherings or learning things.

"The books that we were supposed to learn in school were full of shit, really. Excuse my language. That kind of education and brainwashing was everywhere, but we still managed to come back from the ashes.

"I had a really wealthy family so I didn't get as much pressure as most women in the Uyghur community, as in China they're corrupt. If you have money, you can do anything there, so that's why I had a rather free and admirable life."

Even so, Muyasser grew up judicious of Chinese authorities. "When I look back now I can see that I feared them, but in that situation, I didn't realise. I learned things at a really young age. I remember being two years old and seeing many Chinese police breaking into our houses and arresting my uncle's friends in front of my eyes.

"That was during the cultural revolution when they were destroying everything – mosques, buildings, everything. They wanted us to put away our identity, put away our religion, put away our cultures, everything. Lots of people were killed.

"No one was educated well. Before that, we had lots of schools. In our culture, studying is a must for every Muslim man and woman; you have to be capable of reading so you are capable of learning. But they were seeking out our religious scholars and we hid some of them in our house. I saw the police grab my uncle and push him against the wall that time. My mum was making traditional food in a big pot. They gathered all the men in our house and took them to the police station. I remember so clearly that the police officer wouldn't let my mum bring the food for them.

"I was maybe two years old. That was a big trauma for me. I was feeling frustrated all the time. I wanted to release my family members. I remember them behind bars, holding onto the iron. I didn't understand. I remember holding my mother's hand. I must have been so little but I remember this really clearly. I don't know why.

"I REMEMBER BEING FOUR YEARS OLD AND STARTING TO READ TRADITIONAL FAIRY TALES ABOUT UYGHUR KINGS, PRINCES AND PRINCESSES, AND I WOULD THINK, WHERE ARE THEY ALL NOW?"

"I remember being four years old and starting to read traditional fairy tales about Uyghur kings, princes and princesses, and I would think, where are they all now? As I got to about five or six I started to realise, we had kingdoms before. What happened?! I kept asking those questions. I realised my country was occupied from a really young age.

"Some of my earliest memories are the letters we got from friends and family members in prison. My father would gather everyone into one room and read the letters. People were crying because their precious brothers and sisters were held in the prison. The cleverest people were captured first and tortured in prison. The people who can speak really well and who read lots of books and who can do lots of things. That's why we were really worried all the time. We knew that they could come and break into our house any time they wanted. That's why I have anxiety. I had really bad anxiety when I lived there. I grew up with it. Like, if someone knocked on the door, I was prepared.

"I've been in Istanbul for two years now and the sound of the sirens of the ambulance is still a scary thing to hear. I'm getting used to it, but I always worry, 'what's happening!?' I know it's the trauma. It's

still haunting me. I'm trying to heal myself. I listen to lectures and they help me know the problem.

"Most of the Uyghurs are telling the same story," she said. "We're dreaming about our homeland. Now I'm here, when I'm wearing my hijab, I fear they will capture me. It's that kind of fear. I still dream about those things."

"It was always my dream to leave because I wanted to be a scholar and I wasn't getting a proper education at home," explained Muyasser. "I had really big dreams because my father protected and encouraged me. He told me that if you are giving knowledge to people, you will be respected and have a really good life. He always gave me women scholars as examples. So ever since I was a little girl I wanted to go abroad and study, but getting a passport is really hard."

"I NEVER GAVE UP ON MY COUNTRY. I WOULD GO BACK BUT IT'S GETTING MORE AND MORE DIFFICULT."

When I asked Muyasser if she dreamed of returning to East Turkestan, her answer was certain. "Always. I never gave up on my country. I would go back but it's getting more and more difficult. I feel fearful of losing people again because I lost so many. I had a big family that gave me pure, unconditional love. I have dreams about them all the time.

"I've lost many previous friendships too that felt like brothers and sisters. I lost contact with all of them at once. Most of them were captured and are in concentration camps. No one knows about them.

"One of my teachers had five daughters. Her dead body was sent home from the concentration camps three years ago. Her and her husband were

relationship goals for everyone. They had a really beautiful, really happy family. They respected each other very well. Then their family was destroyed. Now I am a mother, I feel these things differently.

"My best friend was in a concentration camp for three years and she recently got released. When I saw her picture I was like... Oh my goodness. I can't explain the feeling. I miss my hometown so much.

"Homesickness is a really painful thing. You know, sometimes I feel like I'm in my kitchen back home, just preparing a meal, like I'm back in that room. Making plans to meet some of my friends, going to school. It's so painful. Extremely painful. Sometimes I wake up with extreme pain in my chest. I sleep with that pain, like all my family history, the genocide, the people who died in the war. To some, they're just numbers, but when your people are suffering, it's not just numbers. They all have loved ones.

"I really love my husband. It would be so hard to lose him right now, or for him to lose me. We are lucky to have each other now, but it's no guarantee. To love is to always live in that fear of losing.

"I often dream about my friends. In my dreams they look tired and tortured. They're really thin, but I'm still really happy to see them. I want to speak with them but they're worried to see me. When I wake up, I used to feel really devastated, but nowadays I'm not as devastated any more. I continue to live, and I am learning how to find peace with the pain.

"I'm now in a good state of mind. Last year, I didn't feel any joy or any happiness in my life. I was really tired, exhausted all the time. But this year, I don't know how, but I can feel joy. I can feel happiness. I can feel the strength in me to do better things.

"Now I'm learning more about history, I'm seeing the world clearly. People don't do things just with kind hearts. They choose to do things that benefit them most. It's really the truth of life, and the truth of this world and the truth of the system that we're living in right now. So I don't have much hope."

"You know what? I'm really open minded. I don't judge people; I can accept any kind of people in any kind of religious identity or any kind of life. I will respect everyone's choice and I want that to happen in the world that my daughter will live in. I am raising her that way. I am raising her not to judge and to love unconditionally, to give help to other people. Our lives are based on that. Tolerance. Religious tolerance, political tolerance... that's the sign of civilization, right? I hope that will be spread across the world so we can live in a more harmonious way.

"We're not needy people. We're not weak. Culturally, we're really humble people who will open the door to anyone. But we're also stubborn. My people have strength and their light shows that they never quit. They never gave up.

"We don't cry all the time. If Syrian people are having a wedding and they're dancing, it doesn't mean there is no war in their country. We mustn't deny them the right to be happy. Do people want them to be sad? Should we cry all the time? We mustn't neglect this part that needs joy."

"Right," I agreed. "You can feel so much pain but still have the capacity to feel joy. Still laugh. Still smile. Still love."

"Because we're human," Muyasser said. "We're human and we have needs."

Jaz with Muyasser (far left), her daughter and other members of the Uyghur community in Istanbul.

NOOR

"Even if every doctor in the world tells me I won't walk again, I know one day I will. I will fight to walk."

From the moment I met Noor, I wanted her to be my friend. She has a naughtiness about her, a cheeky smile she flashes after speaking, often accompanied by a giggle.

Noor is one year older than me, but has lived a very different experience up until now. I first met her in 2016, in her home in a predominantly Syrian neighborhood in the city of Izmir, in western Turkey. Izmir has always been a transit hub for asylum seekers attempting to cross from Turkey to Greece via the short stretch of Aegean Sea that lies between them. On a clear day, you can see the Greek Islands of Lesvos, Chios and Samos on the horizon, and regular ferries run between the two countries for just a few Euros a trip. It blew my mind to see these journeys advertised to tourists on notice boards outside travel agents, knowing that people who didn't happen to possess the required documents were risking their lives in rubber dinghies to cross the very same stretch of water.

Noor was one of these people. Having grown up in Damascus, she didn't have the visa required to enter Europe legally, but she had attempted the journey three times by the time I met her in Izmir. Noor urgently needed medical care, which wasn't available in Turkey, because she had a dream and a goal: to walk again.

When I met Noor she was using a wheelchair and suffering from severe pain in her legs and hands, leaving her unable to move them. But this hadn't always been the case. As we sat drinking sweet tea on her living room floor, her older brother Ahmed proudly showed me pictures on his phone of his little sister running and dancing freely.

While Noor's mum Amal prepared a feast of stuffed vegetables on the floor next to us, feeding me bits of the rice mixture with her hands as she went, Noor told me her story.

SYRIA

"I had a normal life. A beautiful house. Syria was so safe before the war. I was a student at Damascus University. It's very famous because it's so old. I was studying law. It was my fourth and final year and I'd just finished an exam. I was waiting for my friends who study biology to finish their exam and come and meet me..."

"I HAD A NORMAL LIFE. A BEAUTIFUL HOUSE. SYRIA WAS SO SAFE BEFORE THE WAR."

As Noor spoke, I sensed that what she was about to tell me was not easy for her to relive.

"As they walked towards me, a bomb hit our university," she said slowly, closing her eyes before continuing. "I saw my friends fly into the air. I fainted and I woke up in the hospital. My friends all died. After that, I couldn't walk."

It seemed that Noor's nervous system had gone into shock from the trauma of what she had witnessed. "They did every test," explained Noor. "They said my brain was normal, my spinal cord was normal. They couldn't understand. After that I was so sad, so tired. I entered into depression."

Noor was 23 when this missile attack happened at her university. She had been planning to specialize in criminal law and had dreams of being a judge or working in the United Nations.

"The few doctors left in Syria found my condition complicated and hard to understand," Noor told me. "My body got weaker, my feet contracted, and now I'm in a wheelchair."

Noor with her mother, Amal.

Not only did Noor have her deteriorating health to contend with, but she was soon forced to make a difficult decision. Her father's health was also waning after he suffered a heart attack from the stress and fear of living in a conflict zone. It seemed impossible for the whole family to leave Syria together. They decided that Noor would leave in search of medical assistance accompanied by her mother and her brother Ahmed, leaving her other two brothers in Syria to care for their father. This heartbreaking choice to split up their family gave them all the highest chance of survival.

"My father can't walk now either, so he couldn't make it to the border," explained Noor. The only way for him to leave Syria is by plane. He always cries on the phone telling me, 'I miss you, I miss you.' When he cries, I cry with him. I don't know what I have to do."

Noor's mother Amal, her brother Ahmed and a family friend carried Noor across the border to Lebanon on their backs, to avoid making noise that might alert the army to their presence. They spent the following three and a half years in Lebanon, living

in a difficult situation and witnessing Noor's health rapidly deteriorate. It became increasingly clear that Noor needed an operation and proper medical advice, so they continued to Turkey in the hope of making the dangerous journey to Europe by boat.

TURKEY

The first time the family attempted the sea crossing, it was the middle of winter, January 2016. The inexperienced driver (a fellow refugee) soon hit rocks and the boat sank. Noor lost everything she owned, including her passport and medical records in the depths of the Aegean. Unable to walk, let alone swim, and only wearing a flimsy life jacket, she faced death right in the eye.

"I thought that was it," she said. "I was so scared, but [the Turkish authorities] saved me and brought me back to Turkey. Then they put us in prison and we didn't eat for days. Since then my condition has been even worse."

It seemed that stress and fear only exacerbated Noor's symptoms further. After a third failed attempt at the sea crossing her family decided to explore another option.

Life in Turkey was hard. Though they lived in preferable conditions to many other Syrians who survived in tents in the rural areas surrounding Izmir, Noor's family struggled to pay rent and put food on the table. With Noor's brother Ahmed also suffering from shock and PTSD, none of the family were able to work. Their unforgiving landlord made it clear that there were other families keen to take their place.

The narrow, even roads of Basmane, the district where they lived, were not easy to navigate with Noor's cumbersome old wheelchair. A missing footrest meant she had to lift one leg over the other to stop her foot from dragging on the ground, and

> **NOOR IS THE BIGGEST SOCIAL BUTTERFLY I KNOW, AND THIS SERVED IN HER FAVOUR WHEN THE ENTIRE COMMUNITY HELPED HER OVER CURBS AND UP HILLS.**

limited movement in her hands made it impossible for Noor to maneuver the bulky chair herself. But Noor is the biggest social butterfly I know, and this served in her favour when the entire community helped her over curbs and up hills. Not long after we'd first met, we were able to fundraise for a new, electric wheelchair for Noor which gave her the autonomy and freedom she so craved.

One evening, we were sitting among a big group of Syrians and international volunteers on the grassy

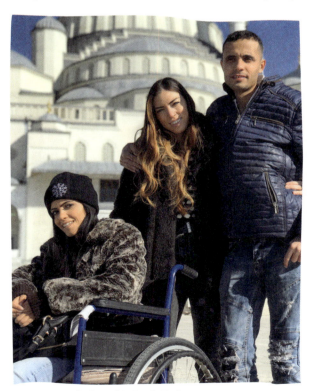

Noor, Jaz and Ahmed in Izmir, Turkey.

promenade along Izmir's seafront, eating stuffed mussels and cig kofte, as many of the locals do on the long summer evenings in the city. As we were chatting, we were approached by a young man who started shouting. Noor translated for me.

"He's telling us to go back to our own country," she rolled her eyes. It was clear his outburst was directed at the Syrians who had been forced across the border rather than the many foreign volunteers. Noor shrugged it off. "Maybe one day he should experience what we've experienced," she smiled. "Only then will he know."

Once when I visited Noor, we took a day trip to the beach. Unable to run into the sea, Noor was carried to the water's edge, as her wheelchair would have gotten stuck in the sand. I was inspired by her bravery as she battled with the painful memories of her last encounter with the ocean, determined to go for a swim. She was strong, yet vulnerable; doggedly determined, yet trapped by her body and her circumstances. Never a victim, she was forever positive, despite her life being jeopardised by decisions outside her control: a war that was nothing to do with her and borders that someone else decided to create.

> **"ONE DAY THAT WILL BE ME FLYING HIGH, FLYING TO ANOTHER COUNTRY SO I CAN HAVE TREATMENT AND FINISH MY STUDIES. SO I CAN START A NEW LIFE."**

A plane flew overhead and Noor pointed towards it, shielding her eyes from the sun with her other hand. "See that plane?" she asked me. "One day that

Jaz and Noor in Izmir, Turkey.

will be me flying high, flying to another country so I can have my treatment and finish my studies. So I can start a new life."

Two years later, her words came true.

CANADA

Canada is one of the only countries I know to have a programme where you can privately sponsor the relocation of a refugee family. The process is slow and bureaucratic: the five sponsors must live within a certain radius of each other, and the refugee family must have £15,000 (CAD $24,427) ready in a Canadian bank account to be eligible. Noor met a Canadian volunteer who helped coordinate five sponsors, and together with our amazing online community we raised the money needed. In November 2017, I flew to Ankara to accompany Noor to her interview at the Canadian embassy. We spent an emotional few days going between medical appointments and official interviews, eating late night pizza in our apartment. On the last day of the trip, their application was accepted and I flew home in a whirlwind of excitement.

I went back to Izmir several months later for Noor's final days in Turkey. An integral part of the community, Noor's home had an open door policy with people constantly coming in and out or chatting to us through the open windows. On muggy summer evenings we would sit on the front steps, playing with the stray cats and sharing tea and biscuits with the neighbours.

I arrived with a giant box of baklava from the local bakery and found Noor's mum in the midst of packing up their entire lives. I wondered what this traditional Arab mum would make of tiny St John's in Canada. How she would weather the winters. Whether she would learn English or meet other Syrians. Whether she would be able to find the ingredients she needed for her incredible cooking.

I sat next to her on the floor, folding clothes as she was intermittently interrupted by more neighbors showing up with food, gifts and words of encouragement and support. It was clear that Noor's family represented hope for so many people within that community. Their opportunity represented a brighter future and a light at the end of the tunnel.

A group of us waved Noor off at Izmir airport with tears in our eyes, not knowing when we would see her next. A few hours later, I got a call from her. Noor was phoning from her layover in Istanbul. She had some bad news. While on this internal flight her father back in Syria had passed away.

"He was holding on until I was out of there," she sobbed down the phone. "He could finally let go now he knows I am safe."

Noor on her flight to Canada.

Noor has now lived in Canada for nearly five years. Things haven't been easy but she remains strong. When I ask about her health, she tells me: "Even if every doctor in the world tells me I won't walk again, I know one day I will. I will fight to walk. In my dreams I don't see myself in a wheelchair, I see myself walking. I will walk and become a judge."

DENMARK

AFGHANISTAN

KHALIDA

"All the decisions of my life as a woman, or any woman in Afghanistan, are in the hands of men. This country is not just built for men. It's also built for women."

Khalida is an absolute powerhouse. I'd known about her work for a while through social media, but it was during the fall of Afghanistan to the Taliban, in the summer of 2021 that I came to really understand the level of her heroism.

Khalida grew up playing football with her brothers in Afghanistan and went on to dedicate much of her life to women's rights and equality within the sport. In a country where women endure many restrictions, she faced serious discrimination from her community as a result.

"It's a beautiful journey when I look back," Khalida told me wistfully. "I've had a lot of challenges and ups and downs. My life has been a rollercoaster."

AFGHANISTAN

"In Afghanistan, football is a national game and everybody plays," Khalida told me. "Football belongs to people who really have very limited opportunities. It's for everybody, no matter which status you have or which level in society you are – the game is for you. You can have a goal with stones and a ball made from socks. Just something round, and then you just play. You don't need a proper uniform or proper shoes. You just play football and enjoy."

Growing up amid ongoing conflict and uncertainty, football was an escape for Khalida. "I remember a little bit of Afghanistan when it was beautiful," she said, "but apart from that, there was war. The first year of school, I was so much looking forward to going, but then the civil war happened and no one could go to school. People were displaced and there were a lot of bomb blasts. When I was in second grade, the Taliban came to power in

Afghanistan and they announced that women and girls were not allowed to go to school or to work. Women and girls weren't allowed to do anything."

Khalida struggled to understand this new reality. "How come half of the population should be deactivated? Removed from society?" she asked. "As women and young girls, we had no part in the war. Our voices were not heard. We were not part of the decision making, so how come they decided for us and banished us from society. I kept asking my father, 'Why am I not allowed to go to school!?' He had a difficult time answering me without making it political. He was trying, but he couldn't answer me."

Khalida came from a well educated, open-minded family who upheld equal treatment of men and women as one of their core values, as well as freedom of speech and expression. "Then all of a sudden, society put that pressure on us that we should belong in the kitchen, we should belong in the home, whereas my father, mother and grandparents were quite against that.

"I hate being in the kitchen," exclaimed Khalida. "I only like to be in the kitchen when I'm hungry. I like checking the refrigerator 10 times a day and I love food, but when someone else is making and I'm eating. Why do you keep telling me I belong to the kitchen? It's not inherently inside me. I cannot even make an egg! I can't even cook for myself, let alone for other people!"

Freedom can be a dangerous thing to believe in. With their views so opposed to those of the Taliban, Khalida's family were forced to flee Afghanistan to survive.

PAKISTAN

"We moved to Pakistan as refugees," Khalida explained. "We left our home, we were on the streets, with blankets. I started working quite early, around nine years old. Everybody was working. I was a shopkeeper."

While seeking refuge from the Taliban rule in Pakistan, Khalida managed to make one trip back home with her grandma. "It was so scary," she said. "The Taliban were beating everybody. They were leading with fear. Even if you weren't wearing socks – for example, even if a woman was covered from head to toe in a burqa but it was a very hot day and she was wearing sandals with no shoes – they would beat her. They would use lashes. I remember. I have those pictures in my mind."

During her years in Pakistan, Khalida played both football and cricket, her active family always encouraging an embrace of sports. In 2001, when the Taliban regime was overthrown, the family decided to move back home to Afghanistan.

"Everything was so different," remembered Khalida. "It was like a ghost country. You didn't see women in the street. They were still worried about the return of the Taliban, so they still wore burqas, but I just couldn't. I really had a difficult time wearing a scarf or a hijab. I just had a difficult time keeping it on my head. It was everywhere but on my head. I wasn't against it, it was just a challenge for me because I was so active. In school one day my teacher told me that he would bring a nail to school and hammer my scarf onto my head."

"Why are you concerned with my hair! Go and do your job," she said to him with her trademark resolve.

Despite the fact that she was now allowed to go to school, Khalida still felt stifled by the protocol of her country. "Life was just difficult for young girls there," she explained. "Go to school but afterwards, go straight home and do kitchen things, and prepare yourself to get married, to get selected by a family for their son. I hated it. I was so against it." So Khalida took to the streets with her ball and started to play. "Which was not acceptable," she rolled her eyes. "By

this time I was a teenager and my body was more feminine. The neighbours started giving me a bad time, calling me a prostitute and telling my brothers they were not real men. They were harassing and abusing my brothers for letting me play with them." So Khalida was forced to stop playing the sport she so loved.

"I had to find a way to continue playing football," she smiled, "so I found a team within walking distance to where I was living and came up with an idea to hide my identity. One of the coaches was fantastic. He helped me go undercover. I wore extra sized clothing and a cap to hide my hair. I looked like a boy. I don't have a very feminine face and we decided that if we go to the training 10 minutes late

and leave five minutes earlier than everyone else, the boys wouldn't get the chance to talk to me. They wouldn't have the opportunity to discover who I am, and that I'm a girl."

"I WORE EXTRA SIZED CLOTHING AND A CAP TO HIDE MY HAIR. I LOOKED LIKE A BOY."

This plan brought Khalida so much freedom and joy. "It was fantastic," she laughed. "The boys would scream at me if I missed the ball but I couldn't shout back. I had to avoid talking so I tried not to make any mistakes on the pitch. Because I never used my voice, they thought I wasn't able to speak. They were

Khalida (right, wearing orange) and other members of the Afghan women's football team in 2007.

173

The Taliban supervising sports lessons at a school. Only boys are permitted to take part.

really curious to find out who I was." Then one day, one particularly curious boy tried to follow Khalida home and discovered the secret she'd been hiding.

"CULTURES ARE MADE BY PEOPLE. THAT MEANS PEOPLE CAN CHANGE CULTURES AS WELL."

"He went back to the team and told them," sighed Khalida. "The coach called me and told me that it was too dangerous for me to continue training. He was very sorry and very sad, but I was not going to stop, no matter what. They cannot decide for me what to do. Cultures are made by people. That means people can change cultures as well."

Khalida rallied together a team of girls at her school. "My mum was my physical education teacher so she jumped on board to help us when we had the conversations with the families. It was tough. My mum had to argue why it's important for girls and women to play football and do any sport or be

physically active. She had to explain that it's nothing against culture or religion."

Yet still, the girls had to train in hiding. "I don't know why because we were just playing for fun, playing to be together," explained Khalida. "We didn't have a kit – we were playing in our school uniform. Our school bags were the goal and we had an old, crazy ball that I called 'magic ball'. We were having an amazing time until we were attacked by a group of young men from outside the school who found out we were a group of girls playing football. They jumped the wall that surrounded our school and they were so aggressive and angry. They started yelling and using a lot of bad words like prostitutes, crazy women. They took the 'magic ball' and destroyed it.

"I was hurting so bad," she continued. "I was used to those words so they weren't getting under my skin, but it was when they took the ball and used a knife to destroy it. They were walking around insulting and harassing us. They took our school bags and ripped our books apart, to create fear among the team. We had many young girls among us. I was so furious and frustrated. Our happiness turned to heavy sadness. It was a big wake up call to the reality of the situation for women in Afghanistan."

A natural leader, Khalida was not about to give up. "I stood up and I said, 'We have two choices'," she told me. "'One, we give up, we go home, cry and complain to our mothers and fathers and never come back and play. The other choice is, no matter what, however many times we get these types of attacks, we'll stand and prove that girls can do any type of sport. We stand, not for ourselves, but for our sisters around the country.'"

Khalida lost some of her players after the attack. "They were scared," she explained. "They didn't want to lose the opportunity to go to school. It was too big a risk for them. I think for me, when I look back, it was the support from my family that gave me the confidence to take the initiative and decide that no

matter what, we're doing this. We started a campaign and went to other schools to talk about what we were doing. That movement was born out of so much frustration. We wanted to change the culture. We wanted to change history. That was very clear."

"Khalida, did you ever feel fear?" I asked her.

She contemplated. "I had nothing to lose. If I don't fight, I would lose the only thing I have – the freedom I get through football. If they take that freedom, I will not have anything. Every time I enter the pitch, it helps me forget the actual moment I'm in. Everything else – the pressure from society, the insults, the disrespect – is off the pitch. That's the freedom I wanted. The freedom in my mind, the freedom in my body to enjoy the moment. I had the fear of losing that and it was that fear that pushed me to fight for it."

It took a few years before Khalida's team was recognised by the football federation, but eventually, in 2007, they became the national women's team of Afghanistan.

"It was the most beautiful moment of our lives: the minute we wore the jersey of Afghanistan, the badge on our chest, the name of our country," Khalida smiled. "I don't know what it feels like to win the World Cup, but for us, that was the most beautiful thing you can feel. When, our national anthem was played, we were just standing there crying. Now our national anthem doesn't represent just the men of Afghanistan, now we can represent our country too. Our sisters back in Afghanistan could see us on their TV. We didn't play football for the sake of the game, we played to take actions to stand for things much bigger. Football was giving us the platform to represent the freedom of our sisters."

In 2009, Khalida became the head of women's football in Afghanistan and the first female board member of the Afghanistan Football Federation – their first female employee since they were established in 1922. From her position of power, she

began hiring as many women as possible, and using any media opportunity to speak about the corruption and the abuse of power in her country. But this wasn't without risk.

"Every time I was raising my voice I was receiving death threats and warnings," she told me. "The stronger my voice was getting, the more I was losing my freedom. I couldn't walk around the city... I had to have someone with me all the time. I was receiving continuous phone calls, threatening to rape me, kill me or put my family in prison to silence me. I was physically attacked by gang men. That's when I knew this was getting really serious and if I continue in my country, I will lose not just my voice but my life."

Khalida was faced with a difficult choice. "If I leave, I can save my voice and I can do much more," she reasoned. "No matter where I am physically, I can always make a difference." Khalida made the decision and left overnight.

"AS A REFUGEE, LIFE IS UNKNOWN AND UNPREDICTABLE. YOU'RE HANGING IN THE AIR LIKE A DOLL BUT YOU DON'T HAVE WINGS TO FLY, AND YOU DON'T HAVE GROUND TO STAND ON. "

"I've had panic attacks, nightmares, anxiety attacks. I ended up in different refugee centres in Europe. Life as a refugee is extreme on so many levels. You have no identity," she said. "You've lost everything. The future's not clear. You don't know what is waiting for you. As a refugee, life is unknown and unpredictable. You're hanging in the air like a doll but you don't have wings to fly, and you don't have ground to stand on. That's the challenge and the frustration because nothing is clear."

Khalida's mental health suffered as a result. "I got really deep depression. I felt that my life had no meaning. I was in the middle of nowhere in a refugee camp in Europe, on my own. I was saying to myself, my dream was to serve my people, to be with them. My dreams were within my country. Every time I dream, my dreams are in Afghanistan. Even the people I know from here in Denmark, my dreams bring them to Afghanistan. Feeling lonely, feeling lost. It hit me so hard. I felt like I lost my purpose and I have to end this life.

"NO MATTER WHERE I AM, I CAN STILL MAKE A DIFFERENCE AND EMPOWER PEOPLE."

"It was when I witnessed a few ladies in the centre try to commit suicide that everything changed. In that moment, I connected back with my purpose and thought, no matter where I am, I can still make a difference and empower people, support people to overcome their challenges. That's when I stopped thinking about ending my life and started encouraging more women and girls to come with me and play football.

"We started running, swimming, biking and playing football in the centre. Sport helped to take us away from day-to-day life for two or three hours, and find solutions together to better our mental health. It helped us to share the common pain and focus on something different."

When Khalida was granted her asylum in Denmark, she started the organisation Girl Power to use sport to empower women and girls from marginalized societies, and build a bridge between two divided communities such as refugee and European citizens, all the while continuing to support her women's teams in Afghanistan.

In the summer of 2020, the Taliban took control of Afghanistan once again. Khalida was instrumental in evacuating not just the national women's football team, but more than 300 others – mostly women in football and their families.

"It was so emotional for me because I was traumatized," she said. What was very, very difficult for me was that I couldn't sleep. I had to support my players to not give up, while I'm in Denmark in my perfect world. I'm guiding people to make a decision on what to do, where to go, how to stay together, in a crisis where one decision can change lives. I was hearing gunfire on the phone, people crying and screaming, and telling them, 'You must leave NOW'. It was a huge responsibility on my shoulders, let alone dealing with my own emotions seeing my childhood repeating itself. I'm so happy and so lucky that this didn't end up as a failed mission and we didn't lose a life."

"Unfortunately there is no life for women and girls in Afghanistan now," Khalida told me. "Women are imprisoned in their homes. The women and girls who went to school, got their education and dreamed of becoming artists and singers, they are abandoned at home. Those who are divorced and want to be an independent woman, are forced to live with a man, as you can't live alone and be single, otherwise you must marry a member of the Taliban. They are banned from school, from sports activities. There are searches, home by home, where the Taliban are identifying human rights activists or feminists and they are getting raped and killed. That is the situation and it's terrifying. I have people with whom I am connected on the ground and they are afraid of losing their life. This is what is happening and

unfortunately the world is turning the other way and forgetting the people of Afghanistan. The women of Afghanistan feel abandoned by the world."

"THIS IS BIGGER THAN ME. SOMEONE HAS TO TAKE SACRIFICES SO SOMEONE ELSE CAN HAVE THOSE OPPORTUNITIES."

Yet Khalida's heart has never left her homeland. "I've never lost my connection with my country," she said. "I'm going to change the culture, the mindset. What has helped me to not give up is that this is not about me. This is bigger than me. Someone has to

take sacrifices so someone else can have those opportunities. In a harsh way, someone has to take the bullet so that change happens. Change always takes sacrifice and that's my motivation."

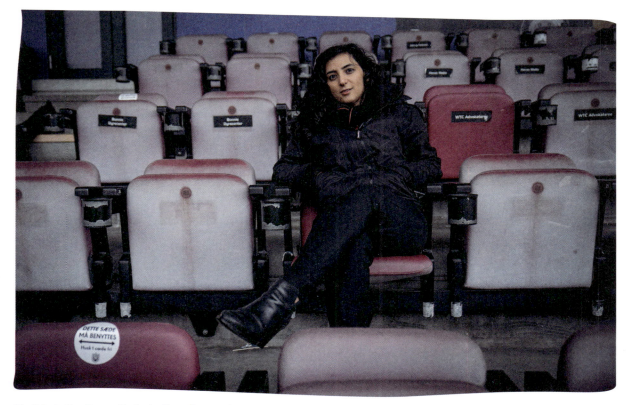

Khalida in the Farum Park stadium, Denmark.

USA

VENEZUELA

MARISELA

"Most of the people protesting on the streets are young people. We're fighting for something that we haven't ever lived."

Seven million people have fled Venezuela, rendering it one of the largest migration crises in the world, second only to Syria. I was introduced to Marisela, a Venezuelan living in Washington DC, by a friend of mine and we instantly connected. I'm honoured to include her story in these pages.

"I was a journalist in Venezuela," Marisela told me. "I ran a radio show during which we would interview people and discuss important topics. It was an hour long and during the last 15 minutes of each show we would open the lines and take calls from listeners. Those conversations used to be full of ideas and creativity, but in recent years, that 15 minutes began to change.

"People began to call in crying. I distinctly remember the desperate voice of one older woman telling us that she lived alone and had low blood sugar and no money for food or medicine. 'I'm going to die,' she said over the crackly line. 'I'm calling this radio show as my last resort to ask for help.' Those kinds of calls began to happen more and more often, until they were every day. That's when I said to myself, 'something is happening in my country and I need to do something about it.'"

"So what was happening?" I asked, trying to understand. Being based in the UK, most of my work in this space has been connected in some way to Europe, meaning my knowledge and experience when it comes to causes of migration in South America is not as extensive.

"From my point of view, it started when Hugo Chávez came into power in 1998. I was just 13 years old. He died in 2013 and was followed by Nicolás Maduro from the same political party. Together,

they've been in power for more than 22 years. They rule the country with no freedom, no rule of law and no human rights. No food, water, electricity, gas or access to basic services like the internet. I remember standing in line for six or seven hours outside the supermarket just to buy a bottle of milk. Most Venezuelan people collect rain as their only source of water."

Maduro's government is hotly disputed, with many suggesting that his re-election in 2018 was the result of rigged polls. Many countries, including the US, refuse to recognise Maduro as president. It is not uncommon for Venezuelan critics of Maduro's regime to be imprisoned or to disappear.

"It happened step by step," continued Marisela. "I cannot tell you the moment that suddenly everything collapsed. It wasn't like that. Every year things got gradually worse. Everything just slowly unravelled."

Chavez's socialist regime, though initially intending to reduce inequality, sent the Venezuelan economy into freefall. Since then, it has gone from bad to worse, with prices soaring to unaffordable levels for even the most basic goods. A report by *Bloomberg* showed that the price of a cup of coffee in the Venezuelan capital Caracas increased by 2,597

"EVERY YEAR THINGS GOT GRADUALLY WORSE. EVERYTHING JUST SLOWLY UNRAVELLED."

percent from August 2020 to August 2021.[6] Venezuelans have been protesting the regime for decades, culminating in the "Mother of all Protests" in 2017, which involved up to six million people.

"Can I tell you one thing that I think is amazing though?" asked Marisela. "I don't know if this is too romantic, but Hugo Chávez came into power when we were young, right? Well, most of the people protesting on the streets are young people. We're fighting for something that we haven't ever lived."

Against the backdrop of this humanitarian crisis, Marisela felt she had to take action. "It wasn't enough just to be a journalist," she explained. "Yes, it's important to keep Venezuelan people informed while there is so much censorship in our country, but I wanted to do more."

In 2016, she gathered a few friends who felt the same way, and together they founded an NGO called Humanitarian Action, supporting low income families in rural areas of Venezuela.

"According to the UN, over nine million people are living with hunger in Venezuela," she said, "so we focused primarily on food security programmes. We have 12 kitchens in four states and we support more than 1,500 people. We feed them every day. We're also teaching people how to produce their own food: beans, corn, rice, coffee, lettuce, zucchini. They have the land and we want to reduce their dependency, not only on our non-profit but also on the regime."

LEAVING VENEZUELA

"My partner David is a politician standing against Nicolás Maduro's party. He used to be a mayor in Caracas until he was illegally removed from office. By 2018, it became clear that it was too dangerous for him to stay in Venezuela. First he went into hiding for one month before deciding to leave through the Brazilian jungle."

Many Venezuelans fleeing the country's extreme deprivation and political instability find themselves crossing the border into Brazil. It's a long journey, crossing sparsely-populated jungle terrain to arrive in Brazil's northwestern city of Pacaraima exhausted and hungry. The border is a hub of illegal activity, and the threat of violence, sexual assault and human trafficking looms large.

"I can say that that time was one of the hardest of my life," Marisela described the pain of waiting for David to reach safety. "It was the fear I was living with. The regime was after him and there were two warrants out for his arrest.

"While he was hiding in Venezuela only three people knew where he was and I was one of them. I had to pretend to go on as normal to try and stay safe. If the regime couldn't find him, they would soon come for me. I went back to my childhood home and the only way I could get to sleep was with my mum lying next to me. She never asked me any questions about David, but mums always know.

> **" I WENT BACK TO MY CHILDHOOD HOME AND THE ONLY WAY I COULD GET TO SLEEP WAS WITH MY MUM LYING NEXT TO ME."**

"My mind was all over the place," continued Marisela. "I would be sitting here talking with you, but my thoughts were with David, wondering how he was. When he decided to leave, he had to make it through a lot of checkpoints. He had the idea to dress up as a priest and asked the church for permission to do so. He travelled with other people

Page 180: Marisela as a child in Venezuela; Left: Marisela sorting clothing donations for Venezuelan refugees in Washington, DC.

Marisela as a child in Venezuela.

who pretended they were heading to Brazil with their priest in the car. We're so grateful for them because they took a huge risk for their own lives and safety, and their families as well."

Marisela decided to leave six months later. "I was able to travel to DC by plane. I got a special visa and we were reunited for the first time in six months."

But Marisela's journey was different to the experiences of her fellow Venezuelans. "I'm not the normal Venezuelan asylum seeker," she told me. "Because my partner is a politician and I'm a journalist it was easier for us to get legal status here in the US, but for most people it's very, very hard. Most don't have the privilege that I had to fly here. That's why millions of Venezuelans are walking the whole continent through Colombia, taking boats to Panama, walking through the jungle, passing the Darién Gap to Costa Rica, Nicaragua, then all the way across Mexico to get to the US border.

"The things I've heard about this journey... it's so horrible," Marisela looked down at her hands. "I've cried thousands of times this year listening to stories of the many women who were sexually assaulted in The Darién Gap [a 66-mile stretch of jungle connecting Panama and Colombia, and one of the deadliest migration routes in the world], not only by one man, sometimes seven men at the same time, in front of their husbands or boyfriends or partners. And the kids, the Venezuelan kids, what they have seen. They want to cry. I want to cry, so often we cry together."

Marisela wiped her eyes as she continued. "We have a country. Venezuela. A beautiful country. So there is no need to live this kind of experience."

Marisela's family are still living in Venezuela. "My mom is a teacher and my dad is a university professor," she told me. "He has a masters and a PhD in history. My mom's salary is $10 per month and my dad's is $30.

He's working and teaching in one of the most prestigious universities in Venezuela. I have to send them money to cover their food, water and health insurance every single month. They're OK because they have me living outside of Venezuela, but without me I don't know what would happen.

"No one is safe in Venezuela. Caracas is one of the most dangerous cities in the world. Just going to the supermarket or to work, anything can happen to you. When people are desperate they do desperate things, especially when there is no rule of law and you can do whatever you want without any consequences. It's a mess.

"If you're against the regime it's even worse," continued Marisela. "The regime wants to control you, so if you are enrolled in their political party, they give you food and coupons for the gas station. One time my dad called me crying. My dad is a tough guy, he never cries for anything. But he said, 'Marisela, I would rather die than enrol in this political party. I won't do it. I'm calling because I don't know what the consequences will be, and to tell you that I love you.'"

THE USA

"When I came to the US, I was very, very tired. I was exhausted," said Marisela. "I thought to myself, OK, no more politics for a while. It took some time, but in 2020 I decided to register our nonprofit in the US so we could help not only Venezuelans inside Venezuela, but also Venezuelan migrants and refugees here in Washington, DC.

"One of the projects that we run is a scholarship programme to learn English as a second language. Our second programme is called 'Shelter a Venezuelan' which is focused on first response. For example, those buses arriving from Texas and Arizona, we're on the ground giving people food, clean clothes and hygiene products." Marisela paused and looked at me intently. "Jaz, we're talking about people who have crossed the whole continent

walking," she said. "They haven't eaten a hot meal or taken a bath for weeks. Right now it's winter and they are not prepared, so this first response is so important."

> "MILLIONS OF VENEZUELANS ARE WALKING THE WHOLE CONTINENT THROUGH COLOMBIA, TAKING BOATS TO PANAMA, WALKING THROUGH THE JUNGLE, PASSING THE DARIÉN GAP TO COSTA RICA, NICARAGUA, THEN ALL THE WAY ACROSS MEXICO TO GET TO THE US BORDER. "

Between November 2021 and September 2022, over 100,000 Venezuelans made this journey on foot towards the US. Unable to afford to travel any other way, they walk 3,000 miles, carrying the contents of their lives on their back. Life is not any easier once they reach the US border. A recent policy change allows the American government to deport Venezuelan asylum seekers back to Mexico, where the ever-increasing refugee population strains public services. It is up to grassroots groups and NGOs like Marisela's to support the new arrivals, offering food and water, medical assistance, legal aid and solidarity.

Our conversation ended when Marisela looked at her watch. "Actually Jaz, I need to go and receive another bus," she smiled apologetically. "But let me know if you need anything else from me. I want to do everything I can to amplify the stories of my fellow Venezuelans."

FRANCE

AFGHANISTAN

SHIKHALI

"I'm thinking about the impossible. I'm finding solutions for the impossible. Possible is easy for me, I'm not looking for the possible; I'm looking for the impossible now."

I first met Shikhali in a refugee camp in Greece many years ago, when he was still on his journey. We stayed in touch as he continued to find the country he would call home. He eventually settled in France.

The first time I visited him in Paris, he was living in a tent under a bridge. We met for a kebab before he joined the many young Afghans spending their nights outside in the cold. Once my eyes had been opened to the extent of the refugee crisis in Paris, I couldn't unsee it. While I might once have been enamoured by the city's architecture and history, I now noticed the young men washing their clothes in the city's fountains and the huddles of tents alongside the canals or under bridges. I wondered about the men selling plastic Eiffel Tower keyrings or padlocks for lovers to attach to the fences around the Sacré-Coeur. Where had they come from and

how had they got here? In one of the world's most affluent cities, why were families who had fled wars now sitting on flattened cardboard boxes inside the Métro stations with their young children, relying on handouts from strangers?

There is a common view that refugees arriving in the UK should have stayed in France because it's a 'safe' country. But there is definitely nothing safe about the rat-infested 'tent cities' that so many children live in within the French capital, many of them unaccompanied and vulnerable to exploitation. Let alone the situation in Calais. I would implore people to look beyond their own experience of the 'City of Love', eating croissants on a weekend break, and recognise that although France might be safe for a European tourist, it certainly isn't for a young Afghan asylum seeker with one leg like Shikhali.

185

SHIKHALI

Three years passed before I saw Shikhali again in Paris, and this time things were very different. He met me at the friend's apartment where I was staying, in the vibrant 18th district of the city, close to the notorious Porte de la Chapelle – a neighbourhood where refugees lived in some of the most difficult conditions of any tented communities I'd seen in Europe. But those days were over for Shikhali. By this time he had found himself a room, learned fluent French and showed up wearing a blazer, sunglasses and oozing a new, very Parisian suave.

AFGHANISTAN

Shikhali was forced to leave Afghanistan as a teenager after the Taliban targeted his family due to his father's work with international aid organisations. "When the Taliban understood where my father was working, they first asked us for money," he explained to me. "My father said no. Then they sent him a letter that said, 'we will kill you'.

> ## "ONE DAY MY DAD HAD AN APPOINTMENT IN THE DISTRICT, AND OUR CAR WAS EXPLODED BY A CONTROLLED MINE."

"Every morning, when I went to school, my father told me to be careful. Then one day my dad had an appointment in the district, and our car was exploded by a controlled mine."

The Taliban had followed through on their threat, attaching an explosive device to the car in which Shikhali and his father were travelling. Shikhali, who was 17 at the time, lost his leg, and devastatingly, Shikhali's father lost his life.

"After that explosion, I had my leg amputated and I was in the hospital for two and half years, but I still wasn't safe. I received another letter from the Taliban. It said: 'We tried to kill you and your father. Your father is dead but you did not die. We will be

Shikhali in Paris.

coming back to kill you.' That's when I decided to leave Afghanistan."

TO GREECE

"I never had a plan to come to Europe, just to Iran or Pakistan to study there for some time," Shikhali explained. Leaving his country had originally just been a temporary measure until it was safe for him to return, but life had other plans.

When he reached the border of Afghanistan, he met a woman from his village who was travelling alone with five children. He took them under his wing, calling her his sister and offering to travel with them. Women and children travelling alone without a male companion face high risks of sexual violence and exploitation at the hands of smugglers and other criminal groups. Shikhali knew that his presence would help keep them safe, and together they crossed the mountains into Iran.

"We were walking for many hours – 15 or 18 hours," Shikhali explained. "It's very difficult. No one wants to walk through the mountains with one leg. No one. But if I don't do that, maybe I'm dead, maybe they will kill me."

"NO ONE WANTS TO WALK THROUGH THE MOUNTAINS WITH ONE LEG. NO ONE."

"When I got to Iran, it's also very complicated there. Have you heard about Afghan refugees in Iran?" he asked me. I had. I knew from Murtaza that the situation in Iran was very difficult, with Afghan refugees facing swift deportation if caught by the Iranian authorities.

"From Afghanistan to Tehran it took us 16 days. In Tehran, I was there for one day and I looked around and saw other Afghans working 20 hours a day in construction, and I said no. I cannot stay here; I have a family with me. I said to the family, 'if you want to go to Europe, I want to go to Turkey, and we'll see how the situation is there'.

"From Iran to Turkey we travelled with 35 people – only three men and the rest were women and children. We lost a girl under the truck of the smuggler . She was seven years old. She died there. She went under the car.

"Then we crossed the border of Turkey," he continued. "We walked for 15 hours in the mountains in the snow. That's very cold for the children and for the women. We were only three men, we could not help everybody."

I asked Shikhali about the pain in his leg. "At that time I wasn't thinking about it because there were children, and they are very important. But then when I came to Turkey and I took off my prosthetic, there was blood on my leg. After one hour in the house, I couldn't move it."

Shikhali and the family arrived in the Turkish city of Istanbul, where Shikhali hoped to stay. But as the country bearing the brunt of the refugee crisis, he was quick to find out that life in Turkey was also not all he had hoped. "I met a lot of Afghan people there who said here is not good because you cannot ask for asylum, and if the police catch you and ask for your papers and you don't have them, they will send you back to Afghanistan."

So Shikhali and the family decided to attempt to enter Europe by crossing the sea to Lesvos.

"It was 2am in the morning. We left from Turkey, Izmir. It was a small ship, about 12 metres. Seventy-five people. I was worried because I'd heard about how crazy and dangerous it is. We were on the water for three-an-a-half hours. The engine of the boat had a problem and it kept cutting in and out. After two-and-a-half hours we saw a small light, very far away from us. That was the police and they took us to Greece. If the Greek police had not come, everybody would be dead."

Shikhali and the other people in his boat were brought to the infamous Moria camp on Lesvos. But Shikhali had a guardian angel. A volunteer in the camp, shocked at the state of his leg and his broken prosthetic, vowed to help him leave the island.

"Never will I forget it," explained Shikhali. "She got me the papers to travel all of Greece, and that way, we got to Athens."

Shikhali and the family got the ferry to the Greek mainland, where they found themselves in yet another difficult living situation, a refugee camp just outside of Athens. This is where Shikhali and I first met. Shikhali made many international friends in this camp, and went on to learn English here. He might have stayed longer, except what happened next was truly heartbreaking.

"I lost my friend. I don't understand what happened to him," he told me. Shikhali's friend Pilal had gone swimming in the sea one evening and drowned. "Everywhere in the camp I saw things that reminded me of him. I needed to leave."

TO FRANCE

Shikhali went west, paying a smuggler $800 to help him hide underneath a truck bound for Italy. After 36 hours spent clinging to the wheelbase, Shikhali finally managed to roll himself out from underneath it when it stopped for petrol. He only narrowly missed falling beneath its wheels as it drove away. "If I didn't turn, I would have been dead there. I came out and I saw I'm black!"

"Covered in petrol and soot?" I asked him.

"Yes and I was so hungry! I tried to go inside the petrol station and the man said 'don't come in here'. I said, I have money! I need to buy some things. And he said, 'don't come in!'"

Shikhali was in the middle of nowhere. After he was refused entry to the petrol station, he began walking towards some lights on the horizon. They led him to a village with an open shop.

"I'm in some village in Italy at 2am. I needed to wash my hair and everything like that... that's not easy because I'm black, I'm covered! I need a shower. I need shampoo or something like this," he laughed. Shikhali bought some juice, but got a shock when he took a sip. "It had grapes on it. I thought it was grape juice," he explained, "but it was wine!"

Luckily the village train station had a 24-hour service, and Shikhali managed to get on a train to Milan. "I was very cold," he told me. "I was only wearing a t-shirt."

He spent the night in Milan in a refugee camp, where he was finally able to shower and find some new clothes. But he soon discovered that being a refugee in Italy is hard. As one of Europe's main entry points, gaining asylum in Italy is very difficult. High numbers of arrivals and a right-wing government result in years of waiting and lots of refusals. He decided to push on to France, but whereas many of us could easily travel this route by train, it wasn't so simple for Shikhali. "The French police had closed the border and they were asking people for their papers,"

he explained. He was forced to use another smuggler, but this one took his money and did not deliver on their end of the deal.

"I gave the smuggler €500 to help me get to Leon. He took my money and left me in the mountains. He dropped me somewhere and told me another car would come. I stood there for five hours and no one came to look for me. He took the money from me, then he left me. From there I couldn't find the way. I walked and walked and found a city. I didn't even have €1 with me."

Shikhali managed to get on the train to Paris. With no money, it wasn't an easy journey.

"The controller of the train came and asked for my ticket. I said I didn't have one. When I arrived in Paris, they had already called the police. I told them I was underage and they transferred me to a house. I ate very well, they gave me clothes, everything was good," he said.

When Shikhali eventually had to tell the truth about the fact he was no longer under 18, he was left to fend for himself on the streets of Paris.

PARIS

"I stayed two months on the street and I waited four and a half years for my papers. I was in a tent under a bridge," Shikhali said. He was not alone. There are thousands of refugees sleeping in makeshift shelters, tents and pieces of cardboard on the streets of Paris. These unofficial camps are dotted around the capital, even springing up in the middle of roundabouts, where people sleep surrounded by rubbish and traffic fumes. French police carry out systematic evictions, but there continues to be as many as 100 refugees arriving in the city every day.

Shikhali has always been resourceful, and he used the tools he had available to him to raise some awareness. "I videoed myself saying 'I'm here, this is my tent and this is the situation'," he explained. "And then volunteers came looking for me."

Shikhali's video had reached lots of international volunteers on social media who sought him out and did what they could to help him. "They were from The Netherlands, Germany, Canada, the United States, England, Greece, Italy," he told me. "A French girl came to see me and she was a doctor, because I had a problem with my leg. It was wounded and I couldn't walk. It had lesions. She helped me."

Finally, something happened that Shikhali had spent the last few years hoping to: he was given a room by the French authorities. He didn't sit still for long on his mission to integrate into life in France. "The most important thing in another society and another country is the language. If I don't speak the language, I would never understand the culture."

"How is your French?" I asked him.

"It's not perfect because French is difficult," he told me modestly. "But after seven months I got two diplomas! Now I have English, French, Dari, Pashto and Persian in my head. I understand Arabic also."

"Tell me that in French," I smiled

"Oui, j'ai appris français, je comprends français, je vis en France et je vais à l'université. J'apprends encore à être français!"

Laughing, I packed up the microphones, conscious of the setting sun and wanting to be ready to enjoy an iftar meal together that evening. I followed him out the door and down the street to a nearby Turkish restaurant, where he exchanged some words in Turkish with the men who worked there. Seeing Shikhali so settled in his new community, I thought about something else he had once said to me: "I'm thinking about the impossible. I'm finding solutions for the impossible. Possible is easy for me; I'm not looking for the possible. I'm looking for the impossible now."

Shikhali ordering food in Paris, France.

"WHY DON'T REFUGEES STAY IN THE FIRST SAFE COUNTRY?"

This is a comment I see a lot on social media, and one I feel there is a lot of judgement and misinformation around. The Geneva Conventions – documents designed to protect refugee rights – do not require refugees to seek asylum in the first safe country they reach. But individual governments will often ignore this fact, using the argument that someone has passed through other 'safe' countries as a reason to deny their asylum claim. Mainstream media also often uses the fact to suggest people are not "real" refugees.

A country that is safe for you might not be safe for someone fleeing a conflict zone. This can be especially true for countries buckling under the pressure of high refugee populations, like Turkey and Greece. If someone isn't legally allowed to work, can't afford to eat or doesn't have anywhere to live, then it doesn't matter how 'safe' the country is.

Just because someone is fleeing their home it doesn't mean they leave their autonomy behind. People might want to settle in a country where they already speak the language, or where some of their family live.

Children in a refugee camp in southern Greece, 2016.

POLAND

UKRAINE

OLENA

"I just want to say to people, try to understand us. It's not about the word understanding, it's about the feeling."

"I never thought that I would be a refugee. That's impossible for me," Olena told me as we sat down in the window of a cafe in central Warsaw, Poland.

It was just weeks after Russia had invaded Ukraine on 24 February 2022, and I think we were all still in shock at this war unfolding so close to home. I'd been on the road for a few months, documenting common and well-trodden migration routes taken by asylum seekers from East Africa and the Middle East towards Europe for the podcast. Never, though, did I expect to have to amend our journey to include refugees of a war within Europe itself.

We headed to the Ukrainian/Polish border to document stories of the overwhelming wave of international volunteers that had set up there to support people as they left their country. It was like no emergency response I had ever seen anywhere in the world. Coordinated and comprehensive, even Ukrainian pets had dedicated organisations to support them. It was heart-warming and life-affirming but also painful when I thought back to the Syrians, Afghans, Eritreans and Palestinians I had spent time with in the previous weeks of that trip. It brought up challenging questions around why we seemed to have selective empathy in Europe towards some refugees over others, and why our governments were able to provide dignified routes to safety for some nationalities, while others were left with only petrifying, life-threatening options.

My takeaway was ultimately positive. If we could do this for one nationality, it showed that international, government-funded hosting schemes, welcome committees and genuine, heartfelt hospitality were possible – if the desire was there.

WARSAW

Olena and I chatted over a breakfast of chunky bread, eggs and coffee. I warmed immediately to her sweet nature.

"I am 34 years old and I'm a refugee in Poland," she told me, as if she hardly believed it herself. "In Ukraine I'm a confident and well known person, and I'm nobody here. It's quite strange."

Olena was not alone. In the four weeks since the war had started, Poland had already become home to around four million Ukrainians. She had left the day the war began after learning she was on a Russian kill list for her work in safety and security services, which she told me very matter-of-factly as we sipped our coffee.

"IN UKRAINE I'M A CONFIDENT AND WELL KNOWN PERSON, AND I'M NOBODY HERE. IT'S QUITE STRANGE."

"I'm a media security and safety expert for journalists," she explained, "so I had my emergency backpack ready one-and-a-half months before the war began. I remember the last peaceful day. I could feel it was my last night of peace so I took two sleeping pills and two antidepressants and had a very good sleep."

Olena took a deep breath as she took us back to the fateful day that she left Ukraine.

KYIV

It was a Thursday. "I woke up, had my breakfast, went to visit my dentist and had lunch with my very good friend," said Olena. "She came quickly, within a couple of hours which is impossible in Kyiv because usually you need to arrange weeks in advance."

"I had lunch in my favourite restaurant, with my favourite dishes, and I had a coffee in my favourite coffee place. I went to my office, took two first aid kits and my work laptop, then I went to meet my friend who is a journalist. He told me that his sources at CNN had told him that the war will start in the morning. So we decided to take my stuff to his place. My emergency bag, two pairs of pants, two t-shirts and that's it. We cuddled as we went to sleep, but I didn't sleep," she said. "I was waiting. I heard the first bomb go off."

"'Fuck,' I thought. 'The war is starting.' I lay there for five more minutes before I said to my friend... 'wake up. The war is starting!' Within 40 minutes the two of us were in the car and leaving our beloved Kyiv."

When I asked Olena how she felt in those moments she said, "as a security expert I knew not to feel, just to do".

Olena and her friend drove to meet some other friends in a village about 100km outside of Kyiv. "It's always safer to stay in villages rather than the town. But after two hours of being there I had a bad feeling. 'Guys – we have to run,' I told my friends, so we left again."

Everyone else in Ukraine was also fleeing the cities and the roads were completely blocked. The two hour journey to another friend's family home ended up taking Olena and her friends seven hours. It was during that drive that Olena got a call from a colleague.

"Olena," he had said to her, panicked, "You need to leave the country. You know the list the Russians have of people they want to kill? Well, your name is on the second line of that list. You need to leave."

"You know when you're working, you don't think you're a very important person, you're just doing your job." Olena looked me straight in the eyes, trying to articulate her disbelief.

Olena and her friends stopped briefly at the friend's family home for a shower, then continued on to the city of Lviv. It took them 48 hours. From there, they spent another two days in the queues of people

trying to cross the border into Poland.

Poland received over 1.5 million requests for temporary protection from Ukrainians in 2021 – the most of any European country – and in the days that followed the Russian invasion, more than 150,000 people crossed the Polish border, forming a 25-mile long queue.

"I DIDN'T SLEEP. I WAS WAITING. I HEARD THE FIRST BOMB GO OFF."

"It was intense," said Olena, "when I think about that now, I can't believe we did it. I've been vegetarian for eight years but I ate chicken soup in that line because the people from the villages came to bring us food, and I thought it wouldn't be polite not to eat it."

Olena crossed the border with no idea of where she was going, or where she would stay once she arrived in Poland. On that journey she got a call from her boss who told her that one of their partners had a house in Warsaw that she wanted to offer to Ukrainian refugees. This is where Olena was living when we met.

WARSAW

"It's very lucky," she smiled. "There's eight of us there. A house for media refugees because all of the people

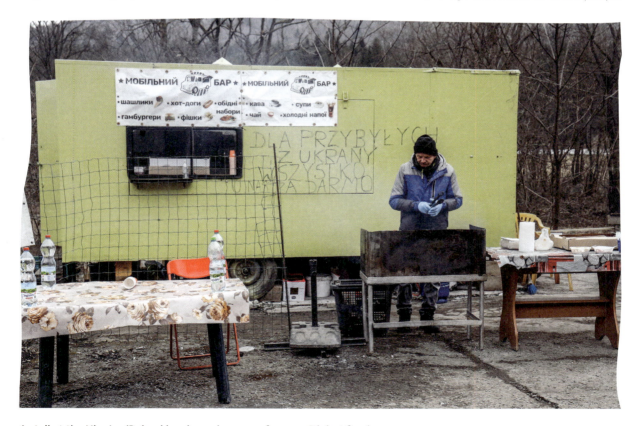

A stall at the Ukraine/Poland border welcomes refugees with hot food.

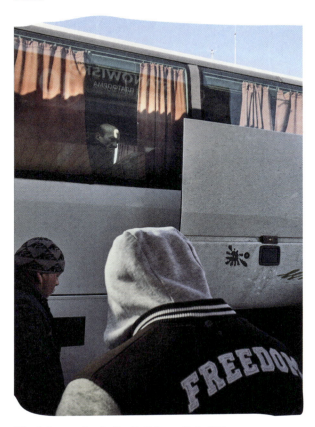

Ukrainians arrive in the Polish capital of Warsaw in March 2022.

are related to [the] media. I have my own room and I'm really very lucky. A lot of people live in one flat, five or six people together."

When I asked Olena about her family, she told me they were still in the centre of Ukraine. "From time to time there are bombs, but because their daughter is a security expert, they go to the bomb shelter every time, so I'm quite happy about that."

I asked Olena if she was worried about them. "I don't have a chance to think about that. I know they are prepared. They have petrol in the car, food, even pills to clean the water. They have everything, and they know what to do."

"More than 70 percent of my male friends are in the army. They are fighting. I always try to message them to tell them I am with them, that I am thinking about them. When people asked me my biggest fear, I always said it was losing my first friend, and it happened. My very good friend, he's a journalist – he was killed by Russians. After that I started to worry more because it became very real."

> **"MORE THAN 70 PERCENT OF MY MALE FRIENDS ARE IN THE ARMY. I ALWAYS TRY TO MESSAGE THEM TO TELL THEM I AM WITH THEM, THAT I AM THINKING ABOUT THEM."**

"How's your sleep?" I asked her gently.

"I don't sleep very well. I forgot the last time I felt that sweet morning feeling after a good long sleep. I wake up every three or four hours."

We got onto the topic of Olena's life in Poland, and I asked her if she felt supported by her new community.

"Yes of course. Flags everywhere, lots of support. For example I had new shoes and they were hurting me, so I went to the pharmacy to get a plaster. I asked the girl for the cheapest ones, and I heard the man behind me say... 'Honey, I will buy the most expensive ones for that girl.' I started to cry. The feeling was very bad because I'm very independent and I can usually buy whatever I want in Ukraine. Just send me back home. But at the same time I was feeling very grateful. I was crying very hard, and the man didn't understand why." Relaying this small act of kindness brought both Olena and me to tears, and it wasn't the only act of compassion she had experienced since arriving to her host community.

"I was at a solidarity concert and I don't often let myself cry, but they were singing a Ukrainian song about when the war would end, and it really affected

me," she told me. A photographer came and cuddled me, and it was just what I needed at the time."

"Sometimes an act of kindness like that is even more impactful from a stranger," I agreed.

Olena spoke about how her life would never be the same. She reminisced lovingly and nostalgically about her city of Kyiv. The food, the service in restaurants. She planned to stay as close to Kyiv as possible, not wanting to leave Poland until she could return home. "I have my parents on the locator on my iPhone so I can see where they are. It feels comforting that they are close," she smiled.

Since leaving Ukraine, Olena has been busy doing her bit to support the war efforts by organising blockades, protests, boycotts and more.

"It's a way to not sit and think. To distract myself from thinking about my friends and my family. We organise a lot of protests and boycotts. I don't have my life now... just a mission."

The following day I headed to a shopping mall in western Warsaw to see Olena and her friends in action as they stood outside a French supermarket chain called Auchan, to protest against its continued presence in Russia. Olena held a sign that said, 'If you shop here you are sponsoring a genocide in Ukraine.'

"We are boycotting Auchan," she explained, "because they've said they will not leave the Russian market, and are using the opportunity of everyone else leaving Russia to develop their business and make profits. Lots of Polish people are asking us why we are standing here and why Auchan is a bad shop, and lots of them say they didn't know. When they understand, some of them don't want to go anymore, but some of them still do."

"Honestly, I'm a bit disappointed that only a few hundred kms from the war, people here don't know that Auchan is still in Russia, and if they do, they

don't care. It's not that difficult to find another shop. For these people it's easy. They don't have bombs, they don't have a war. People in Ukraine don't have any choices now. But people don't want to think, they just want to eat."

Olena and her friends were dedicated to the protest and spent hours outside not just this store, but other branches in the city. I sat with a couple of them as they took a break in the food hall of the mall for some lunch.

"WE ORGANISE A LOT OF PROTESTS AND BOYCOTTS. I DON'T HAVE MY LIFE NOW... JUST A MISSION."

"I just want to say to people, try to understand us," Olena told me, full of emotion. "It's not about the word understanding, it's about the feeling. We don't have our childhood place anymore. No one will understand more than those who are in the same situation. My Belarusian friend just had to run because of the regime there. She left her country just three months ago and she's in Poland now too and wanted to meet me. When I saw her, she gave me €200. I said to her, 'Marina! What are you doing!? You're in the same situation! Why? I don't need it!' And she was crying and she said, 'I just understand. It's not about the money, it's about the support.' That's true solidarity, empathy and love."

Olena's name has been changed to protect her identity.

UK

SOUTH SUDAN

GIEL

"It's a story which is not mine alone, but of everyone who has died at sea, or in prison in Libya. This story belongs to them but they cannot tell it."

I heard about Giel before I met him. The story of what he, along with some of his fellow countrymen, had achieved in Libya is well-known among the international refugee community. Other South Sudanese friends told me I must include his story in these pages, and when he shared it with me, I understood why.

"I've been through a terrible situation that I would love for other people to hear about," he began, with the trademark smile that barely leaves his face. "A lot of people are still going through it, so I hope it's a story worth telling. It's important for people to know exactly what kind of situation we are going through." Giel sighed. "It's a story which is not mine alone, but of everyone who has died at sea, or in prison in Libya. This story belongs to them but they cannot tell it. Because I've survived, I have to tell it."

SOUTH SUDAN

Giel reminded me of my own foster brothers and as he spoke I felt huge waves of empathy for all he has experienced in his short life. I asked him to start at the beginning and tell me a little about his childhood and when things started to change.

"South Sudan is a beautiful country and we have lots of cultures and traditions. I hail from the Nuer society I grew up with my parents and six siblings. We lived together happily, swimming in the river, playing football. I had lots of friends because I'm a friendly person."

"Popular?" I smiled at Giel.

"Well, sociable" he replied humbly. "I was a very active child and my parents loved me a lot because I was a good kid. Then, in 2013, when I was about 9 or 10 years old, things turned into a nightmare."

"On 15 December 2013, conflict broke out in the capital city of Juba. Me and my father were staying with my uncle, auntie and cousins there at the time, while my mum and siblings were back in our home town of Bentiu."

When South Sudan erupted into civil war in 2013, opposing leaders exploited national identities to mobilise fighters. The Dinka, the country's largest ethnic group, had the backing of the military, and soon took control of the country, targeting the minority Nuer people.

"Suddenly the suburb we were staying in was surrounded by soldiers. The killing was so much that my auntie decided to take us kids to a UN camp near the airport to seek protection, but to get there we had to pass many checkpoints. The first time we were stopped, I was so scared. My auntie told us not to speak; she would do the talking because she knows Arabic. All of us kids kept very quiet and didn't look the soldiers in the eye. My cousins were only about six or seven at the time."

Thankfully, Giel's auntie didn't have the distinctive facial scarification of the Nuer people, and managed to convince the soldiers that they were from the Arabic-speaking region of Equatoria. Her courage and calmness in the face of several interrogations meant they reached the UN camp safely. Two days later they were joined by Giel's uncle. He had some tragic news.

"I DIDN'T KNOW WHAT DEATH WAS. I HAD NEVER LOST A PERSON WHO WAS SO SPECIAL TO ME. I DIDN'T BELIEVE IT."

"'Your father has been killed,' he told me. I was shocked. I didn't know what death was. I had never lost a person who was so special to me. I didn't believe it. Even now, I still can't believe that my father actually died. I just can't accept it."

A Nuer woman with traditional facial scarification.

With no chance to bury their father, Giel and his family were never able to say goodbye. Separated from his mum and other siblings, he was left to process his emotions alone.

"I couldn't grieve together with my mum and siblings. I went a week without eating any food. My mood changed from being a friendly child, laughing and smiling, to feeling like everything was ruined. I was traumatised. A lot of my friends from school never made it to the camp. Lots of children were being killed and my friends were among them. It was scary, you know. It was tough."

Giel's home state of Bentiu, predominantly home to Nuer people, was so heavily attacked that it is now almost entirely decimated. Where there were once houses is now overgrown bushland, with most former residents living in a UN refugee camp.

Giel lived in the camp for five years. Although he went to school and made friends there, he felt trapped by its parameters. "As I started to grow, my life became so boring," he explained. "I could only go

within half a kilometre. It was hot, frustrating and unhygienic. We had no clean water, no food, nothing.

"Let me tell you about the first time I tried to leave the camp. It was early 2018 so I was 13, and a few friends and I decided to go to a market close by called Konya Konya in Juba. We wanted to buy a couple of things. When we got there we were approached by a man who looked at me and said, 'You are Nuer! You come from the UN camp!' He took a knife from his belt and literally wanted to slaughter us. I ran to some women who were selling vegetables and jumped in the middle of them. They saw the man running with his knife and they hid me. I stayed there in the heat for three or four hours because the man was refusing to go, saying 'I will not leave until I kill this boy.' Finally, I made it back to the camp. I never went to the market again."

Driven by a desire to search for his mother, Giel left the camp for good in 2018. "I had to know whether she was still alive," he explained. "I left early in the morning with some friends who said they had family in Khartoum in Sudan, so we decided to head there. We didn't have money but we planned to hide inside a boat travelling down the Nile. I left with only the shorts, sandals and football jersey I was wearing."

Giel and his friends snuck onto the boat and hid between the crates of cargo for two days. When their hunger became impossible to ignore, they made themselves known to the crew. They were surprised at these unexpected passengers, but shared some bread and took the boys to safety.

"They didn't share everything with us though," said Giel. "There were so many mosquitos but the men only had one net each. My friends and I stayed up all night and slept during the day, otherwise it was impossible to sleep."

"Do you know the saying 'If you think you're too small to make a difference, try sleeping with a mosquito'?" I smiled at Giel, who laughed back.

Once back on dry land, Giel and his friends found

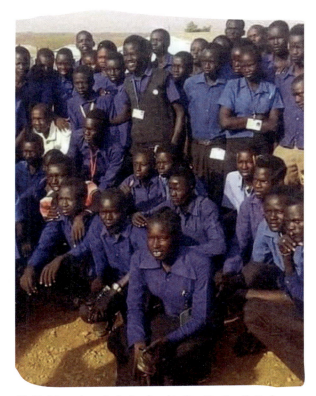

Giel (pictured centre) at school in Bentiu, South Sudan

a market and went in search of some food. Here they met a local woman who ran a restaurant. "When she heard where we were from and how we had got there, she welcomed us inside like and fed us the first proper meal we'd had in days. 'Oh my children!' she exclaimed, as we inhaled fish and cassava."

"THEY SAID THINGS TO US ABOUT A UNITED SUDAN AND HOW IT WAS BETTER WHEN WE WERE NOT FIGHTING. WE DIDN'T KNOW WHAT THEY WERE TALKING ABOUT. WE WERE INNOCENT ABOUT THE POLITICS OF THE COUNTRY."

Giel as a young boy in South Sudan, before he was
forced to flee.

The friends hid in the back of the next truck
heading to the border of South Sudan and Sudan,
where they were questioned by soldiers, but their
young age worked in their favour. "They saw we were
just boys and they let us pass," said Giel. "They said
things to us about a united Sudan and how it was
better when we were not fighting. We didn't know
what they were talking about. We were innocent
about the politics of the country."

SUDAN AND LIBYA

As soon as they had crossed the border into Sudan,
Giel and his friends were approached by a tuk-tuk
driver who was kind to them. He explained that they
would not make it to Khartoum without money, and
offered them jobs looking after livestock on his farm
for a week.

"We were so naive," Giel said. "We were trusting
and excited. 'That's an easy job!' we thought. Me and
my brother used to look after our goats, cows and

sheep when we were little. We'd take them to graze
then bring them home at night."

But all was not what it seemed. The boys were
separated and Giel was taken by the man to a
remote village and dropped off with a family. He was
held captive here for several months, forced to work
long, gruelling hours in exchange for a hunk of bread
a day. "I was very hungry," said Giel sadly. "Sometimes
I would catch a goat and milk it in my mouth. The
family made me sit separately from them but I
started to pick up some Arabic words.

"After one week I told the man that it was time to
go and rejoin my friends. He made a call and told me
they wanted to work for another two weeks. He
wouldn't let me speak to [my friends]. After three
weeks, the same thing happened again. Frustrated, I
confronted him saying 'I need to talk to my brothers!'
He said 'If you talk to me like that again I will beat
you, you are my slave.'"

One day, when he was taken to the market to buy
more livestock, Giel met another man who noticed
the pain in his face and helped Giel hide while his
enslaver negotiated a sale of goats with another
market vendor.

"I began to work on the market alongside this
new man who had saved me," Giel said. "I felt so
happy and relieved. He told me we were going on a
business venture together to get more camels and
sheep. He called me his little brother and told me we
were going to a place called Libya, and that there
were white people there. 'OK! I would love to go
there!' I said. I had never seen white people before."

But when they finally arrived in Libya, Giel was
imprisoned. The man he was travelling with reassured
him that everything would be fine. "Every day, I stood
by the door of the prison waiting for him. He never
came back. It wasn't until months later that I
understood that he took me there to sell me."

Giel is not alone in this harrowing experience.
Displaced people are especially vulnerable to

enslavement, often deceived by smugglers exploiting their desperation. In 2018, the UN reported that asylum seekers in Libya are regularly bought and sold on open slave markets, facing torture or death for failing to comply with their enslaver's orders.[7]

"I cried every day inside that prison. In Libyan prison they bring you one plate of macaroni per seven people. It's made only with water and salt. The first two days I tried to eat some but I didn't get anything. On the third day, I had to be ready, just to get one bite and then it was gone.

"After two months, a man came to buy someone to look after his livestock. He took me to his home and showed me the shed outside where I would sleep. This new man told me he had paid a lot of money to get me out of the prison. 'If you try to escape, I will take you back there,' he said to me."

It wasn't until Giel met some other Sudanese boys while out buying groceries for his enslaver that he realised this man hadn't released him from prison, but bought him as a slave. "[The Sudanese boys] helped open my eyes to what was actually happening, and everything felt different after that."

Giel eventually escaped his captor with the help of his new Sudanese friends, who smuggled him into the boot of a taxi inside a pile of grass and paid for his journey to a town two hours' drive away.

"I owe those boys my life," said Giel. "The driver dropped me on a roundabout where lots of other Sudanese people wait, looking for work. There was

A man herding cattle in South Sudan. The cattle are groomed in ash to keep pests away – a traditional farming method.

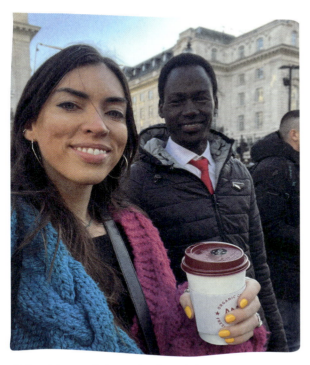

Giel and Jaz on their way to give a talk.

still a lot of grass all over me. I didn't have time to clean myself. I looked messy and dirty but I was free. I immediately met other Sudanese people on that roundabout. 'Why are you so dirty like that?' they asked me. One of them bought me some mango juice and a cake and took me home to a house where there were all migrants. 'We are going to Europe,' he said. 'Where's Europe?' I asked. 'Oh it's just across the sea,' he smiled."

"I decided I wanted to go too. I was very excited. I thought the journey would be simple: we get in a boat and we go."

But this was not the case. After hours spent crammed in the back of a lorry, Giel was pushed with hundreds of others into a tiny dinghy. In the middle of the sea, the unimaginable happened: the boat's flimsy rubber tore and it began to sink. "It was the biggest tragedy I have ever faced in my life," he said. "Seeing people that you have talked to drowning in front of your eyes. It was heartbreaking."

Clinging to the edge of the sinking boat, Giel was eventually rescued by the Libyan coast guard and taken back to prison. "They started beating all of us with the butt of a gun, with metal, with tubes, with wood. They broke my friend's hand. The prison was very big, with about 30 people per room. There were hundreds of people there.

"In the mornings they would beat you one by one. They give you a telephone to call your family and they torture you while your loved ones listened. I didn't have anyone to call."

THE ESCAPE

"One day, seven new Nuer people arrived in my room. They looked around at how weak we were and immediately decided we couldn't stay here, even for one night. They said, 'We have to escape today.' I said 'What... are you crazy?! You can't escape, the guards have guns!' But they said, 'If we wait even one week, we will be too weak, we have to do it today.'

"WE RELEASED EVERYONE FROM THAT PRISON: CAMEROONIANS, PALESTINIANS, BANGLADESHIS... PEOPLE FROM ALL DIFFERENT COUNTRIES."

"The guards would open each room one by one. When they got to our room, the Nuer men jumped at the guards, overpowering them. They grabbed the guns, beat the person who had the keys, took them from his hands and threw them to me. I started opening each gate as quickly as I could. We released everyone from that prison: Cameroonians,

SOUTH SUDAN ~ UK

Palestinians, Bangladeshis... people from all different countries. Everyone was running. The guards shot a lot of people and some people were caught. But the rest of us outnumbered the guards. Together, we pushed open the main gate and scattered, running in different directions into the city. We were free.

"From that day on we were heroes," Giel smiled. "We became famous and loved by all these people who had been there for months."

Giel attempted the crossing into Europe once more, but once again he was caught by the Libyan coastguard and taken back to prison.

"Because of our previous escape, they beat Sudanese people extra badly after that," he told me. "One day they were beating my friend and I tried to stop them, so the guard took a padlock, a big metal one, and tried to smash my teeth out with it. I bent my head down and he ripped my ear. You can see it in the photos."

Incredibly, Giel managed to escape once again, this time using the blankets they slept under to envelope and disarm the guards when they opened the door to the cell. With his fellow inmates, he ran through a sea of bullets, scaled the gate and jumped seven metres to the ground.

"It was like a firing squad," said Giel. "I was the first to jump, then my friends, and finally a Syrian friend of ours. When he jumped he broke his leg three times: his ankle, his knee and his hip. We had already started running but we heard him cry, 'Don't leave me! Mata khaluni!' he shouted in Arabic. 'Don't leave me alone!'"

The guards were fast approaching, but Giel and his friends went back for him. They carried him into the olive groves surrounding the prison, putting a hand over his mouth to muffle his cries. "We couldn't leave him. He had been a friend to us," Giel explained. "He had smuggled couscous into the prison and

shared it with us so we couldn't let him die."

They hid in an irrigation system among the trees. The guards were all around them, yelling at them to show themselves but Giel and the others kept quiet. "Our Syrian friend was in so much pain, but he kept quiet because he knew that if they found us we would all be dead."

Eventually, as the sun set, the guards gave up their search. Their Syrian friend had a brother in Libya, and they borrowed a phone from a local shop to call him for help. "He called us two taxis and invited us to sleep in his home. He was so grateful for what we had done. He told he knew someone who would take us to the sea in exchange for saving his brother's life.

"I was very scared. I told my brothers, 'I don't want to go, I want to go home to South Sudan. I don't want to go to prison again.' But they convinced me, telling me that maybe this time we could make it. There is no other way out of Libya than to go to Europe. It was hard but I had to accept it. You can't go back. The only choice is to go to the sea and risk your life.

"When we arrived at the beach we found them preparing the boat. The boat is plastic so it can very easily break. You can't wear jeans with a zip or a belt with a buckle because if you sit mistakenly you will tear it.

"We stayed for two days in the sea without food or water. They did give us a little water but people fought over it and it was soon gone. We had a few dates and some lemons and limes. That's all we had. You can't even pee. It was cold and very frightening, with a lot of dangerous sea creatures around you.

"After two days we saw the Italian rescue boat. I didn't believe it at first. Even when I was inside it I didn't believe it. All of the people were crying. Every person. There were babies, there were pregnant women, we were all saved. We spent seven days on that rescue boat. The migrant rescue ship. We were eating rice with sauce, salt and sugar. We had water.

It was a relief. Did I really survive? I never believed I would get to Europe or get rescued. It took me a week to believe it. I cried and cried. It was like a dream. Maybe I'll wake up tomorrow and find myself in the same situation that I was in, in a camp, or in a prison eating only pasta and water, or wake up to someone beating me for no reason. It really was a huge trauma and I believe it was a life lesson. Everything happens for a reason. Whether I survived or I didn't... It's called destiny."

Not long after writing Giel's story for this book, I asked him to join me in giving a talk at an office in central London. He was waiting for me at Charing Cross Station wearing a shirt and tie, with a notebook in his hand. The entire office fell silent

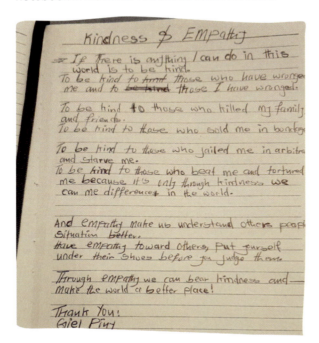

Above: Giel's poem, 'Kindness & Empathy';
page 207: Jaz and Giel in London, 2022.

listening to his incredible story. After he had finished speaking, he opened up his notebook. "I wrote something last night. Would you mind if I shared it with you?" he asked. He began to speak to the enthusiastic nods. "This poem is called 'Kindness and Empathy'."

The words that came next saw tears streaming down most of the cheeks in the room, and I am honoured to share the page of his notebook with you here.

EUROPE

"We arrived in Italy and they gave us masks and sprayed us with sanitiser," said Giel. "We had to stand in line for food and they took us to a huge bunker with so many bunk beds lined up next to each other. There were so many of us."

Giel had arrived to Europe in 2020 in the midst of the pandemic. He was 15 years old.

"They gave us toothpaste and soap," he continued. "We had to stand in a long line to go to the shower but people were so happy. They were dancing and singing songs. That night I slept for 12 or 13 hours. It was the first time I could sleep without waking up in the night with the fear that someone was going to shoot me or kidnap me or beat me. I had many nightmares that night."

It became clear to Giel that he couldn't stay in this place. One by one his friends began to leave, heading towards France. Giel heard from others that if he stayed in Italy it would be hard to get asylum and he might even get deported. So he followed the others to France and, like so many who had travelled before him, ended up in Calais.

"People were trying to get to England. I didn't know about England, but my friends told me that we could all go to school there. They said we'd see stadiums like Chelsea and Manchester United. We chatted a lot about England and it stuck in my mind."

Giel attempted to reach England several times,

hiding in the back of lorries or underneath them, hoping the police dogs wouldn't smell him behind the wheels. He eventually crossed the channel in a rubber dinghy, and was brought to a foster home in the UK. "There were some difficult boys there and it was hard to live together. There was one boy who was rude to me at first, but when he realised I'm a good guy, he was nice to me and now he's my friend.

"I started college and I did very well. I won the Bright Star of the Year Award in 2022. I learned English and now I'm studying business. When I turned 18, I had to move out and be independent. Now I share a house with some friends."

But although he was safe, Giel's mind was dominated by thoughts of his mother and family, and whether they were still alive. But then, a miracle happened. "I had a friend on social media who was back home in Bentiu. I sent him a message telling him I had lost contact with my family and was now in the UK. I didn't know where they were living now, but I knew where they used to live. He was in the UN camp and he told me if they were in the camp, he would find them. He had to search hard, but he found them! When I heard that, my tears dropped. It's very hard for me to cry, but my tears dropped. When I spoke to my mother, she couldn't talk and I couldn't either. We couldn't believe it.

"'My son Giel. Is that you? Is it really you?'

"Those were the first words I heard. I said, 'Yes mum, it's me. I'm alive, mum.'

"It was the happiest moment of my life. I feel so relieved knowing my mother and siblings are all fine. I just wish I could go back to her. I've missed her. Even when I'm sleeping at night or sitting alone reading, I want to be with her. I see my little siblings on video call and I don't recognise them!

"In South Sudan, when you give birth to a child you create a song for them and you sing it to them when they cry. My mum taught my brothers my song. They sang it for me on the phone."

"Did you tell your mum about what you have been through?" I asked.

"Yes a little bit," Giel replied. "I told her that I have been a slave in Libya and I nearly drowned in the sea.

'You shouldn't have done that!' she said.

"I told her, 'I had no choice mamma. It was the only thing I could do. I found myself in these situations and there was never any choice... but I'm safe now.'"

UK

GREECE

HOLLY

"This refugee crisis is happening, whether I'm on the ground helping or not, it's happening."

Sometimes you meet somebody who just gets it and you instantly click. Holly is one of those people for me. The founder of Indigo Volunteers, she is known in the sector for her amazing work coordinating thousands of volunteers, always doing so with a smile on her face.

Holly and I have been on a similar journey, both plunging head first into the grassroots response to the European refugee crisis back in 2015, and have definitely both been on a steep learning curve ever since. Holly doesn't have lived experience of displacement, but her story is here to answer one of the most common questions I get asked on social media: what can I do to help?

"When you do work like ours, it's so immersive. It's absolutely not a nine-to-five. It's a 24/7 kind of thing that takes over your whole life. You live and breathe

it," laughed Holly, recognising how much I could relate. "I work stupid hours. Being a founder means there's no one to tell you to take a break and you're responsible for your own time management. But the thing is, it's not as if it doesn't matter if I don't send this email. It really does! This work is so important and it's something I care about so much."

Holly has always been in the business of care for others, starting her career as a paediatric nurse. "My nursing journey definitely informed my work now," she explained. "I always felt like I can help, I can add, I can make it better. But during my time as a nurse, I remember feeling that something in my life wasn't quite right. I would come home to the same front door every day and feel something in my stomach. It was turning, exploding. I loved nursing but I knew I needed to do more. Honestly, my body made the

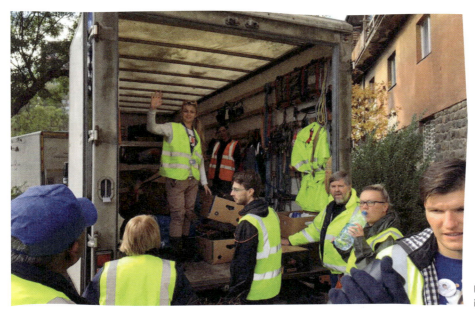

Holly at a distribution in Kosovo.

decision for me. I know it sounds weird but that is what happened. It was my gut."

So when the news began to show children arriving to the shores of the Greek Islands in boats, Holly followed that overpowering gut instinct and moved to Greece.

"I'd travelled before and wanted to volunteer," explained Holly, "but the crazy thing was, I couldn't actually afford to because all these companies charged so much money to do so. They were making money from people's goodwill and it didn't seem right." I related to Holly's words. As a teenager, I knew I wanted to travel and do something useful, and had looked into a whole host of gap year offerings and companies. The fact that I was able to pay for the privilege of going to teach in a classroom having barely finished school myself didn't sit right, but with my teenage naivety I didn't understand why.

One Christmas, not long after finishing school, I worked a temp job answering the phones at one such gap year company. I remember a British teenager complaining to the company. He had booked himself an expensive trip to Brazil to teach football to kids in the favelas but was annoyed that, when he got there, the Brazilian kids ran rings around him.

> **I SLOWLY BECAME AWARE OF AN INGRAINED, OFTEN SUBCONSCIOUS NARRATIVE WHEREBY WE FEEL THAT WE AUTOMATICALLY HAVE SOMETHING TO OFFER, JUST BY BEING FROM THE WEST.**

I slowly became aware of an ingrained, often subconscious narrative whereby we feel that we automatically have something to offer, just by being from the West. A deep self-righteousness seeped in generations of colonialism.

Holly had recognised this too. "There must be a responsible platform that matches people with organisations needing their particular skills without profiting while doing so," she thought, but she hadn't been able to find one. "It's such a fine balance," she told me, as we winced at the naive savourism of our teenage selves. "Yes, having [gap year] experiences does open your eyes. We all have to be open to making mistakes and learning and growing, and I see the value in some of these experiences as a stepping stone to doing things better, but there must be a way to do this ethically."

And so, Indigo Volunteers was born. "If you're young and you don't have any experience or skills, you can work in a warehouse or distribution centre, sorting clothes, or in the kitchen chopping vegetables," explained Holly. "You can chop a lot of vegetables in a week, and it's fun! There needs to be an entry point into a world that you know nothing about, while still feeling supported."

Indigo Volunteers is where I now direct anyone wanting to volunteer within the refugee sector. They currently support 50 grassroots humanitarian projects and organisations by providing them with volunteers, and they do so ethically and for free. By carefully hand-picking and matching people based on their skills and time commitment, they make sure the needs of each project are met.

Four years after moving to Greece, Holly got pregnant. She talks openly about how taking time away from her first baby, Indigo, for her maternity leave was not easy. "I struggled with the idea of taking six months off to focus on one person instead of hundreds of people. But having Matteo has just made me even more inspired to continue this work. Every night I imagine going back to a tent with my baby instead of a comfy bed. I think about how

difficult it must be to raise a child with so few resources around, and no family. How do you know what to do? I couldn't have done this without my mum here with me."

"THERE MUST BE A RESPONSIBLE PLATFORM THAT MATCHES PEOPLE WITH ORGANIZATIONS THAT NEED THEIR PARTICULAR SKILLS WITHOUT PROFITING WHILE DOING SO."

Working in a politically divisive space is challenging. The need for material support is ever-growing, the circumstances are often made more difficult by hostile government policy, and burnout is rife. But the challenges faced by volunteers and aid workers can't ever be compared to those faced by people fleeing their homes and making dangerous journeys across the world in search of safety.

"We only have one life," Holly once told me wisely, referring to the mental toll that humanitarian work can have. "But I wouldn't change a thing." We might have to compromise and sacrifice along the way, but these sacrifices are so minimal in comparison to what others endure. Those of us with time and strength to spare can lighten the burden that others have to carry.

UK

SYRIA

EMAN, ALI, ALMA, SEEMA & HAMOUDI

"Life is teaching us everyday. Everything we experience is learning."

In the summer of 2018, a man knocked on my parent's front door. "Hello," he said. "I just wanted to let you know that you have new neighbours. They're a young Syrian family who have been relocated from Lebanon. They don't speak much English, and everything is new to them, so it felt like the right thing to do to let you know."

This man, Jeremy, was a stranger to us. Little did he know that we had three people living in our house who knew exactly what it was like to arrive in the UK as an asylum seeker, one of whom even shared a language with this new family. Jeremy could never have foreseen what a beautiful thing he did that day,

not just for Eman, Ali and their two young daughters, Alma and Seema, but for us, too. It sparked a beautiful friendship between our two households.

Seeing your culture, your village and all the things that feel so familiar to you through the eyes of someone for whom it's all so strange and new is fascinating. My mum introduced Eman to the local supermarkets – Waitrose, Sainsbury's, Lidl – and their varying degrees of cost and convenience. She baked cakes and Eman made stuffed vine leaves and other delicious Syrian dishes. It wasn't long before we loved little Alma and Seema like they were our own nieces or cousins. The girls learned English quickly,

213

acting as miniature translators for their parents, who were not too far behind them.

In 2021, Eman gave birth to a third child, Mohamed, or Hamoudi for short. When he was a couple of weeks old, my mum and I went to visit them. Eman's English was nearly fluent by this point, and she told us that it was the first time she had been able to enjoy these early days with a new-born, having had her first two children under very difficult circumstances. She told my mum and me her story over a cup of sweet black tea.

THE WEDDING

Eman and Ali got married in early 2018 in their village outside of Damascus, Syria. They had big plans for their wedding, and Ali had been working and saving to create their dream marital home for years. Eman was due to move in on their wedding night, and both were beyond excited.

The day before their wedding, there was heavy bombing in the area. "We decided to continue because we had booked everything," explained Eman. "We didn't want to cancel, but it was a very scary day. We invited a lot of people but many of them didn't come because they were afraid to travel or even leave the house."

When the newlyweds approached the front door of their new home after the wedding, it had been looted. This is common across Syria, where rebel groups take advantage of the high number of empty houses, selling looted furniture and possessions in stolen-goods markets. Among the chaos, furniture had been taken and ruined, and the house Ali had spent so long perfecting was unliveable.

"We went to stay with Ali's parents," Eman told us. "It was very hard." This is where they had their first baby, a girl named Alma, but things continued to become more dangerous in their area. "When [the government] dropped chemical bombs on us, that's when we decided to leave. We stayed two days in a bomb shelter, then arranged to go at night to another safe place. The army was coming to all the houses in Syria, and if they found men who were not in the army, they took them to jail or killed them."

LEBANON

"Ali went to Lebanon first to find us a house, then I followed with baby Alma who was two months old. I crossed the border by car. It wasn't difficult back then.

"Homes were expensive in Beirut and Syrians are paid badly. We couldn't afford to live in a house on our own, so we shared with other Syrian families. During this time, I had baby Seema. Even though life was difficult, I didn't want to leave Lebanon. I felt close to my family back in Syria and we always thought the war would end soon and we would go home."

> "I DIDN'T WANT TO LEAVE LEBANON. I FELT CLOSE TO MY FAMILY BACK IN SYRIA AND WE ALWAYS THOUGHT THE WAR WOULD END SOON AND WE WOULD GO HOME."

When Eman entered Lebanon, she registered with the UN in case there was anything they could do to help her young family. She had hoped they might help with food, medicine or even accommodation, so she was shocked when the UN called to tell them they had been selected for relocation to the UK.

"Ali was very happy and excited, but I was scared," she told us. "When they called, it was only 10 days after I had given birth to Seema. After that call, I bled. I was so nervous. I just didn't want anything else hard for us."

Her reservations were understandable. Displaced from the comfort and familiarity of their homes and support networks, life as a pregnant refugee or new

mother can be immensely traumatic. Without access to adequate medical care, women are often forced to give birth in unhygienic conditions, with no pain medication. As if life in a refugee camp or overcrowded accommodation wasn't hard enough anyway, imagine surviving these precarious circumstances with a new-born baby. It is no wonder that a recent study of Syrian refugee families living in Turkey found that 81 percent of mothers were suffering from PTSD.[8]

But despite the difficult circumstances she has endured, Eman's strength is incredible. Her resilience and bravery, her determination to do whatever it takes to keep her family safe, calls to mind a description from the writer Glennon Doyle: "When the real trouble hits, we sit down next to our babies, we turn their faces towards ours until they are looking away from the chaos and directly into our eyes. We take their hands in ours. We say to them, look at me. It's you and me. I'm here... We will hold hands and breathe and love each other, even if we're falling from the sky."

So, despite her nervousness, Eman and her family embarked on another journey. "We did a lot of meetings and interviews," she explained. "They

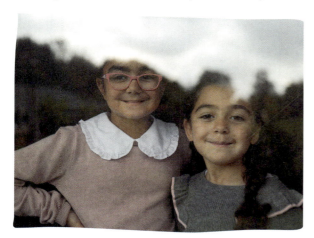

Alma and Seema at home in Kent, UK.

arranged the day of travel. It was my first time on an aeroplane."

Eman, Ali and the girls were one of very few families to travel to the UK this way, as part of a government scheme to relocate 20,000 Syrians over a five-year period (if this sounds like a lot, it works out as 4,000 per year, compared to Germany, who accepted one million refugees in 2015 alone).

THE UK

When Eman and Ali arrived in the UK, they were housed in a small flat directly next door to us. "To have our own house, with my children, that's all I ever wanted," smiled Eman. "We didn't have internet or wifi for the first two weeks. We only had a small phone that the social worker gave us. There was just £2 credit on it for emergencies. We used it straight away to call my family and let them know that we had made it here."

> ## "TO HAVE OUR OWN HOUSE, WITH MY CHILDREN, THAT'S ALL I EVER WANTED."

Although their basic needs of housing and safety were covered, things were still difficult. The neighbour below Eman and Ali would bang loudly on his ceiling with a broom if he heard the girls making any noise, triggering memories of the war zone they had fled.

"I felt like I had no freedom," said Eman. Eventually, a local Refugees Welcome group helped them find another home. Here, they had baby Hamoudi, in a calm and comfortable environment.

"Life is teaching us every day. Everything we experience is learning," said Eman. When I asked her what her plans were for her future in the UK, she said, "I want to learn to drive next! I've just booked my theory test. Oh, and finally to get British citizenship and to see my parents again."

**No place is ever too small if
the heart is big enough**

زره چی تنگ نه شی ځای نه تنګیږی

Pastho proverb

KINDNESS & EMPATHY

A poem by Giel Piny

If there is anything I can do in this world, it is to be kind.

To be kind to those who have wronged me and to those I have wronged.

To be kind to those who killed my family and friends.

To be kind to those who sold me in bondage.

To be kind to those who jailed me arbitarily and who starved me.

To be kind to those who beat me and tortured me.

Because it is only through kindness that we can make a difference in the world.

Empathy helps us understand each others' situation better.

Have empathy towards others, put yourself in their shoes before you judge them.

Through empathy we can bear kindness and make the world a better place.

ABOUT THE AUTHOR

Motivational speaker and podcaster Jaz O'Hara has worked to support refugees and asylum seekers since 2015 through founding The Worldwide Tribe, Jangala and Asylum Speakers. Leaving behind a career in fashion design, Jaz began her work in this sector after a Facebook post she wrote about her first trip to the Calais Jungle in July 2015 went viral. The stories she shared in that post went on to raise £250,000, reach over 13 million people and spark the collection of physical donations by the tonne, filling warehouses across the country. Jaz has worked tirelessly in refugee camps across the world ever since, telling the stories that too often go unheard.

As a writer for *The Huffington Post*, winner of *Marie Claire*'s 'Future Shaper' award and member of Amnesty International's 'Collective', Jaz has become a leading voice on the topic of migration, speaking everywhere from TedX to the United Nations in NYC. Jaz's work comes from a personal place, and dates back to early 2015 when her parents began fostering an unaccompanied minor named Mez from Eritrea (see his story on page 22). Mez was the first of four new brothers to join Jaz's family, respectively from Afghanistan, Sudan and most recently, a 13-year-old boy from Libya. *Asylum Speakers* is the continuation of this global family.

Jaz and her team are dedicated to challenging the fear-based narrative of today's media and society and do so through film, talks and the podcast upon which this book is based, *Asylum Speakers*.

ACKNOWLEDGEMENTS

Thank you to my DK fam. Flo Ward, this book exists because of you and I couldn't have done it without you. Pete, thank you for believing in me, and Sarosh, thank you for your considered insight. Gulwali and David for opening the book so perfectly and Milla for understanding my vision and so patiently bringing it to life. Sophie for your artwork and creative input, Miyka for your unwavering support.

My family. Mum and dad for inspiring me every day with your constant examples of unconditional love. Nils for being my rock for 30+ years. Amber, for your generosity and kind nature. Fin for your creative input and impeccable eye. Hannah and Gil – the best sisters-in-law I could dream of. Meseret for always trusting me with your story, Bego for your stoic calm. Z for inspiring us with your determination, dedication and discipline, and Arash for sweetly making us all laugh.

All my pals who carried me through the ups and downs. Slaydies – the best girl gang ever ♥ Sequoia for your energy and enthusiasm for life and for your incredible portraits. My mentors Steve (for our walks), Edson, Jack, Marisol, Selfa and Esther. I couldn't have done this without you.

Finally, to every person who shared the precious gift of their story for this book. It's truly an honour to know each and every one of you, to learn from you and to do my best to represent your experience in these pages. You have each had a profound impact on my life and I will continue to give what I can to highlight our shared humanity.

FURTHER RESOURCES

FIRSTHAND EXPERIENCE

This book exists to amplify the stories of the people within it, who I have built cherished personal relationships with, and from whom I believe we can all learn. Their stories also represent the millions of others on a journey towards safety and the opportunity to reach their potential. The best place to learn about migration is always from those with firsthand experience. Several people within these pages have also told their stories through their own books or films and I encourage everyone to seek these out.

Books:
The Lightless Sky by Gulwali Passarlay
Hope Not Fear by Hassan Akkad
Butterfly by Yusra Mardini
The Girl who Beat ISIS by Farida Khalaf

Films and TV programmes:
The Swimmers
For Sama
The Good Lie
War Child
Exodus: Our Journey to Europe

HOW TO VOLUNTEER

The best place to find out more about volunteering with refugees and asylum seekers in Europe is Indigo Volunteers, an organisation founded by Holly Penalver (see her story on page 208). Indigo directly and efficiently connects volunteers with humanitarian organisations, matching volunteers to projects that fit their skills and preferences while prioritising the latest needs of organisations on the ground. Find out more at **indigovolunteers.org**

For volunteering with refugees and asylum seekers in the US, Refugee Council USA has a helpful directory of current voluntary opportunities:
rcusa.org/get-involved/volunteer

REFERENCES

1: "Homeless refugees on the rise due to flaws in the asylum process", Immigration Advice Service (iaservices.org.uk/).
2: "Five Years On: an analysis of the past and present situation at the UK-France border, five years after the peak of the Calais 'jungle' camp", Refugee Rights Europe, 2021 (refugee-rights.eu).
3: "Women", UNHCR (www.unhcr.org/uk/women).
4: "Punishing compassion: Solidarity on trial in Fortress Europe", Amnesty International, 2020 (www.amnesty.org).
Index Number: EUR 01/1828/2020

5: "Combating modern slavery experienced by Vietnamese nationals en route to, and within, the UK", Independent Anti-Slavery Commissioner, 2017 (www.antislaverycommissioner.co.uk/).
6: "The price of a cup of coffee in Venezuela is up 285,614% in one year", *Bloomberg*, 2018 (www.bloomberg.com/).
7: "Executions, torture and slave markets persist in Libya: UN", *Reuters*, 2018 (www.reuters.com/).
8: "Post-traumatic stress disorder among Syrian refugees in Turkey: a cross-sectional study", Int J Psychiatry Clin Pract. (2015). DOI: 10.3109/13651501.2014.961930.

INDEX

PICTURE CREDITS

The publisher would like to thank the following for their kind permission to reproduce their photographs:

(Key: a-above; b-below/bottom; c-centre; f-far; l-left; r-right; t-top)

6: Sequoia Ziff (www.sequoiaziff.com). 13: Finlay O'Hara. 14: Jaz O'Hara. 17: Both images Jaz O'Hara. 18: Marc Sethi. 22: Photograph by Sequoia Ziff, collage by Milla Adler. 24: Mez. 25: Pete Davies (www.petergdavies.com). 27: Finlay O'Hara. 29: Finlay O'Hara. 31: Image courtesy of Mez. 32: Photograph by Olivier Yoan (www.olivieryoan.com) for Gung Ho London (www. gungholondon.com), collage by Milla Adler. 34: Finlay O'Hara. 35: Finlay O'Hara. 37: Image courtesy of Oeda. 38: Photograph by Sequoia Ziff, collage by Milla Adler. 40: Ibrahim. 41: Ibrahim. 42: Photograph courtesy of Brendan, collage by Milla Adler. 44: Getty Images: Justin Tallis / AFP (tl). 45: Thorsten Kieforth of Sea-Watch. 46: Brendan Woodhouse. 48-49: Giles Duley (gilesduley.com). 50: Photograph by James Day (jamesdayphoto.com), collage by Milla Adler. 52: Jaz O'Hara. 54: Photograph by Jaz O'Hara, collage by Milla Adler. 56: Jaz O'Hara. 57: Jaz O'Hara. 58-59: Nils O'Hara. 60: Photograph Getty Images: Jeff J Mitchell, collage by Milla Adler. 63: Getty Images: Jeff J Mitchell (b). 64: Photograph Alaa Dukhan, collage by Milla Adler. 66: Maddie Kaufman. 67: Abdulazez Dukhan (azyeux.com). 68: Abdulazez Dukhan. 69: Abdulazez Dukhan. 70: Photograph by Sequoia Ziff, collage by Milla Adler. 73: Gulwali Passarlay. 75: Sequoia Ziff. 76: Gulwali Passarlay. 77: Jaz O'Hara. 78-79: Sequoia Ziff. 80: Photograph Joshua Coombes, collage by Milla Adler. 82: Jaz O'Hara (l), The Great Oven (greatoven.org) (r). 83: The Great Oven. 84: The Great Oven. 85: The Great Oven. 86: Photograph Sequoia Ziff, collage by Milla Adler. 89: Both images Hassan Akkad. 90: Jaz O'Hara. 92: Photograph Sequoia Ziff, collage by Milla Adler. 95: Sequoia Ziff. 96: Photograph Maximilian Baier (maximilianbaier. com), collage by Milla Adler. 99: Getty Images: Alexander Hassenstein (t). 100: Alamy Stock Photo: Kai Pfaffenbach / Reuters (b). 101: Getty Images: Alexander Hassenstein (tl). 102: Alamy Stock Photo: BJ Warnick / Newscom (b). 103: Getty Images: Remy Steiner (tr). 104: Photograph Fynn Stoldt (heinstoldt.com), collage by Milla Adler. 106: Fynn Stoldt. 108-109: Sequoia Ziff. 110: Photograph courtesy of Karina Ambartsoumian-Clough, collage by Milla Adler. 112: Karina Ambartsoumian-Clough. 113: Karina Ambartsoumian-Clough. 114: Karina Ambartsoumian-Clough. 115: Karina Ambartsoumian-Clough. 116: Photograph Sequoia Ziff, collage by Milla Adler. 119: Sequoia Ziff. 120: Photograph Sequoia Ziff, collage by Milla Adler. 122: Both images Yara Eid. 123: Yara Eid. 124: Both images Yara Eid. 125: Sequoia Ziff. 129: Getty Images: Andrew Aitchison / In pictures (tr). 130: Getty Images: Nhac Nguyen / AFP (bl). 132: Photograph Alice Aedy (aliceaedy.com), collage by Milla Adler. 134: Adrian Shankar. 135: Getty Images: Stringer / AFP (b). 137: Getty Images: Zaid Al-Obeidi / AFP (t). 138: Photograph Hannah Aiyana, collage by Milla Adler. 140: Both images by Jaz O'Hara. 141: Getty Images: AFP (tr). 143: Hannah Aiyana (hannahaiyana.com). 144: Photograph Sequoia Ziff, collage by Milla Adler. 147: Courtesy of Jaz O'Hara / Jangala. 148: Photograph by Jaz O'Hara, collage by Milla Adler. 151: Sequoia Ziff. 153: Both images Jaz O'Hara. 154-155: Marc Sethi. 156: Photographs Joshua Coombes, collage by Milla Adler. 158: Getty Images: Frederic J. Brown / AFP (bl). 160: Jaz O'Hara. 163: Jaz O'Hara. 164: Photograph Jaz O'Hara, collage by Milla Adler. 166: Kelli Scott. 167: Jaz O'Hara. 168: Jaz O'Hara. 169: Kelli Scott. 170: Photograph Getty Images: Tariq Mikkel Khan / Ritzau Scanpix / AFP, collage by Milla Adler. 173: Getty Images: Massoud Hossaini / AFP (b). 174: Getty Images: Bulent Kilic / AFP (tl). 177: Getty Images: Tariq Mikkel Khan / Ritzau Scanpix / AFP (b). 178: Photograph courtesy of Marisela, collage by Milla Adler. 180: Marisela. 181: Marisela. 182: Marisela. 184: Photograph by Jaz O'Hara, collage by Milla Adler. 186: Jaz O'Hara. 189: Jaz O'Hara. 190-191: Sequoia Ziff. 195: Getty Images: Dominika Zarzycka / NurPhoto (b). 196: Getty Images: Bartek Sadowski / Bloomberg (tl). 198: Photograph Sequoia Ziff, collage by Milla Adler. 200: Getty Images: Stefanie Glinski / AFP (tr). 201: Giel Piny. 202: Giel Piny. 203: Getty Images: Tony Karumba / AFP (b). 204: Jaz O'Hara. 206: Giel Piny. 207: Sequoia Ziff. 208: Photograph Sequoia Ziff, collage by Milla Adler. 210: Holly Penalver / Indigo Volunteers. 212: Photograph Sequoia Ziff, collage by Milla Adler. 215: Sequoia Ziff. 219: Photograph Sequoia Ziff, collage by Milla Adler.

Cover: repeats of collage portraits on pages 22, 32, 38, 42, 50, 54, 60, 64, 70, 80, 86, 92, 96, 104, 110, 116, 120, 126, 132, 138, 144, 148, 156, 164, 170, 178, 184, 192, 198, 208, 212 (see above).

DK

Penguin
Random
House

DK LONDON

Commissioning Editor Florence Ward
Designer Christine Keilty
Managing Art Editor Jo Connor
Managing Editor Pete Jorgensen
Production Editor Marc Staples
Production Controller Louise Minihane
Publishing Director Mark Searle

Illustration, styling and cover design Milla Adler

DK would like to thank Sequoia Ziff for her photography, Sarosh Arif for her editorial support, Tom Howells for proofreading and Vanessa Bird for indexing.

First American Edition, 2023
Published in the United States by DK Publishing
1745 Broadway, 20th Floor, New York, NY 10019

Page design copyright © 2023 Dorling Kindersley Limited
DK, a Division of Penguin Random House LLC
23 24 25 26 27 10 9 8 7 6 5 4 3 2 1
001–336207–July/2023

A catalog record for this book
is available from the Library of Congress.
ISBN 978-0-7440-8370-5

DK books are available at special discounts when purchased in bulk for sales promotions, premiums, fund-raising, or educational use.
For details, contact: DK Publishing Special Markets,
1745 Broadway, 20th Floor, New York, NY 10019
SpecialSales@dk.com

Printed and bound in Slovakia

For the curious
www.dk.com

MIX
Paper | Supporting
responsible forestry
FSC™ C018179

This book was made with Forest Stewardship Council™ certified paper - one small step in DK's commitment to a sustainable future.
For more information go to
www.dk.com/our-green-pledge